M ezzanine

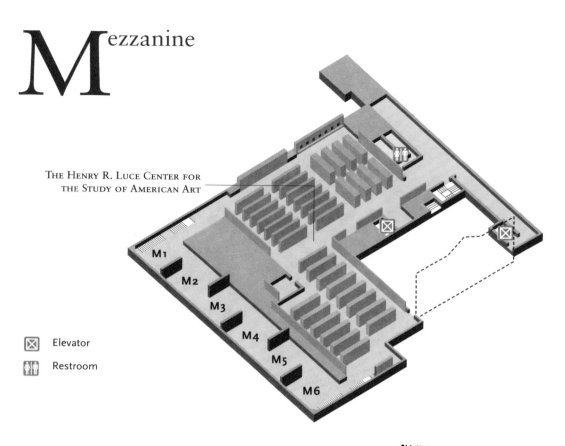

The Henry R. Luce Center for
the Study of American Art

☒ Elevator

👫 Restroom

M1
M2
M3
M4
M5
M6

D1534152

Mezzanine

A Walk Through the American Wing

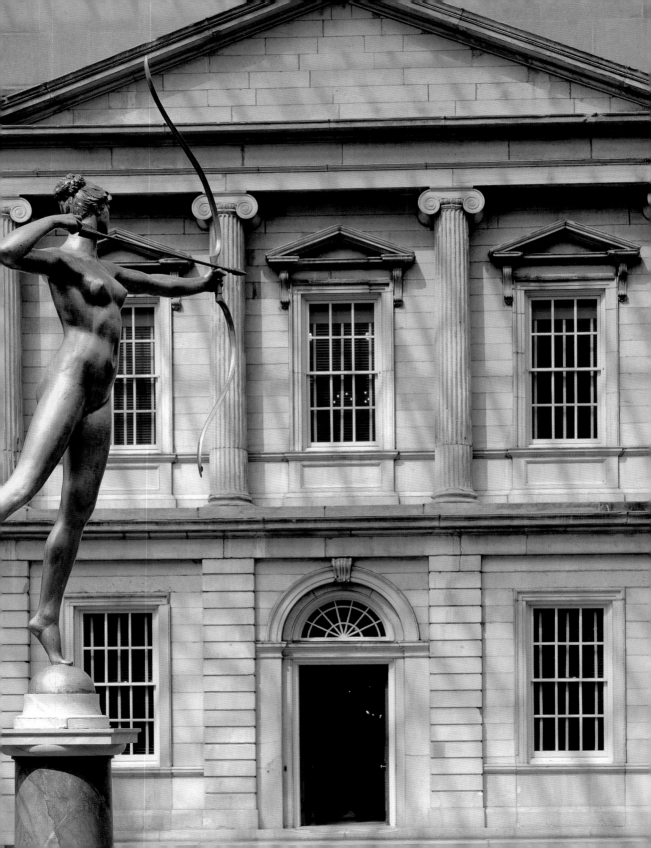

A Walk Through the American Wing

By the Curators of the American Wing

THE METROPOLITAN MUSEUM OF ART, NEW YORK
YALE UNIVERSITY PRESS, NEW HAVEN AND LONDON

This publication is made possible by the William Cullen Bryant Fellows.

Published by The Metropolitan Museum of Art, New York

John P. O'Neill, Editor in Chief
Joan Holt and Dale Tucker, Editors
Antony Drobinski, Emsworth Design, Designer
Megan Arney, Production Manager

Color separations by Professional Graphics, Inc., Rockford, Illinois
Printed and bound by Arnoldo Mondadori, S.p.A., Verona, Italy

Library of Congress Cataloging-in-Publication Data
Metropolitan Museum of Art (New York, N.Y.). American Wing.
A walk through the American Wing / by the curators of the American Wing.
 p. cm.
ISBN 1-58839-013-6 (pbk. : alk. paper)—ISBN 0-300-09369-1 (pbk. : alk. paper : Yale University Press)
 1. Art, American—Catalogs. 2. Decorative arts—United States—Catalogs. 3. Art—New York (State)—New York—Catalogs. 4. Metropolitan Museum of Art (New York, N.Y.). American Wing—Catalogs. I. Title.

N611.A6 M48 2001
709'.73'0747471—dc21 2001044730

All photographs by The Photograph Studio, The Metropolitan Museum of Art, except the following:
David Allison: figs. 77, 78, 81, 92; Gavin Ashworth: figs. 17, 18, 21, 42 (© Robert Mussey); Castro/Huber: fig. 158; Richard Cheek: figs. 16, 19, 24, 32, 37, 43, 47–49; Schecter Lee: figs. 11, 85, 86, 96; John Bigelow Taylor: fig. 166; Jerry L. Thompson: figs. 6, 7, 116, 121, 128, 133–135, 139, 147, 156; Paul Warchol: figs. 5, 58, 60, 88, 94; Bruce White: pp. 14–15; fig. 54

Cover: Emanuel Leutze, *Washington Crossing the Delaware* (detail; fig. 126)
Frontispiece: Facade of the Branch Bank of the United States (detail), built by Martin E. Thompson (fig. 1)
Pages 2–3: Entrance loggia from Laurelton Hall (detail), by Louis Comfort Tiffany (fig. 2)
Pages 14–15: Card table (detail), by Charles-Honoré Lannuier (fig. 54)
Pages 124–25: George Caleb Bingham, *Fur Traders Descending the Missouri* (detail; fig. 111)
Pages 198–99: Winslow Homer, *Fishing Boats, Key West* (detail; fig. 162)
Endpapers: Map of the American Wing, designed by John Papasian

Contents

Director's Foreword

The American Wing is a favorite destination for the Metropolitan's visitors, so I am particularly pleased that, once again, there is in print a handy and dependable guide to its treasures. The joint work of the curatorial staffs of the Departments of American Decorative Arts and American Paintings and Sculpture, the text is informed by the latest scholarship presented in an informal and accessible manner.

The original inspiration for such a volume was *A Handbook of the American Wing*, published at the time of its opening in 1924. The *Handbook* was written by the two men most closely involved with the Wing's creation: R. T. Haines Halsey, collector and trustee-chairman of the Committee on American Decorative Arts, and Charles O. Cornelius, assistant curator of Decorative Arts. This popular work was reprinted six times between 1924 and 1938 and culminated in 1942 in an enlarged and revised edition by Joseph Downs, the first curator of the American Wing. This volume was never reprinted. It was not until 1980, with the opening of a greatly enlarged American Wing, which included paintings and sculpture as well as decorative arts, that *The American Wing: A Guide* by Marshall B. Davidson, himself a one-time curator in the American Wing, was published. This book is now long out of print.

The American Wing is a living organism, with its collections and their means of display continually evolving. Since 1980, for example, literally hundreds of works of art have been acquired thanks to the generosity of many collectors and donors; a half dozen important period rooms, including a masterpiece by Frank Lloyd Wright, have been installed; and the Henry R. Luce Center for the Study of American Art, in which most of the Wing's reserve collections are on public view, has opened. Changes will continue, and it is our hope that this new volume, organized to guide the visitor through three stories and many galleries, will be as popular, and go through as many editions, as the original *Handbook*.

This publication would not have been possible without support from the William Cullen Bryant Fellows of the Metropolitan Museum, to whom we extend our continued gratitude.

Philippe de Montebello, *Director*

Introduction

Almost from its inception in 1870 The Metropolitan Museum of Art has been committed to promoting the nation's fine and decorative arts. American paintings and sculpture were prominent in the Museum's collection from the outset, owing to the strong support of such founding trustees as Frederic Edwin Church, Eastman Johnson, and John F. Kensett, all renowned painters, and William T. Blodgett and Robert Gordon, enthusiastic collectors of works by their fellow founders. In 1872 the Museum acquired its first American sculpture, an allegorical female nude by Hiram Powers entitled *California* (1849–58). In 1874 a group of unfinished landscapes from Kensett's last summer's work (1872) was given by his brother, providing the core of one of the collection's strengths—Hudson River School paintings. Five years later, the Museum's first director, General Luigi di Cesnola, recommended that the Metropolitan gather a representative selection of early American paintings, thus initiating a program of assembling by gift and purchase a comprehensive range of American fine art from colonial to contemporary. Major loan exhibitions held at the Museum, including memorial shows commemorating painters such as Thomas Eakins and John Singer Sargent and sculptors such as Augustus Saint-Gaudens, and later, more scholarly loan exhibitions created impetus for further growth.

In the field of decorative arts, acquisitions of examples from the shops of New York's finest contemporary designers and craftsmen began as early as 1877. In that year, William Cullen Bryant gave to the Museum the silver vase made by Tiffany and Company in 1875, which had been commissioned

to honor his eightieth birthday. During the 1880s various magnificent objects, including furniture made for the 1876 Centennial Exposition by Pottier and Stymus, were accessioned in order to manifest "the application of arts to manufacture and practical life," one of the purposes outlined in the Museum's charter. The gift of H. O. Havemeyer in 1896 of his collection of Tiffany Favrile glass culminated two decades during which the Metropolitan had shown its dedication to acquiring and showing current American design.

Meanwhile, Americans began to develop an interest in their colonial past. In 1909, as part of New York City's Hudson-Fulton Celebration, the Museum mounted a loan exhibition of the arts of colonial America and the early Republic, intended, as Robert W. de Forest, the Museum's president between 1913 and 1931, later recollected, "to test out the question whether American domestic art was worthy of a place in an art museum." The display, which focused on furniture, silver, and portraits, but also included ceramics, glass, pewter, and textiles, was a tremendous popular success. The Metropolitan quickly abandoned its pursuit of late-nineteenth-century objects in favor of American decorative arts made before 1815. Through the generosity of Mrs. Russell Sage, in 1910 the Museum purchased the extensive furniture collection of H. Eugene Bolles, which became the nucleus of a separate American Wing. It was soon decided that these domestic objects would be best shown in a new structure incorporating rooms taken from colonial and Federal houses that had either been demolished or were in danger of it. Accordingly, the Museum acquired some two dozen

rooms from houses along the East Coast. These were assembled in a three-story building, designed by architect Grosvenor Atterbury and faced with the marble facade of the Branch Bank of the United States (see fig. 1), a gift of Robert W. and Emily J. de Forest. The building, which opened to the public on November 10, 1924, reflected the cultural nationalism that characterized American political, intellectual, and cultural life in the 1920s.

During the late 1940s American paintings, which had been displayed with European works and cared for by the same curators, were moved into their own galleries under the aegis of the Department of American Paintings and Sculpture. In 1968, in connection with a major expansion of the Museum's facilities, a larger American Wing was conceived to accommodate paintings, sculpture, and drawings by American artists born by 1876 and decorative arts from the colonial period to the early twentieth century. The new Wing, combining the 1924 building and spacious additions designed by Kevin Roche John Dinkeloo and Associates, opened in 1980. (Paintings and sculpture by artists born after 1876 and decorative arts created after World War I are exhibited by the Department of Modern Art; American prints are housed in the Department of Drawings and Prints.) Two years later the physical and programmatic affiliation between the two Departments of American Art was recognized by the merging of the curatorial staffs under the direction of a chairman; John K. Howat was appointed as the first incumbent of the Lawrence A. Fleischman Chairmanship. One of the important innovations resulting from the reorganization was the construction of the Henry R. Luce Center for the Study of American Art on the mezzanine of the American Wing. Opened in 1988, the Center makes available in open study storage works not shown in period rooms or galleries, allowing freer access to and fuller use of our sizable and varied holdings.

The quality and importance of the collections have attracted to the American Wing scholars devoted to the joyful tasks of acquiring, caring for, and interpreting the Metropolitan's American fine and decorative arts. In preparing *A Walk Through the American Wing* the members of the current staff hope to share their own enthusiasms for a selection of the collection's masterworks and to entice visitors to make their own discoveries. This guide was coordinated by Morrison H. Heckscher, Lawrence A. Fleischman Chairman of the American Wing, and H. Barbara Weinberg, Alice Pratt Brown Curator of American Paintings and Sculpture, and was written by them and their colleagues, as follows:

American Decorative Arts
Alice Cooney Frelinghuysen (Anthony W. and Lulu C. Wang Curator); Peter M. Kenny (Curator); Amelia Peck, Frances Gruber Safford, and Catherine Hoover Voorsanger (Associate Curators)

American Paintings and Sculpture
Carrie Rebora Barratt (Curator); Kevin J. Avery and Thayer Tolles (Associate Curators); Stephanie Herdrich (Research Associate); Dana Pilson (Research Assistant)

The previous guide, published in 1980, was largely the work of the late Marshall B. Davidson—art critic, author, and former curator in the Wing—and we are indebted to him for the concept of a brief, helpful volume to lead the visitor on a tour of our galleries. In this publication we propose tours of the four principal components of the American Wing: the Charles Engelhard Court, the period rooms and galleries housing decorative arts, the galleries containing paintings and sculpture, and the study collections. The visitor may explore each section separately, in sequence, or, with the help of the maps, cross over from one to another at will. We anticipate that the guide will assist visitors in planning their tours before they come to the Museum as well as when they are in the galleries, and that it will provide a souvenir of their experience and an invitation to return.

Morrison H. Heckscher
H. Barbara Weinberg

A Walk Through the American Wing

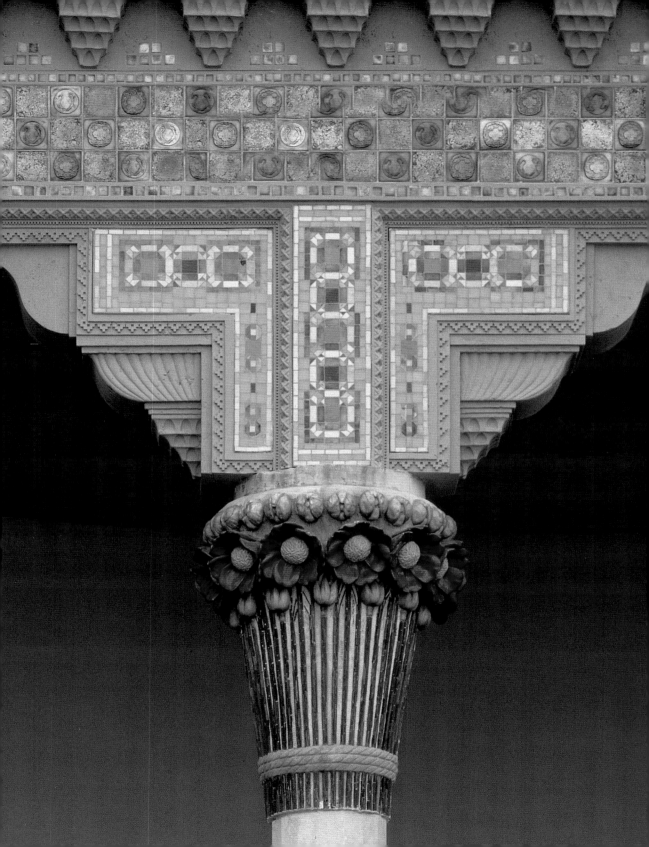

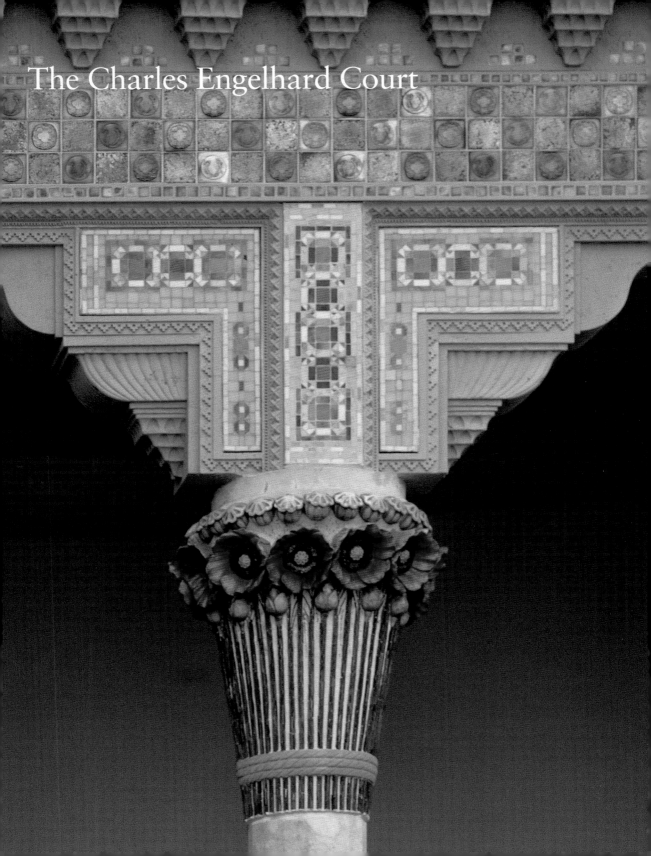

The Charles Engelhard Court

The Charles Engelhard Court

The principal approaches to the American Wing are from the Medieval Treasury and the Arms and Armor Galleries into the Charles Engelhard Court (fig. 1). This vast glass-roofed enclosure, completed to the designs of Kevin Roche John Dinkeloo and Associates in 1980, serves as a grand vestibule to the American Wing. Visitors are offered a chance to pause—to enjoy the sunlight, the plantings, the sound of fountains, and a park view. The court is also the place where American architectural elements, stained-glass windows, and monumental sculpture are displayed.

The largest and most complete of the architectural elements, and the main focus of the court on its north side, is the facade of the Branch Bank of the United States (fig. 1), originally located at 3 (later 15) Wall Street in Manhattan next to the site of New York's original City Hall. The structure was built between 1822 and 1824 by architect Martin E. Thompson. The bank's white Westchester County marble facade—two stories high, seven bays wide, its projecting center bays capped with a classical pediment—is emblematic of a number of handsome public buildings in the classical style that were New York landmarks before 1825, when the city began its explosive growth after the opening of the Erie Canal. The Ionic columns and cornice moldings, based upon Grecian models, are precursors of the Greek Revival style of architecture that later swept the nation. The building was dismantled in 1915 and the facade reerected here in 1924 as the entrance to the American Wing.

The south wall of the Engelhard Court is dominated by the four-column entrance loggia to Laurelton Hall, the summer estate at Cold Spring Harbor, Long Island, designed by Louis Comfort Tiffany for himself and completed between 1902 and 1905 (fig. 2). By that time Tiffany had already gained an international reputation, especially for his work in glass. The loggia was among the few architectural elements to survive a fire that destroyed the house in 1957. It heralds two of Tiffany's key influences: exotic cultures, which he absorbed during his travels abroad, and nature. The overall design derives from Indian and Egyptian architecture, and the capitals crowning the limestone columns feature some of his favorite plants—lotus, dahlia, poppy, and saucer magnolia—each represented in three stages of growth, from bud to seedpod. Colorful mosaic panels surmount the capitals, and the whole is crowned by a frieze of bright blue iridescent glass tiles.

In the court are displayed six other major works by Tiffany, including four leaded-glass windows, an iridescent blue-and-gold glass mosaic column, and a garden landscape mosaic and fountain that exemplify Tiffany's interest in color and light. Stretching the medium to hitherto unknown limits, he used myriad hues of glass to create lush, illusionistic effects.

One of the most sumptuous Tiffany windows, *Autumn Landscape* (fig. 3), greets visitors as they enter the Engelhard Court from the Medieval Treasury. A triumph in colored glass, the window dates from late in Tiffany's career, when he was semiretired from his work at Tiffany Studios. The scene depicts a stream emanating from distant mountains and falling into a placid pool in the foreground, a theme Tiffany had developed several decades earlier for memorial windows. Here all of his glassmaking techniques were brought to

1. The Charles Engelhard Court, looking north to the facade of the
Branch Bank of the United States, built by Martin E. Thompson,
1822–24. The bank's accomplished classical design, worked in
mellow local marble, is characteristic of Thompson, the leading
New York architect of the 1820s. Gift of Robert W. de Forest, 1924

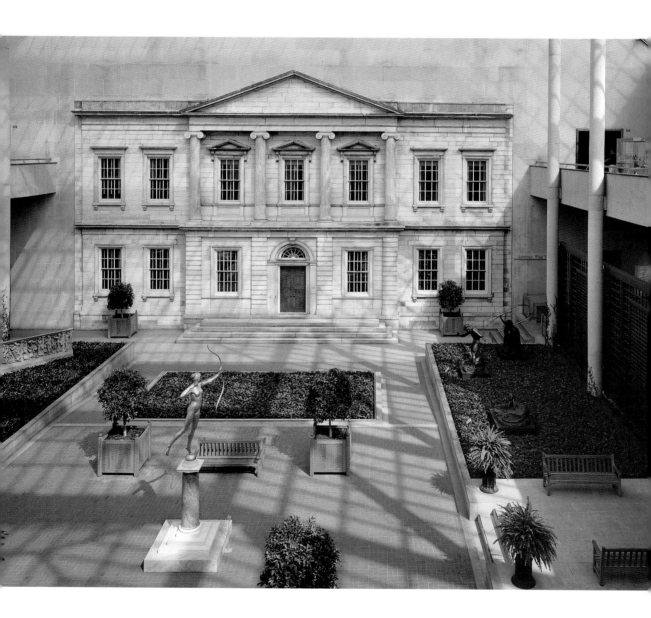

2. Louis Comfort Tiffany (1848–1933). Entrance loggia from Laurelton Hall, Cold Spring Harbor, New York, ca. 1902–5. Limestone, granite, ceramic, and Favrile glass. In the loggia Tiffany combined exotic influences—Indian, Roman, Egyptian, Byzantine, and even Celtic (in the lanterns)—to give a fantastic quality to Laurelton Hall. Gift of Jeannette Genius McKean and Hugh Ferguson McKean, in memory of Charles Hosmer Morse, 1978 (1978.10.1). *Pan of Rohallion*, 1890, by Frederick William MacMonnies: Lent by Asadur and Shelley Azapian

3. Louis Comfort Tiffany. Tiffany Studios. *Autumn Landscape*, 1923–24. Leaded Favrile glass. A quintessential autumnal image, the window is ablaze with glowing colors and rich in surface textures. Gift of Robert W. de Forest, 1925 (25.173)

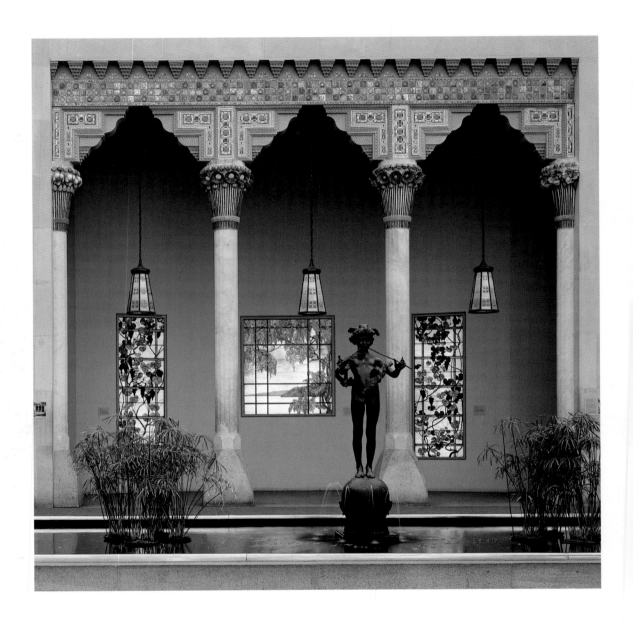

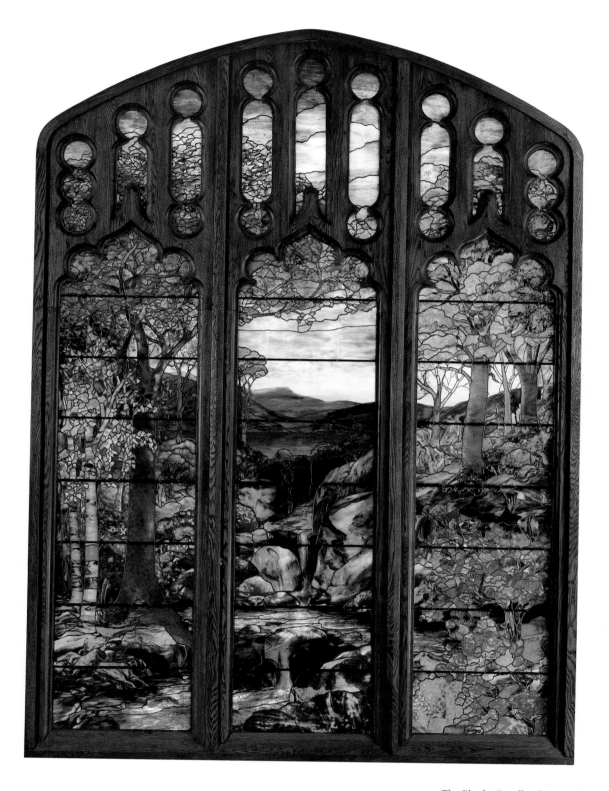

bear: internally mottled glass to evoke light streaming through autumn foliage, glass textured to look like rippling water, confetti glass, and plating of as many as six layers to modulate color and convey the effects of depth and recession. The window was intended for the new residence of Boston real-estate magnate Loren Delbert Towle. Towle's premature death precluded its installation, and the window was purchased by Museum president and American Wing founder Robert W. de Forest for the Metropolitan in 1925.

The Metropolitan owns the most comprehensive collection of American stained glass in the country. The earliest piece (in the Luce Center) dates from the mid-seventeenth century and is by the

Dutch glass painter Evert Duyckinck, who worked in New Amsterdam (later renamed New York by the British). The Engelhard Court has a number of important examples installed around its perimeter, beginning on the west side with a mid-1840s window executed in the medieval manner, utilizing paint and silver stain, by William Jay Bolton and his brother John as part of their commission for Minard Lafever's Holy Trinity Church (now Saint Ann's and the Holy Trinity) in Brooklyn Heights.

John La Farge, known for his evocative painted landscapes and floral and figure studies, is credited with first developing opalescent glass for windows. The Museum's holdings of La Farge's glass span his career. The earliest example, *Peonies*

4. Frank Lloyd Wright (1867–1959). Window triptych from Avery Coonley Playhouse, Riverside, Illinois, 1912. Glass and zinc. A departure from Wright's early windows, in which motifs are in earth tones and are loosely derived from natural forms, this one is in bright primary colors and boldly geometric in design. Purchase, The Edgar J. Kaufmann Foundation and Edward C. Moore Jr. Gifts, 1967 (67.231.1–3)

Blown in the Wind (see fig. 81), reflects his interest in japanesque motifs and compositions, as well as his use of richly colored and textured glass. *Welcome* (1908), directly opposite Tiffany's *Autumn Landscape*, was one of La Farge's last windows. At its center, a classically garbed maiden in the pose of Andromeda pulls back a portiere to beckon a visitor. La Farge often incorporated highly decorative glass borders, and here the central panel is surrounded by classical urns and garlands that recall Pompeian designs.

The stylistic finale to the collection, and a complete departure from the lush, dense windows of Tiffany and La Farge, is the patterned glass of Frank Lloyd Wright, represented by a triptych from the playhouse commissioned in 1912 by Mr. and Mrs. Avery Coonley of Riverside, Illinois (fig. 4). The use of colorless, transparent glass, flat primary colors, and geometric, largely rectilinear forms is characteristic of Wright's work in glass. Originally made for a nursery or kindergarten, the window is playful in its shapes—the bold circles and flaglike forms remind us of the exuberance of a parade.

Behind and at either side of the Tiffany loggia is a pair of staircases, each two stories high, from the Chicago Stock Exchange Building, an office tower designed by Louis H. Sullivan in 1893 and completed in 1895 (fig. 5). Sullivan, the preeminent architect in the Midwest during the late nineteenth century and a mentor of Frank Lloyd Wright, specialized in skyscrapers and banks. His architecture is notable for its use of surface ornament that combines naturalistic foliage and geometric patterns. On the landings midway up the staircases are displays of architectural fragments

from various Midwestern buildings, now demolished, that exemplify Sullivan's decorative style.

The Metropolitan Museum's collection of American sculpture is acclaimed for its lifesize statues in marble and bronze, a selection of which is on view in the Engelhard Court. In this space the history of American sculpture and its development as a profession may be accurately traced, from the Neoclassical artists who worked in Italy and carved in marble to those who mastered the Beaux-Arts style in France and cast their works in bronze. Beginning in the 1830s sculptors were drawn to Florence and Rome for the inspiration of ancient and Renaissance works of art, the availability of expert marble carvers, and an abundant supply of marble. By 1875 artists were opting for Paris, where they received rigorous training at the École des Beaux-Arts and other academies in a naturalistic style more suited to the bronze medium.

Many of the Metropolitan's preeminent examples of American Neoclassical sculpture are installed on the west side of the Engelhard Court, adjacent to Central Park. Horatio Greenough's bust of George Washington (1827–28; MMA version, 1832) depicts the *pater patriae* with blank eyeballs typical of imperial Roman and late antique portraits and with the massive, wavy locks of Hellenistic ruler images. While the earliest American sculptors in Italy preferred this more severe classicism, a later generation favored narrative in their ideal works. In Randolph Rogers's *Nydia, the Blind Flower Girl of Pompeii* (ca. 1853–54; MMA version, 1859), the heroine negotiates her way through the rubble-strewn streets of Pompeii (symbolized by a broken

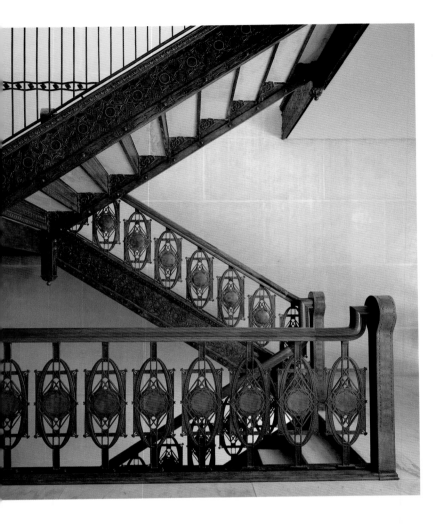

5. Louis H. Sullivan (1856–1924). One of two pairs of staircases for the Chicago Stock Exchange Building, 1893. Cast iron with electroplated copper finish. Sullivan was uniquely skilled at integrating utilitarian construction and elegant ornament. Purchase, Mr. and Mrs. James Biddle Gift and Emily Crane Chadbourne Bequest, 1972 (1972.50.1–4)

Corinthian column) with her hand cupped to her ear to emphasize her acute sense of hearing.

Late-nineteenth-century monumental sculpture is installed in the center and on the east side of the court. Augustus Saint-Gaudens's *Victory* (1892–1903; MMA cast, 1912 or after) derives from his gilt-bronze equestrian statue of General William Tecumseh Sherman. One of New York's most impressive public monuments, the Sherman monument (1892–1903) forms the centerpiece of Manhattan's Grand Army Plaza at Fifth Avenue and Fifty-ninth Street. With her right arm out-stretched, the winged figure leads the mounted general forward. In her left hand she holds a laurel branch, the symbol of honor. Frederick William MacMonnies presented his *Bacchante and Infant Faun* (fig. 6) to architect Charles Follen McKim for installation in the courtyard of the Boston Public Library, designed by McKim's firm. After a furor over the bronze's "drunken indecency," McKim offered it to the Metropolitan. On the balcony is Daniel Chester French's reduced replica of *Mourning Victory* (fig. 7), created as the central element of the *Melvin Memorial* (Sleepy Hollow

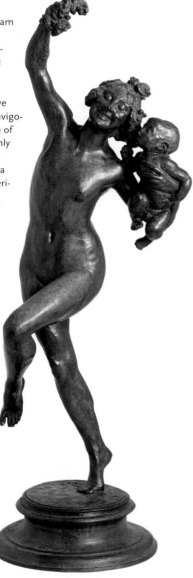

6. Frederick William MacMonnies (1863–1937). *Bacchante and Infant Faun*, 1893–94; this cast, 1894. Bronze. The active spiraling form, invigorating naturalism of the body, and richly textured surfaces make this statue a paradigm of American Beaux-Arts sculpture. Gift of Charles McKim, 1897 (97.19)

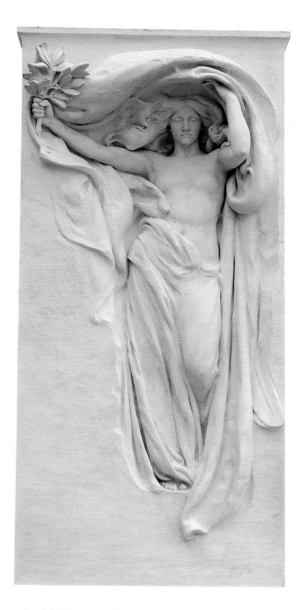

7. Daniel Chester French (1850–1931). *Mourning Victory*, from the *Melvin Memorial*, 1906–8; this version, 1912–15. Marble. The over-lifesize figure projects the duality of melancholy (the downcast eyes and somber expression) and triumph (the projecting laurel leaves and draped American flag held high). Gift of James C. Melvin, 1912 (15.75)

8. Augustus Saint-Gaudens (1848–1907). Mantelpiece from Cornelius Vanderbilt House, New York, 1881–83. Marble, mosaic, oak, and cast iron. The Latin inscription may be translated as "The house at its threshold gives evidence of the master's good will. Welcome to the guest who arrives; farewell and helpfulness to him who departs."
Gift of Mrs. Cornelius Vanderbilt II, 1925 (25.234)

9. Karl Bitter (1867–1915). All Angels' Church pulpit and choir rail, 1900. Limestone, oak, and walnut. Bitter looked to Northern Italian Renaissance examples as inspiration for the general form of the pulpit, which is installed in the Engelhard Court much as it once was in All Angels' Church. Pulpit and choir rail: Rogers Fund, 1978 (1978.585.1, 2); south side of choir rail and walnut trumpeting angel surmounting oak sounding board: Lent by All Angels' Church (L.1983.53.1,2)

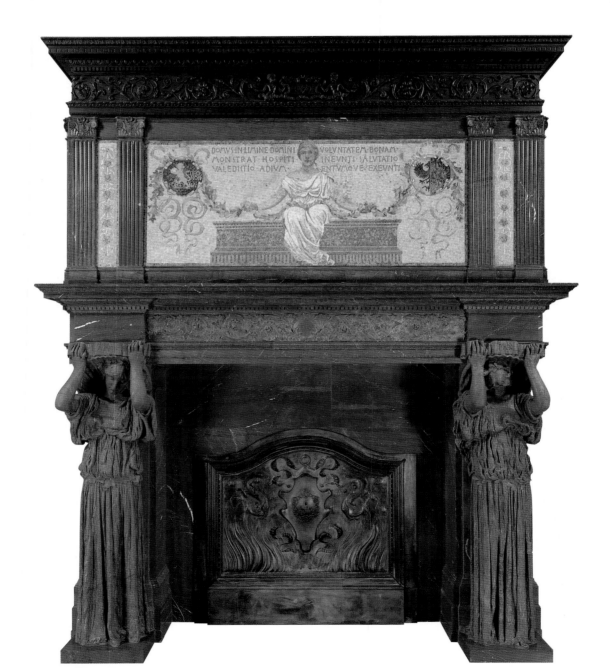

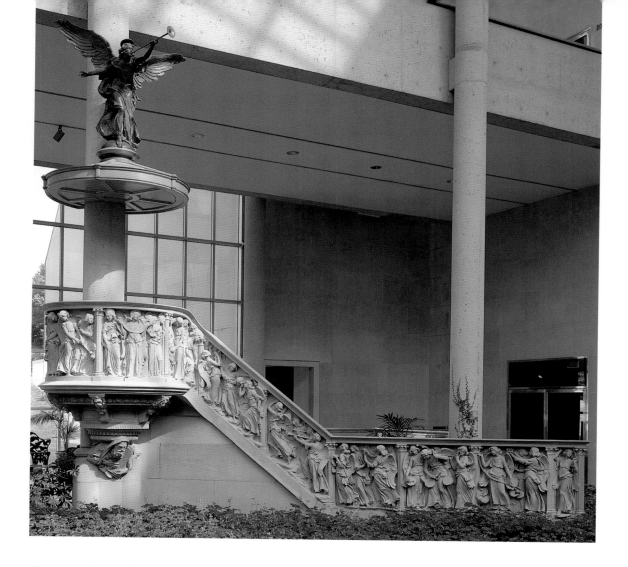

Cemetery, Concord, Massachusetts). James C. Melvin erected the monument as a tribute to his three brothers who perished in the Civil War.

Collaborations between sculptors and architects resulted in many of the most innovative and inspiring artistic productions of the Gilded Age. Saint-Gaudens's Vanderbilt mantelpiece (fig. 8) was originally installed in the mansion designed by George B. Post for Cornelius Vanderbilt II on Fifth Avenue between Fifty-seventh and Fifty-eighth Street. The caryatid figures, *Amor* and *Pax*, support the massive entablature, above which is a mosaic bearing the Vanderbilt family crest and monogram. These classically draped females reappeared in the artist's oeuvre, achieving their last and most ethereal form in the gilded *Amor Caritas* (1880–98; MMA cast, 1918), installed on the east side of the Engelhard Court. For the remodeling of All Angels' Church in 1897–1900 (New York; demolished, 1978), Karl Bitter designed the pulpit and choir rail (fig. 9). High-relief angels carved in limestone walk, dance, or climb on heavenly clouds, play musical instruments, or carry appropriate symbolic attributes. Above the pulpit a trumpeting angel, carved in walnut, surmounts the oak sounding board.

Decorative Arts

Meetinghouse Gallery

Colonists who settled along the eastern seaboard during the seventeenth century re-created the homes they had left behind as nearly as their skills and the materials at hand would permit. Immigrant artisans built houses and furniture and plied other trades according to the particular English or Continental training they had received. Many came from small towns and villages, and some of the crafts they practiced still reflected late medieval traditions of northern Europe, primarily England, rather than Renaissance influences.

The main architectural feature of the third-floor central gallery is its high open-timbered ceiling, the heavy trusses of which resemble those of great English Gothic and Tudor halls (fig. 10). They were adapted from the roof of the Old Ship Meetinghouse in Hingham, Massachusetts, built in 1681 and still serving its congregation. The furniture in the gallery is primarily from New England and illustrates the two styles represented on this floor: that of the seventeenth century and the William and Mary style.

Seventeenth-century furniture, which reflects late Renaissance and Mannerist designs of northern Europe and England, is installed at the east end of the gallery. The pieces are essentially rectilinear in form and generally built of weighty stock. Case furniture was usually made of oak by the panel-and-frame method. Chests were the principal storage units. The example from Ipswich, Massachusetts (fig. 11), displays one mode of ornamentation popular in the seventeenth century: low-relief carving of stylized plant forms and simple geometric shapes. Such carved ornament was brought to the colonies from rural England, where each region had developed distinctive designs.

Immigrant artisans from urban centers transplanted another method of decoration, composed of applied elements and moldings forming geometric patterns. The effect was usually distinctly architectural, whether on large cupboards or on small cabinets such as that from Salem, Massachusetts (fig. 12), which bears a multiplicity of glued-on components. Several kinds of wood were employed; originally, they differed in color, adding to the complexity of the scheme. Black paint on the turnings simulated ebony, a wood not available locally.

At the close of the seventeenth century new concepts derived from the European Baroque led to a style now called William and Mary (after the monarchs who ascended the British throne in 1689), which remained popular until the 1730s. Furniture in this taste—displayed at the west end of the gallery—had a distinctly vertical emphasis and was lighter in scale; the wood of choice was walnut. A Boston high chest, with trim lines and smooth surfaces typical of case pieces in this period (fig. 13), illustrates the basic change in design: the overall form is no longer strictly rectilinear but is enlivened by a curved skirt and stretchers. Also reflecting the three-dimensional quality of the Baroque, the legs' turnings juxtapose strong bulbous shapes with narrow tapers. A like preference for striking effects is evident in the highly figured veneers on the front of this

10. Meetinghouse Gallery. The monumental oak beams of the ceiling, with dramatic rounded trusses that suggest the ribs of an upside-down boat, were inspired by those of the First Parish Church, Hingham, Massachusetts, built in 1681 and popularly known as the Old Ship Meetinghouse.

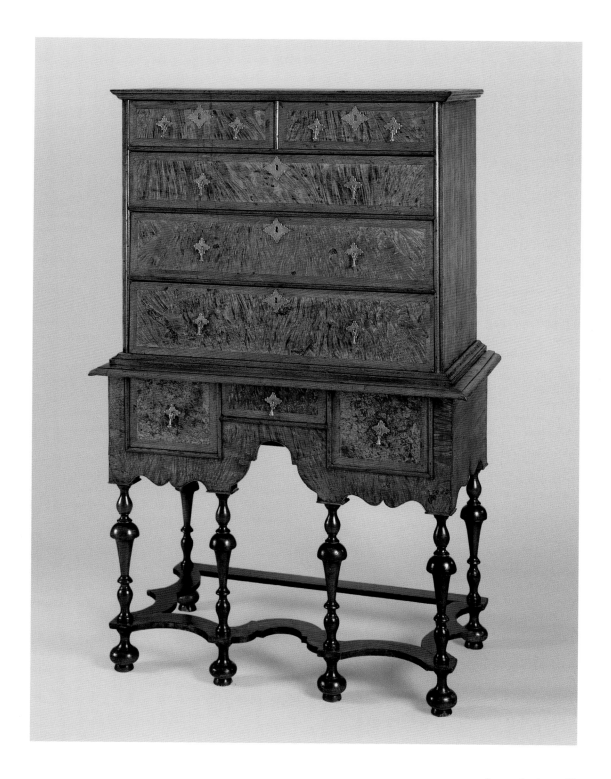

Hart Room

GALLERY 303

The Thomas Hart house, built in Ipswich, Massachusetts, before 1674, was the source for the American Wing's earliest interior woodwork, which is basically medieval in character and carries on traditions familiar to colonists in their native England (fig. 14). The massive oak timbers of the post-and-beam framing are largely exposed and stand out against the white plaster walls and ceiling. The casement windows are small with diamond-shaped leaded panes (here reproductions). Embellishments to the woodwork are few: on the main timbers, most obviously on the central ceiling beam, the edges are chamfered, and the pine sheathing of the fireplace wall has bead-molded edges.

The Hart house very likely first consisted of only this room and a chamber above it. A small entry containing stairs set against the chimney mass was situated beyond the door to the right of the fireplace. The Museum's room is furnished to suggest its various uses as a single downstairs living space. Known as the hall, it served for cooking, dining, and sleeping.

Thomas Hart was a tanner and farmer. The inventory of his "goods and chattels" taken after his death in 1674 lists the basic furnishings usually found in a modest but comfortable seventeenth-century household: chests, tables, seating furniture, linens, earthenware, and iron and brass utensils. As was typical, the most costly single item noted is a bed (one of three listed); during this period the term "bed" included bedding, curtains, and frame. The textiles, largely imported, were expensive, and the high value assigned to Hart's best bed, which had a feather mattress and bolster, indicates it was fully curtained. (The frame, bedding, and hangings in the room are all handmade reproductions.) Wool was the most popular fabric for draping a bed, with red and green the favorite colors.

The other furniture dates from the second half of the seventeenth century and is mainly of Massachusetts origin. Notable is the oak panel-and-frame cradle (fig. 15). A rare survival, its frame, like the room's woodwork, is decorated with chamfers and moldings. The carved oak chest to the right of the bed was made in Ipswich and is in the same shop tradition as the one in the Meetinghouse Gallery (see fig. 10).

The cupboard to the left of the fireplace has distinctive serrated moldings and applied turnings characteristic of Plymouth County case furniture. Elaborate panel-and-frame cupboards such as this were expensive and usually found only in more affluent homes. Hart did not own one. The stools and rush-bottomed, turned chairs represent the ordinary seating of the period. The chair-table, an uncommon form, saved space in such a multipurpose room.

14. Hart Room, Ipswich, Massachusetts, before 1674. Hall fireplaces were typically larger than those of other rooms in a house. They were intended for the preparation of food and often contained a recessed oven. Munsey Fund, 1936 (36.127)

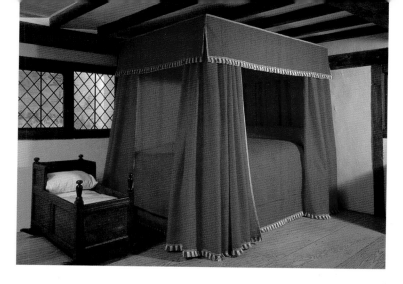

15. Bed and cradle in the Hart Room. Cradle, eastern Massachusetts, 1640–80. White oak. In most 17th-century houses nearly every room was used for sleeping as well as other activities. This oak cradle, one of about a dozen known examples from the 17th century, is essentially a well-balanced arrangement of rectangles offset by the curves of the turned finials and rockers. Cradle: Gift of Mrs. Russell Sage, 1909 (10.125.672)

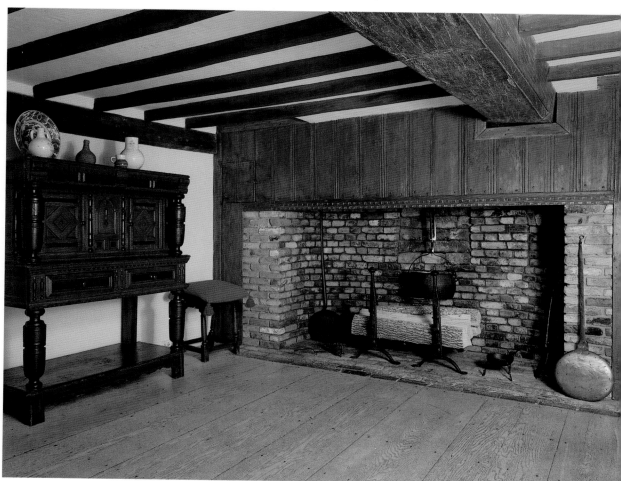

Wentworth Room

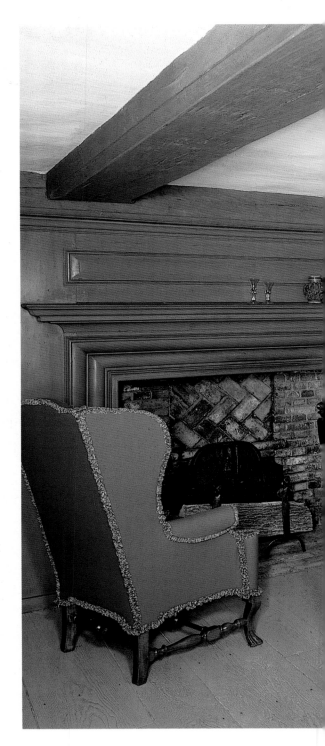

The room from the John Wentworth house, built between 1695 and 1700 in Portsmouth, New Hampshire, illustrates changes in interior architecture and furniture design at the end of the seventeenth century (fig. 16). Fewer structural elements are visible here than in the nearby Hart Room, and sliding-sash windows with wood muntins have replaced the leaded-glass casement windows of the 1600s. Raised, or fielded, panels outlined by bold moldings, which reflect Baroque concepts introduced about 1700 by the William and Mary style, give the fireplace wall a more elegant character than plain sheathing.

Wentworth, a merchant, sea captain, and lieutenant governor of New Hampshire from 1717 to 1730, built a grand house that was at the forefront of fashion. The structure had two full stories and a garret. It was constructed around a large central chimney, with the main stair abutted against the front of the chimney mass and contained within the front entry. (The entry, which features the earliest use in New England of a spiral design on stair balusters, is installed on the opposite side of the Meetinghouse Gallery.) This second-story room was to the right of the stair and ran the full depth of the house. Originally it was probably the best chamber—the principal bedroom used for entertaining as well as for sleeping.

The furniture is all in the William and Mary style that was coming into fashion in the British

16. Wentworth Room, Portsmouth, New Hampshire, 1695–1700. The dark red of the pine paneling matches traces of the original paint. It was customary to keep chairs lined up against the walls, to be brought out only when needed. Sage Fund, 1926 (26.290)

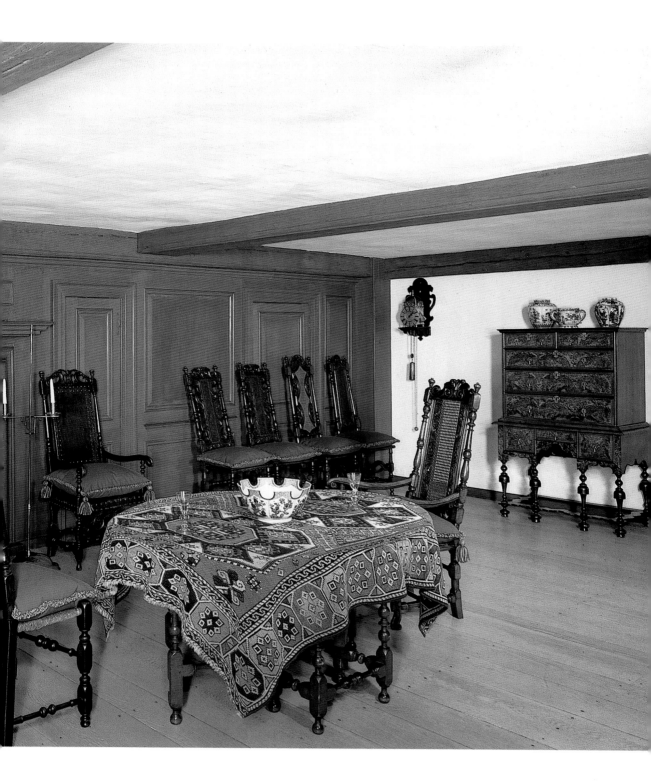

17. Chair, eastern Massachusetts, 1710–30. Maple. Carved crests on William and Mary chairs typically rise up to a central motif and combine C-scrolls and foliage. The chair's carved feet, of a popular type now often called Spanish, have a strong outward thrust. Gift of Mrs. Screven Lorillard, 1952 (52.195.8)

18. Table, probably Rhode Island, 1710–30. Maple and pine. This dining table has hinged leaves, which, when raised, rest on supports that pivot out from the frame—a type that became popular about 1700. Today it is generally known as a gateleg table. Gift of Mrs. Russell Sage, 1909 (10.125.133)

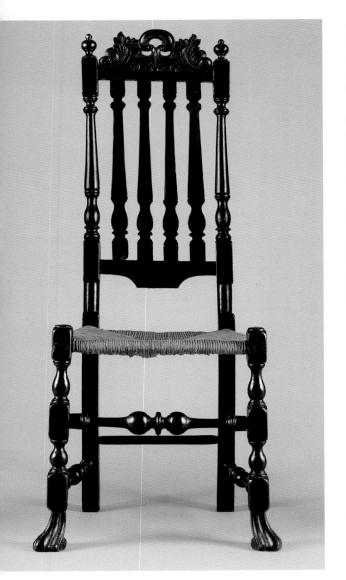

colonies at the time the house was built. The light scale and verticality and the C-curve that was one of the important elements of the style are exemplified by the tall-back chairs. English cane examples, like those to the right of the fireplace, were imported, usually in sets of six or twelve, and were instrumental in introducing the William and Mary style in seating. Colonial counterparts, usually made of maple, were generally upholstered in leather rather than caned, and less expensive models, such as the one from Massachusetts (fig. 17), had turned banisters in the back and a rush seat. This chair includes the columnar, vase, ball, and ring shapes that constitute the vocabulary of William and Mary turnings. The rounded forms tend to be full and bold much like the half-round projecting (bolection) molding that surrounds the fireplace opening. Similar strong contours characterize the legs of the Massachusetts high chest of drawers, one of the new forms that came into fashion with the William and Mary style. Other new forms shown in the room are the dressing table, the oval table with drop leaves (fig. 18), the easy chair, and the couch (daybed).

Well-to-do colonists like Wentworth furnished their homes with luxuries such as the Turkish carpet used on the table in place of a simple wool covering. The English looking glass and clock and the Chinese porcelain also denote an affluent household. Matching fabric for upholstery, loose cushions, and bed and window curtains followed the fashion.

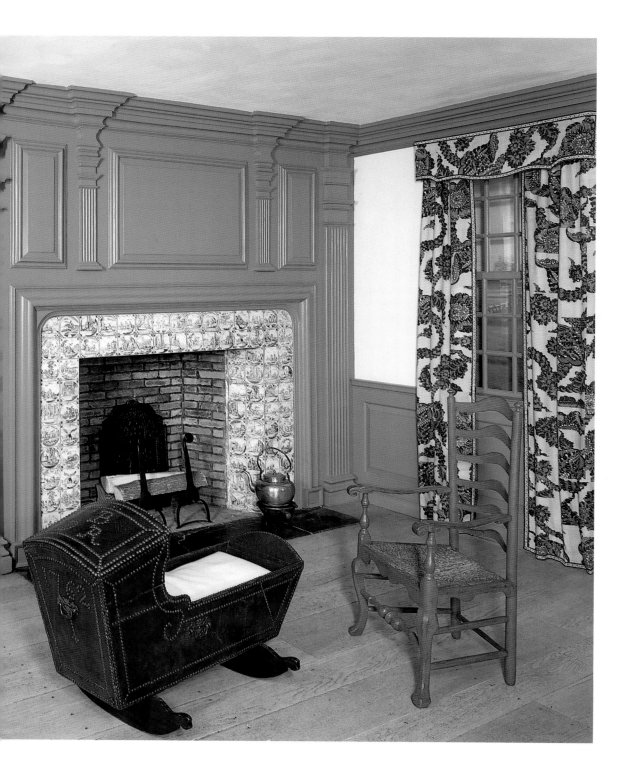

20. *Kast*, probably New York City, 1690–1720. Yellow poplar, oak, and pine. The striking painted decoration of this *kast* features pendants of fruit within architectural niches. At the center of one pendant is a pomegranate, a symbol of fertility, suggesting that the kas was a dowry piece. Rogers Fund, 1909 (09.175)

Dutch colonists introduced to the New York–New Jersey area a distinctive cupboard, called a *kast*, which was made in that region until the early 1800s. With a bold projecting cornice and a heavy base molding, it was strongly architectural. *Kasten* decorated in grisaille, such as the one in this room or the similar example in figure 20, are uncommon. They were based on Dutch prototypes painted to simulate heavy Baroque carving. As on all *kasten*, two large doors open to a shelved interior for the storage of linens.

The furniture in this installation, spanning the eighteenth century, is all from the mid-Atlantic region. The leather-covered cradle is a great rarity. Dated 1762 and inscribed with the initials of

Derick and Rachel Brinckerhoff of New York, it was made just before the birth of their first child. The large settee, with a walnut frame and leather seat and high back, is a form made in Pennsylvania. Throughout the eighteenth century rush-bottomed, turned chairs continued to provide much of the everyday seating, and regional forms developed. Chairs with numerous graduated arched slats in the back were popular in Philadelphia and the Delaware River valley. Those favored in New York and the Hudson River valley featured vase-shaped vertical back splats and pad feet; they are also shown in the Hewlett Room.

New York Alcove, Wentworth Stair, Hampton Room, and Newington Room

GALLERIES 308, 307, 306, 305

On the south side of the Meetinghouse Gallery is an alcove containing a paneled fireplace wall from a house in Ulster County, New York. Prominent among the New York furniture displayed there is a high chest, one of only a few with spiral-pattern legs, and a desk-on-frame that retains an early Dutch inscription inside the lid. Adjacent to the alcove and off one corner of the Meetinghouse Gallery is a suitelike assemblage of three diminutive rooms. The first features the front staircase from the John Wentworth house in Portsmouth, New Hampshire (a chamber from the house is installed on the opposite end of the floor). The stair is a powerful exercise in Baroque architectural ornament, incorporating boldly paneled and molded walls and the first known use in America of twist-turned balusters. The second, the Hampton Room, is a square chamber whose walls and ceiling are entirely encased in wood panels from a house in Hampton, New Hampshire. The third is the Newington Room, whose paneled fireplace wall is said to have come from a house in the Connecticut River valley town of Newington, near Hartford. The paneling is a rare instance of eighteenth-century woodwork that was never painted; it has now oxidized to a velvety dark brown. A number of pieces of furniture in these last two rooms, however, retain their old painted decoration (fig. 21). The combination of unpainted woodwork and painted furniture was a favorite of the Colonial Revival style of the 1920s, when these galleries were first installed.

21. Chest with drawer, Connecticut, 1715–35. Pine, yellow poplar, and oak. Chests with painted floral decoration—an economic alternative to more costly inlaid or japanned ornament—were popular in the early 18th century, particularly along the Connecticut shore. Gift of Mrs. J. Insley Blair, 1945 (45.78.4)

New England Furniture

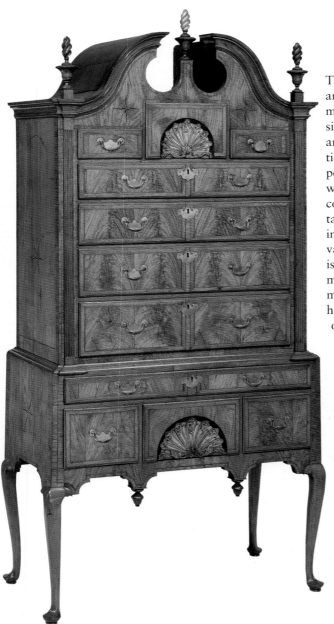

The large central gallery on the second floor—its architectural details adapted from New York merchant James Beekman's 1763 country mansion that stood at what is now Fifty-first Street and First Avenue—is the setting for an introduction to New England furniture of the late colonial period. Until the mid-eighteenth century Boston was the largest and richest city in the British colonies in America and the principal arbiter of taste. There, about 1730, cabinetmakers had introduced an elegant new style of cabinetwork, a variation on the international Baroque that today is commonly called Queen Anne after the British monarch who died in 1714. The elaborate ornamental scrolls, turnings, and pierced carvings of high-style William and Mary furniture, displayed on the American Wing's third floor, give way here to curving forms, cabriole legs, and undulating facades.

The high chest of drawers and matching dressing table were the first types of cabinetwork to incorporate the new fashion, and one wall of this gallery is devoted to them. The traditional Boston William and Mary flat-top and turned-leg high chest of drawers was given a scroll pediment and cabriole legs (fig. 22)—the distinctive features of what was to become the most characteristic and ubiquitous of eighteenth-century American furniture forms.

22. High chest of drawers, Boston, 1730–40. Walnut, walnut veneer, and white pine. This chest, stylistically among the earliest pieces in the gallery, is one of six known Boston bonnet-top high chests with figured walnut veneers, inlaid stringing, compass stars, and carved-and-gilded shell drawers. Gift of Mrs. Russell Sage, 1909 (10.125.62)

23. View of New England Furniture Gallery, showing a high chest and dressing table from Newport. The Newport makers refined the design, replacing the upper shell with drawerlike panels and integrating the lower shell into the skirt. Left to right: Gift of Mrs. E.P. Moore, in memory of Rear Admiral E.P. Moore (1980.139); Gift of Yvette and Thomas Cole, in memory of Louis W. Cole, 1994 (1994.449)

24. Desk and bookcase, shop of Nathaniel Gould (d. 1781), Salem, Massachusetts. Mahogany. This richly figured piece, by Salem's leading 18th-century cabinetmaker, demonstrates the wide influence and longevity of the Boston block-front style. Gift of Mrs. Russell Sage, 1909 (10.125.81)

25. Bureau table, or kneehole chest, by John Townsend (1732–1809), Newport, Rhode Island, 1765. Mahogany. The lobed shells surmounting the blocking made it possible to unify the design with a straight-molded cornice. Gift of Mrs. Russell Sage, 1909 (10.125.83)

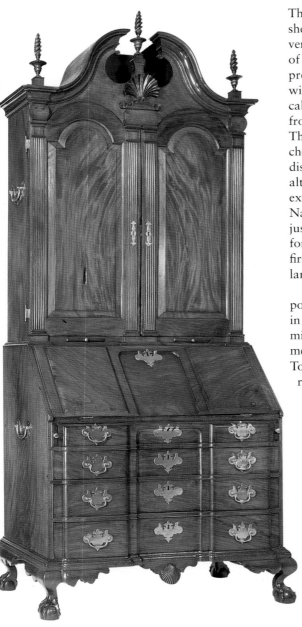

The costliest examples sported carved-and-gilded shells in their pediments and skirts and were veneered in figured walnut or painted in imitation of oriental lacquer (fig. 38). When experience proved that these surface treatments could ill withstand the rigors of the New England climate, cabinetmakers turned to solid woods—mahogany from the Caribbean or local maple and cherry. They often sawed out in bold shapes the fronts of chests, desks, and desks and bookcases, all forms displayed in this gallery. The "block front," with alternately projecting and receding surfaces, exemplified by the desk and bookcase from the Nathaniel Gould shop (fig. 24), was introduced just before 1740 and remained in fashion for forty years; bombé and serpentine shapes, both first produced in Boston about 1750, were popular alternatives for desks and chests.

Newport, Rhode Island, also a prosperous seaport, was the other leading cabinetmaking center in colonial New England. There, beginning in the mid-1740s, a group of native-born Quaker craftsmen, led by members of the Goddard and Townsend families, developed a regional style of refined and original cabinetmaking. They looked to Boston for inspiration but transformed what they saw into something new. By doing away with the aggressive gilded shells on high chests, they rendered the form more coherent (fig. 23, left); by adding boldly carved shells to block fronts (fig. 25), they unified and enriched their design. In this gallery one can compare Newport block-and-shell chests and desks with their Massachusetts antecedents. That each major urban center developed a distinctive regional style is perhaps the most compelling feature of the American furniture industry in the eighteenth century.

Off to one side of this gallery is an alcove with furniture from rural New England,

27. Alexandria Ballroom, Alexandria, Virginia, 1793. Under the musicians' balcony, Philadelphia chairs flank an upholstered settee from that city. Boston Queen Anne side chairs surround the mahogany spinet made in 1765 by John Harris (act. 1730–69), from London. Ballroom: Rogers Fund, 1917 (17.116.1–4).

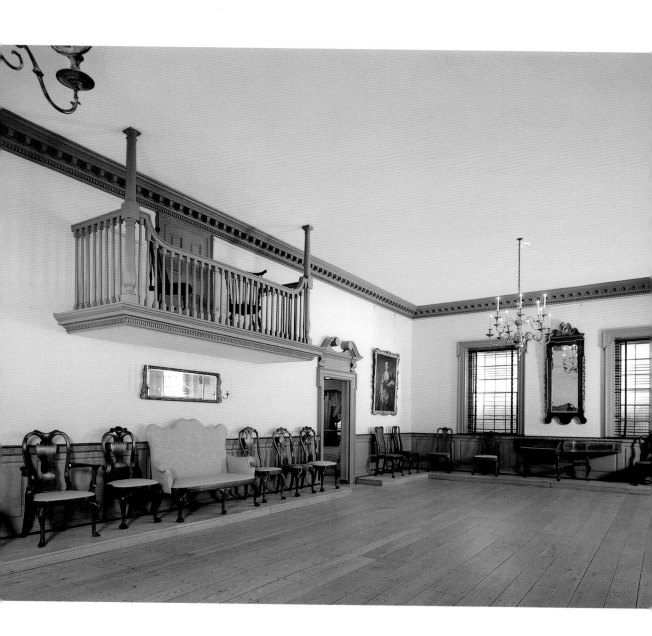

Powel Room

This room, an upstairs back chamber from 244 South Third Street, Philadelphia, illustrates that city's infatuation with the London Rococo in the years just before the Revolution, when Thomas Chippendale's famous pattern book, *The Gentleman and Cabinetmaker's Director* (third ed. 1762), set the tone. The signature of the style is realistic carving of elements from nature—leafage, flowers, and fruit—together with C- and S-shaped scrolls.

The house, originally built in 1765–66 for the merchant Charles Steadman, was purchased in August 1769 by Samuel Powel, the city's largest landowner, then recently returned from seven years on the grand tour and soon to be married. Powel immediately set about remodeling his new home and fitting it out in the latest London fashion: in this room the paneled fireplace wall received a tabernacle-frame chimneypiece embellished by Philadelphia's best craftsmen, with carved brackets to support the mantel shelf, as well as applied scrollwork and foliage for the tablet and corners of the overmantel. The naturalistic carvings were highlighted in verdigris. The ceiling decoration is a replica of the stuccowork that plasterer James Clow installed in 1770 in an adjacent ballroom, which was entered through the door to the right of the fireplace. The hand-painted Chinese wallpaper is from the 1700s but is not original to the room. (The plaster and wallpaper treatments stem from the Museum's decision in the 1920s to make the room's architecture reflect the gamut of Rococo decoration.)

Although it may once have served as a bedchamber, the room is now furnished as a parlor with pieces based upon contemporary Philadelphia household inventories. In accord with common usage, a marble-slab, or pier, table stands between the windows; there is a desk and bookcase against another wall; a circular tea table is fully set in the center of the room; and armchairs and side chairs abound. The furniture displayed here was all made in Philadelphia of mahogany in the fully carved Rococo style.

The room has seen its share of American history. Powel, who in 1775 was the last colonial mayor of Philadelphia and in 1789 the first postwar mayor, was well known to President George Washington and Vice President John Adams, both of whom frequented the Third Street house.

28. Powel Room, Philadelphia, built 1765–66; remodeled 1769–71. This room, one of a handful of high-style Rococo rooms from Philadelphia to survive, contains carving by London-trained immigrants. Rogers Fund, 1918 (18.87.1–4)

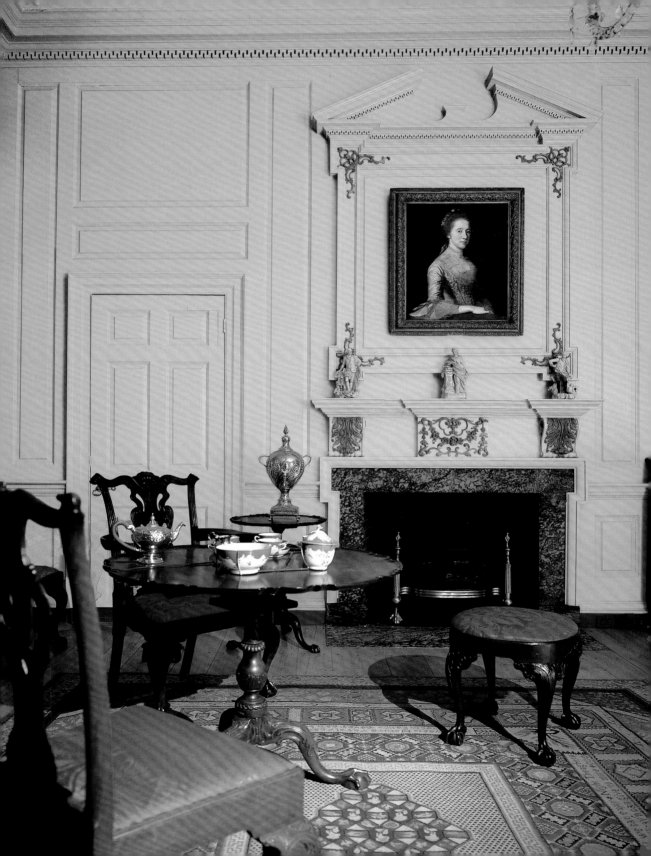

Pennsylvania German Gallery

Doorway from the Daniel Fowler House

The gallery adjacent to the Powel Room features a painted chimney breast and corner cupboard from a Lancaster County, Pennsylvania, farmhouse. Here also are examples of the distinctive European artistic traditions retained by the Pennsylvania Germans (immigrants from the Rhine valley and the Palatinate who settled in large numbers to the north and west of Philadelphia): colorfully painted storage chests (fig. 29), open dressers exhibiting local earthenware, and the drawn or printed and hand-colored birth or baptismal

certificates called frakturs. In a stair hall leading from the second floor of the 1924 building to the higher second floor of the 1980 addition is a monumental broken-scroll pedimented doorway from the Daniel Fowler house, Westfield, Massachusetts, of about 1762 (fig. 30). It is of wood, carved and painted to imitate stone, and translates the stately language of Italian Renaissance architecture into a lively New England vernacular.

29. Dower chest, Berks County, Pennsylvania, ca. 1780. Yellow pine and tulip poplar. Although typical German construction and painted decoration were used, the unicorns, copied from coats of arms, show the influence of the first English settlers in Pennsylvania. Rogers Fund, 1923 (23.16)

30. Doorway from the Daniel Fowler house, Westfield, Massachusetts, ca. 1762. Rogers Fund 1916 (16.147)

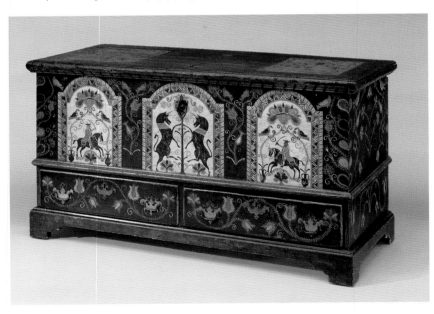

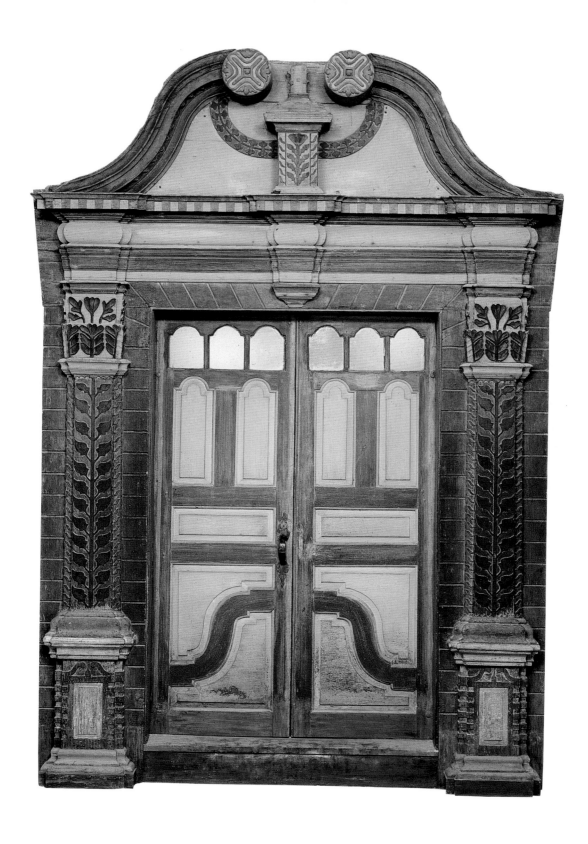

Philadelphia Furniture

In this gallery are displayed masterpieces of Philadelphia furniture in the Rococo style. By the third quarter of the eighteenth century Philadelphia had supplanted Boston as the largest and richest of colonial American cities. In matters of style the wealthiest Philadelphians, notably Samuel Powel (a room from his town house is nearby; see fig. 28) and General John Cadwalader, looked to London and the designs of Thomas Chippendale. British-made goods in the latest fashion were eagerly sought, but, as relations between the Mother Country and her colonies worsened during the 1760s, it became politically unacceptable to order such imports. In consequence, many ambitious and talented

London-trained craftsmen emigrated to Philadelphia, where they fulfilled the demand for London-style pieces with locally made versions. These included richly carved examples of the most favored local forms: massive high chests (fig. 32) with matching diminutive dressing tables; round, tilt-top tea tables; and easy chairs with outward-scrolled arms. Hanging in this gallery is John Singleton Copley's portrait of Mrs. John Winthrop (fig. 33), who is seated in an upholstered chair and at a circular table, both of which echo the form of the Philadelphia examples on view (fig. 34).

31. *John Locke* (1632–1704), from a desk and bookcase, Philadelphia, 1765–75. Mahogany. The famous British philosopher was the preferred subject for portrait busts that embellished the scroll pediments of Philadelphia desks and bookcases. Gift of Bernard and S. Dean Levy Inc., 1992 (1992.181.1)

32. High chest of drawers, Philadelphia, 1762–70. Mahogany, mahogany veneer, tulip poplar, and yellow pine. With its cornice moldings and side finials copied from designs in Thomas Chippendale's *The Gentleman and Cabinetmaker's Director* and its carving on the large lower drawer taken from Thomas Johnson's *Book of Designs,* both published in 1762, this high chest illustrates the influence of London pattern books on American furniture. John Stewart Kennedy Fund, 1918 (18.110.4)

33. John Singleton Copley (1738–1815). *Mrs. John Winthrop (Hannah Fayerweather)*, 1773. Oil on canvas. Copley portrayed Hannah Winthrop's face, clothing, and setting with great care and skill, but the most telling objects in the picture are the nectarine she holds like a gem in her right hand and the branch in her left. The Winthrops kept an orchard in Cambridge, Massachusetts, and their success with rare fruit was renowned. Morris K. Jesup Fund, 1931 (31.109)

34. Tea table and easy chair, Philadelphia, 1760–75. Mahogany; mahogany with walnut, tulip poplar, and yellow pine. Tilt-top tea tables—with round tops affixed to "birdcages" that rotate on columnar tripod stands—and easy chairs with gracefully scrolled arms were among the most distinctive furniture forms in Philadelphia. Either could be had in plain walnut or in carved mahogany, as here. Table: Rogers Fund, 1925 (25.115.31); chair: Gift of Mrs. C. F. Dickson, 1963 (63.114)

Van Rensselaer Hall

In scale and decoration this room is representative of the largest and most elaborate interiors in pre-Revolutionary America. It was the central entrance hall (the doors at either end led outside, the broad archway to the stair hall) of the Palladian-style mansion built by Stephen Van Rensselaer II on the banks of the Hudson River near Albany, between 1765 and 1768, shortly after his marriage to Catherine Livingston. At this time these families were the two greatest landholders in the Hudson River valley.

The hall's interior treatment, in full-blown Rococo mode, illustrates how rich, landed colonials emulated the styles of the English gentry. For example, the magnificently carved wood spandrels flanking the arched opening are copied exactly from an engraved design by the London carvers Matthias Lock and H. Copland, first published in 1752 but reissued January 1, 1768, just in time to attract the attention of Philip Livingston, Catherine's father, who was then in London. At the same time Livingston ordered the hand-painted wallpaper, the greatest glory of the room. Its rectangular classical landscapes are after engravings of canvases by Gian Paolo Panini and Joseph Vernet, and the irregularly shaped

35. Van Rensselaer Hall, Albany, New York, 1765–68.
A side door, which now leads to a room from Marmion, a Virginia plantation, once led into a parlor or dining room. The tassel-back chair, which descended in the Van Rensselaer family, and the pier table have the thick legs and square claw-and-ball feet characteristic of New York cabinetwork. Woodwork: Gift of Mrs. William Van Rensselaer, in memory of William Bayard Van Rensselaer, 1928 (28.143). Wallpaper: Gift of Dr. Howard Van Rensselaer, 1928 (28.224)

representations of the Four Seasons, after Nicolas Lancret. Whereas in England the grandest houses would have been embellished with massive oil paintings in carved-and-gilded frames, here even the richest colonist had to settle for made-to-order paper copies.

Arrayed around the room are examples of the distinctive types of tables and chairs most favored by New York cabinetmakers and their clients—marble-topped pier tables, serpentine-side card tables, and tassel-back chairs. The scallop-back settee is a rare documented work by the upholsterer Joseph Cox, who emigrated from London to New York in 1756.

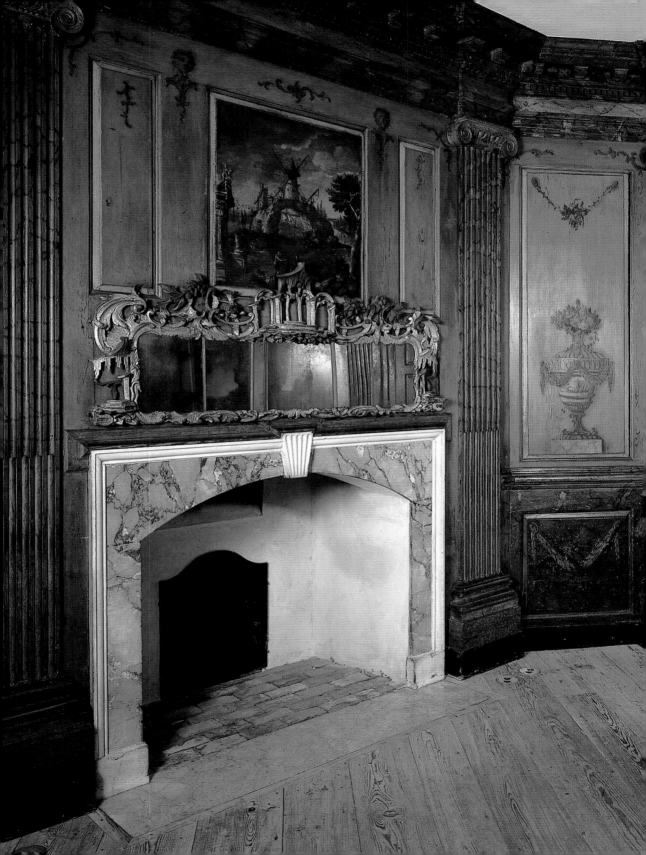

Marmion Room

This fully paneled room, the most ambitious decoratively painted interior to survive from colonial America, was the principal parlor in Marmion, a plantation house in the northern neck of Virginia, twenty-five miles south of Mount Vernon. The estate was established in the seventeenth century by William Fitzhugh, and the house dates from the mid-eighteenth century. The paneling, however, might have originated somewhat later, when it was decided to enlarge the room and add a third window. (The ingenious carpenter flanked the new window with corner cupboards to mask the fact that the fireplace was no longer exactly in the corner.) The woodwork is unusual in incorporating the complete Ionic order—molded bases, fluted pilasters, carved capitals, and a full entablature—according to sixteenth-century Italian architect Andrea Palladio. Judging from its style, the painting—landscapes and seascapes; Rococo fruit stands and classical cornucopias; and marbleized woodwork—cannot date much before 1770. The artists (more than one hand is discernible here) are unknown. In order to highlight the decorative program on the walls, the room is now shown unfurnished.

36. Marmion Room, King George County, Virginia, paneled 1735–70; painted 1765–80. The fantasy world of art and nature evoked by the anonymous artists is in striking contrast to the perfectly proportioned architectural order. Rogers Fund, 1916 (16.112)

Verplanck Room

Everything in this room descended in the family of the New York merchant Samuel Verplanck, and most of it was probably originally in the parlor of the house at 3 Wall Street (later the site of the Branch Bank of the United States; see fig. 1), which Verplanck acquired in 1763. The japanned desk and bookcase and the Rococo gilt looking glass, brought from England, attest to the fact that in New York, where loyalist sympathies were particularly strong, much elaborate furniture was still imported. The other furniture, including an en suite card table and chairs in the center, was made in New York, albeit in the English manner. In the cupboard to the left of the fireplace are pieces from the family's service of Chinese export porcelain; flanking the fireplace is a pair of export porcelain hearth jars. The portraits over the settee, of Samuel Verplanck (left) and his brother Gulian (right), were painted by John Singleton Copley in the summer of 1771, during his only visit to New York.

The room's paneled fireplace wall and other architectural fittings are from the 1767 house of Cadwalader Colden Jr., near Newburgh, in Orange County, and were acquired by the Museum to provide an appropriate setting for the Verplanck family possessions.

37. Verplanck Room, from the Colden House, Orange County, New York, 1767. These furnishings, all descended in the Verplanck family, provide a unique opportunity to re-create an 18th-century New York interior. Woodwork: Purchase, The Sylmaris Collection, Gift of George Coe Graves, by exchange, 1940 (40.127)

Mid-Eighteenth-Century Decorative Arts

This long gallery is in good part lined with alcoves, each of which showcases the craftsmanship of one of the leading urban cabinetmaking centers. At the south end, by the doors leading to the galleries of Asian art, is a section devoted to japanned furniture; two pairs of high chests and dressing tables, one with its en suite looking glass, and a tall clock form the largest concentration of such pieces anywhere (fig. 38). Japanning—the painted imitation of oriental lacquerwork—was fashionable in Boston during the first half of the eighteenth century. It was an alternative to walnut veneering as surface decoration on the most costly case furniture, but because of the inherent fragility of the painted decoration, few examples of it now survive.

At the other end of the gallery are displays of the solid, heavyset furniture favored in New York (as in the Van Rensselaer Hall; see fig. 35), and, by contrast, the gracefully contoured and crisply carved Rococo-style seating furniture of Boston. Three alcoves midway through the gallery are devoted to the Newport cabinetmakers, including four pieces signed and dated between 1756 and 1789 by the best-known master of the group, John Townsend.

This portion of the gallery also houses oil portraits by John Singleton Copley and a selection of his pastels. The artist's affluent clients would have been aware that pastel portraits were fashionable in England, and Copley may have enjoyed the expedience and brilliance offered by the crayons. Few masters of this difficult medium have been able to match his virtuoso rendering of satin, lace, pearls, flowers, and background drapery (fig. 39).

Along one wall is a group of tall clocks made in the various colonies (fig. 40). The eighteenth century was the golden age for these timepieces, which in the late nineteenth century came to be called grandfather clocks, a name derived from a popular song of the 1870s. The long, narrow waist housed the pendulum and weights that made it possible to keep accurate time for eight days at one winding. Clockmakers made the brass movements, but cabinetmakers, working in their own local idioms, made the cases that housed them. The examples displayed here are arranged chronologically to show both the stylistic evolution of the cases—from the figured walnut veneers in the William and Mary style to the carved mahogany in the Chippendale style—and the variations among the regional cabinetmaking centers.

Along another wall are clocks from the early nineteenth century, when New England clockmakers revolutionized the industry and created small, relatively inexpensive wall and shelf pieces for America's burgeoning middle class. The Massachusetts shelf clock, produced in a variety of designs from just after the Revolution into the early 1800s, consists of a box-on-box, the upper housing the mechanism and the lower providing space for the weights that drove the works and the pendulum. Clocks by Aaron Willard Jr. (fig. 41) and by David Wood, among others, are on display. About 1802 Willard invented his "Improved Patent Timepiece," known today as a banjo clock. With its gilded-and-painted decoration, precise workmanship, and fine proportions, the eight-day timepiece was so successful that other New England makers copied it despite Willard's patent. The unsigned banjo clock in this gallery attests to this practice.

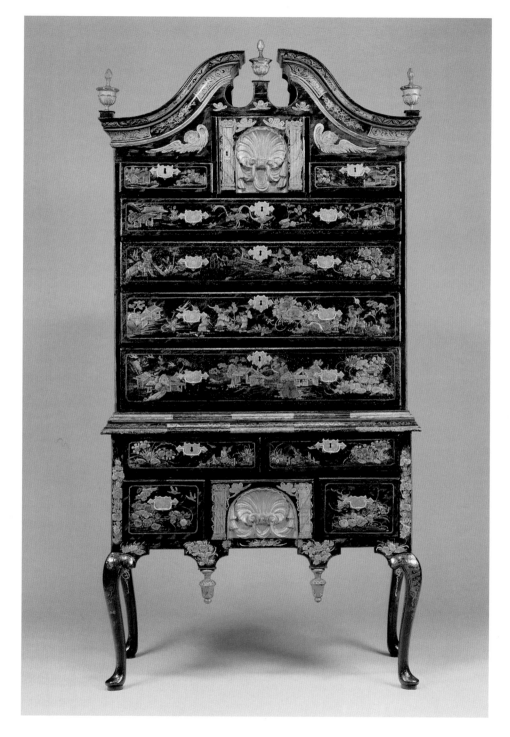

38. High chest of
drawers, Boston,
1730–50. Maple
and pine,
japanned. The
technique of
japanning,
which uses paint
and varnish to
imitate oriental
lacquerwork,
came to America
from England at
the end of the
17th century.
Purchase,
Joseph Pulitzer
Bequest, 1940
(40.37.1)

39. John Singleton Copley (1738–1815). *Mrs. Edward Green (Mary Storer)*, 1765. Pastel on paper mounted on canvas in original carved-and-gilded frame. Copley expertly worked his pastels as he did his oils. In both media he subjugated all sense of stroke to the portrayal of convincing solidity and texture. Charles B. Curtis Fund, 1908 (08.1)

40. Tall clock, by Benjamin Willard (1743–1803), Roxbury, Massachusetts, 1772. Mahogany. This clock is one of the earliest works by Simon Willard but was signed and retailed by his brother Benjamin to James Mears in 1772. Gift of Dr. and Mrs. Brooks H. Marsh, 1976 (1976.341)

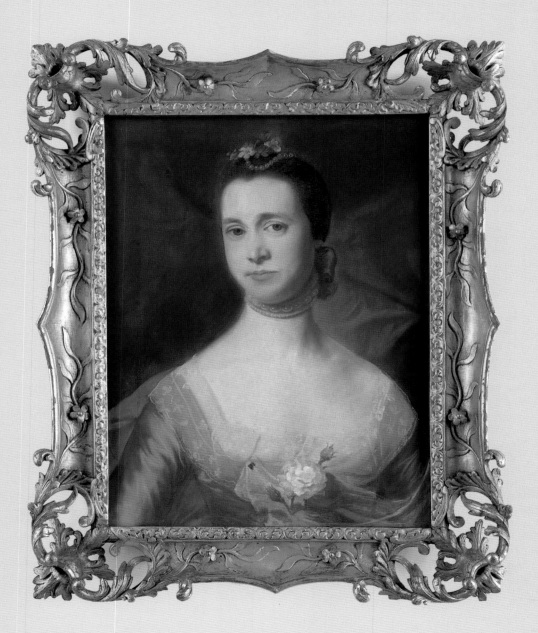

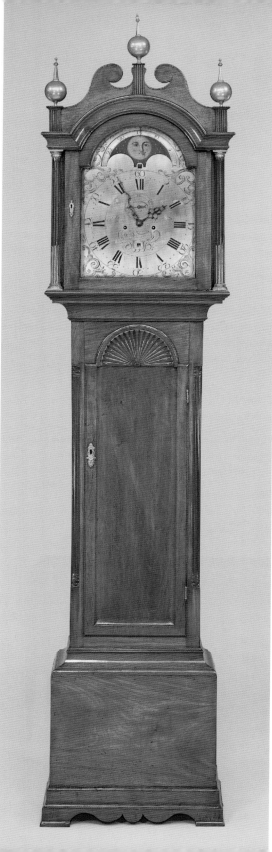

41. Shelf clock, works by Aaron Willard Jr. (act. 1780–1823), Boston, 1790–1800. Mahogany and brass. This thirty-hour shelf clock appears to be a spring-driven wall clock with brass feet resting on a bracket. However, it is of a single piece, with the boxlike bracket below concealing the pendulum and weights. The Sylmaris Collection, Gift of George Coe Graves, 1930 (30.120.65)

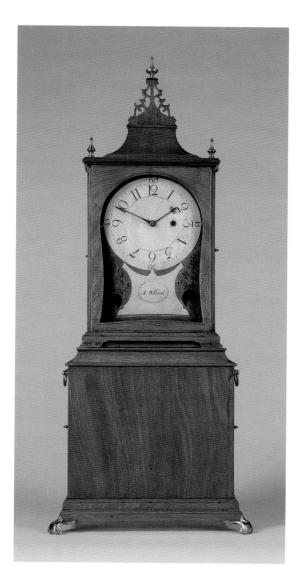

Federal Gallery

The material displayed on the first floor of the original 1924 building dates from the decades following the Revolutionary War that are broadly referred to as the Federal period, when fresh currents of taste flowed into the new republic from Europe, notably England and France. Intellectual interest in classical antiquity, stimulated by recent excavations at Pompeii and Herculaneum, swept these countries in the mid-eighteenth century. In the visual arts classical notions of balance, order, and restraint began to replace the carefree exuberance of the Rococo.

The front doorway of the facade of the Branch Bank of the United States leads from the Engelhard Court into a large gallery devoted to American furniture from the early republic's principal seaport cities (fig. 43). Slenderly proportioned arched door surrounds from a Baltimore Federal town house—the dining room from which is

installed in the adjacent gallery—and reproduction woodwork from other contemporary American buildings produce a sympathetic architectural setting for a regional survey of furniture in the Classical Revival style of the early Federal period (1790–1825).

Boston supported a community of excellent cabinetmakers during the Federal period, chief among whom were the father-and-son partnership of John and Thomas Seymour. A superb sideboard attributed to the workshop of Thomas

43. View of the Federal Gallery, showing a New York pillar-and-claw dining table, a set of lyre-back side chairs attributed to Duncan Phyfe (1768–1854), and a pair of marble-topped pier tables perhaps also made in his workshop. Instead of the brilliant contrasting veneers of New England, Phyfe preferred rich, uniformly toned mahogany with low-relief carving in classical motifs.

42. Sideboard attributed to the workshop of Thomas Seymour (act. 1794–1843), Boston, 1805–15. Mahogany and satinwood veneers; wood and ivory inlays; white pine and cherry. As dining rooms became increasingly important to social life, elegant sideboards, with storage for china, plate, and wine bottles, were introduced. Gift of the family of Mr. and Mrs. Andrew Varick Stout, in their memory, 1965 (65.188.1)

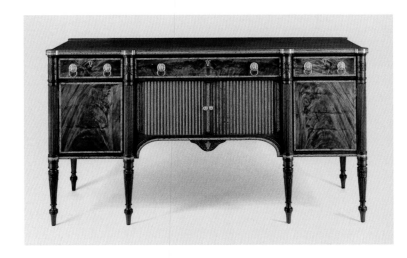

54 · FIRST FLOOR

45. Desk and bookcase, Baltimore or Philadelphia, ca. 1811.
Mahogany, satinwood, and satinwood veneers and inlays, églomisé
panels, cedar, and poplar. The basic design of this desk is from
plate 38, the "Sister's Cylinder Bookcase," of Thomas Sheraton's
Cabinet Dictionary (1803), one of the widely disseminated English
pattern books, which along with George Hepplewhite's *Guide* and
the *London Cabinet-Makers' Book of Prices* (both 1788), provided
sources for American craftsmen. Gift of Mrs. Russell Sage and
various other donors, by exchange, 1969 (69.203)

Baltimore Dining Room

Adjoining the Federal Gallery is a room—originally a parlor—that was removed from a house built at 913 Pratt Street, Baltimore, just before the War of 1812 (fig. 47). Now installed as a high-style dining room, it is richly furnished in a manner consistent with the wealth and stature of one of its owners, the merchant Henry Craig (d. 1823). The architectural detailing conveys a sense of geometric purity and subtle refinement typical of the revived classicism of the early Federal period. It is achieved here through the repetition of elliptical panels in the dadoes under each window and the arched niches flanking the fireplace that in turn are echoed in the frieze on the delicately proportioned chimneypiece.

By the beginning of the nineteenth century the port of Baltimore had grown to a population of 35,000 and had become the principal market center for most of the South and parts of Pennsylvania. This prosperity created a demand among Baltimoreans for luxury goods, particularly imported porcelains, textiles, metalwork, and furniture. It also benefited the city's developing furniture industry, with leading makers such as John and Hugh Finley and William Camp competing with the English imports. In this room there are several examples of Baltimore workmanship, including the graceful card tables in the arched niches and the dining table at the center, all of which bear the distinctive local design of downward-tapering, inset light wood panels in the legs with husk inlays. The set of mahogany square-back chairs of Southern or Mid-Atlantic manufacture, the pair of carved-and-gilded Boston looking glasses with candle arms and églomisé tablets, and the imported items—an English chandelier and mantel garniture and a Parisian porcelain dinner service (fig. 46)—could well have been owned by a Baltimore merchant who, like Craig, had far-flung trade connections. Wealthy Baltimoreans paid close attention to drapery and upholstery fabrics. Here the curtains and valances are of reproduction silk, and the chair seats have been re-covered in a durable, deep blue horsehair, a material appropriate for dining chairs. A painted floor cloth, also modern but typical of the early nineteenth century, has been laid under the table, a practical solution to ensure the long life of expensive flooring or carpeting.

46. Tureen and platter from a dinner service attributed to Dihl and Guerhard, Paris, 1800–15. Painted-and-gilded porcelain. The tureen on the dining table was made as a special order for an American client. The cover depicts Liberty holding the American flag with an eagle at her feet. Purchase, Solomon Grossman Gift, in memory of Berry B. Tracy, and the Vincent Astor Foundation, 1994 (1994.480.1a,b–2)

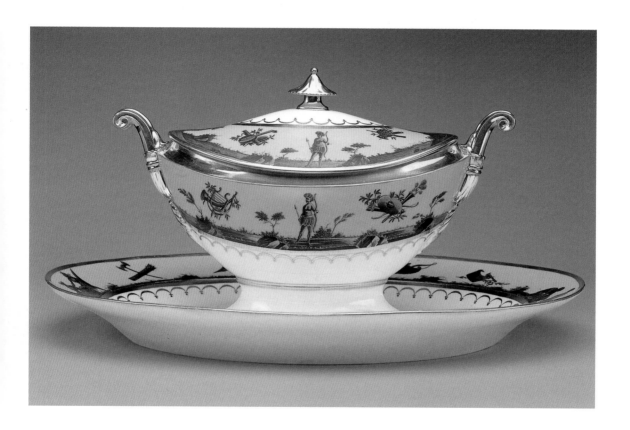

47. Baltimore Dining
Room, Baltimore,
Maryland, ca. 1810.
A 1796 portrait of
William Kerrin
Constable by Gilbert
Stuart hangs over the
fireplace. On the card
tables are a pair of
Chinese export urns
of 1785 to 1815 in the
Classical Revival style.
Rogers Fund, 1918
(18.101.1–4)

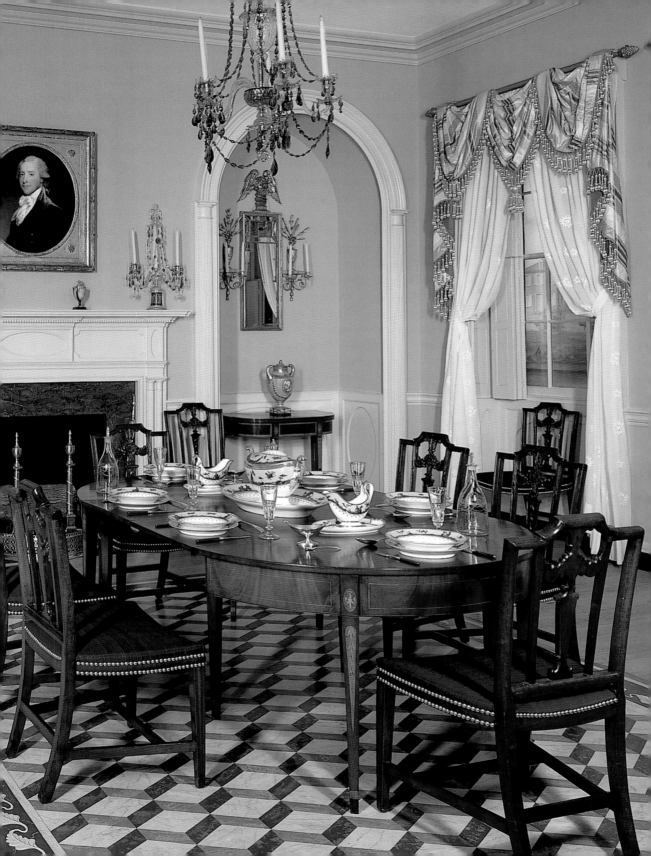

Haverhill Room

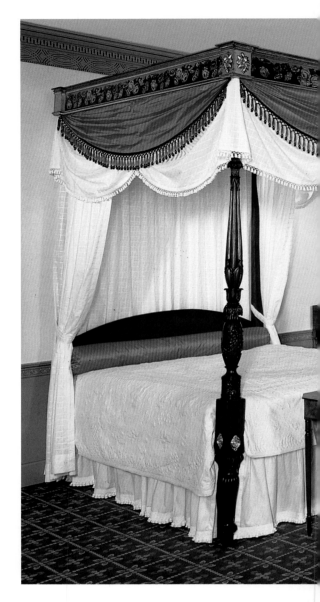

Off the side of the Federal Gallery opposite the Baltimore Dining Room is a room from a house built about 1805 for James Duncan Jr. (1756–1822) of Haverhill, Massachusetts, a small but thriving town north of Boston along the Merrimack River. The delicate composition ornament on the chair rail and chimney breast, the slender, reeded columns with gilded capitals and bases that flank the fireplace and overmantel, and the fret design in the cornice, copied directly from William Pain's *The Practical Builder* (1774, printed in Boston, 1792), noticeably harmonize in this Neoclassical interior (fig. 48). The room is furnished as the bedroom of a New England merchant prince. Befitting this status, as well as the original location of the Duncan house, the furniture displayed is of the best quality and reflects styles typical of Boston and Salem, Massachusetts, and Portsmouth, New Hampshire. Dominating the room is one of the finest surviving American Federal beds, which descended in the Derby family of Salem. The mahogany bedstead—made in Boston and possibly in the shop of Thomas Seymour—has exquisitely carved foot posts attributed to Thomas Whitman, a skilled immigrant English carver employed by Seymour as a subcontractor on some of his furniture projects.

The bureau, or chest of drawers, features a "drop panel" in the skirt that is characteristic of furniture produced in and about Portsmouth. A rhythmic sense of movement and dramatic interplay of light and shade are achieved in its graceful serpentine facade, where bold geometric panels of flame-grain birch, symmetrically grouped across the facade, are divided and contrasted by dark mahogany cross-banding.

48. Haverhill Room, Haverhill, Massachusetts, ca. 1805. The bedstead's richly painted-and-gilded cornice may be the combined achievement of John Doggett and John Penniman, respectively Boston's leading looking-glass-frame maker and ornamental painter. Rogers Fund, 1912 (12.121)

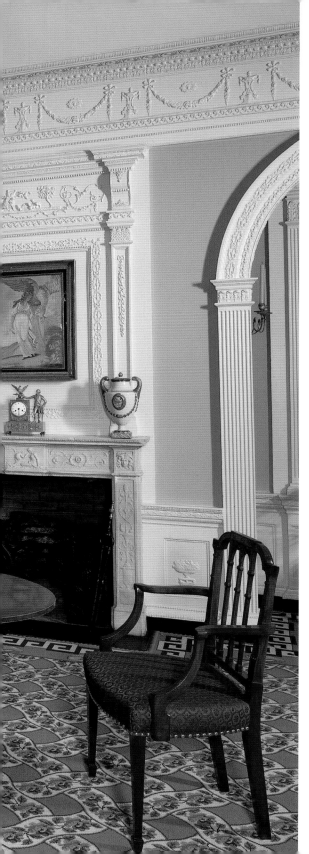

Benkard Room

Adjoining the Neoclassical Gallery on the west side is a parlor from a house in Petersburg, Virginia, dating to 1811, that serves as the setting for furniture collected in the early twentieth century by the discriminating Mrs. Harry Horton Benkard (fig. 49). The woodwork is enriched by stuccolike composition ornament in the form of delicate arabesques, foliage, and other motifs. It may be the work of Robert Wellford of Philadelphia, who in 1807 advertised his workshops as the "original American composition ornament manufactory."

The furniture in the Benkard Room represents a summary statement of American Neoclassical form and ornament. Here are brought together seating furniture and tables, principally from New York, made under the influence of the English furniture designer Thomas Sheraton. The sofa is singularly graceful, with a square back and carved crest often associated with the New York firm of Slover and Taylor, although Duncan Phyfe is also known to have sold sofas of this design. Two inlaid Pembroke, or drop-leaf, tables with shallow folding leaves represent a type that gained wide popularity in post-Revolutionary years, especially in New York. Their compactness made such tables suitable for a variety of uses. A pair of Boston card tables and a mahogany and satinwood secretary-bookcase from Baltimore are also on view, along with a variety of period lighting and other decorative accessories that were all once part of Mrs. Benkard's collection.

49. Benkard Room, Petersburg, Virginia, ca. 1811. The design of the square backs on the chairs is unique to New York in American furniture. It was derived from a design conceived by Thomas Sheraton in 1792 and published in successive volumes of his *Cabinet-Maker and Upholsterer's Drawing Book*. Rogers Fund, 1916 (16.61)

Neoclassical Gallery

Entered through the arched opening in the north end of the Federal Gallery is a room dedicated to some of the earliest furniture to be made in America under the influence of the French Neoclassical style. The room is a composite of decorative elements typical of Neoclassical halls. The doorframes, with their richly carved corner blocks, are from the Halsted house, erected in Rye, New York, about 1825. The walls simulate the trompe l'oeil ashlar masonry in the Alsop house, which still stands in Middletown, Connecticut.

Although an enthusiasm for the art of ancient Greece and Rome was at the heart of European furniture design after 1750, it was not until the 1790s that French craftsmen began to imitate actual Greek and Roman forms and decoration in an attempt to revive the lost grandeur of antiquity. They developed the monumental *style antique* that became the official mode of the Napoleonic Empire. Napoleon's court architects and designers, Charles Percier and Pierre-François-Léonard Fontaine, all but codified the new fashion in their *Recueil des décorations intérieures* (1801 and 1812). The style soon spread to England, where it was adapted in the designs of Thomas Hope and George Smith, published in 1807 and 1808, respectively.

In America *le style antique* arrived from both France and Britain. The first great cabinetmaker to produce massive and opulent furniture in this manner was Charles-Honoré Lannuier (see fig. 50). The pier table with gilded cast-metal caryatid supports, which dates to about 1815 and bears his label, is a tour de force of Empire ornamentation. Directly opposite is an equally extraordinary example by Joseph B. Barry and Son of Philadelphia made about the same time (fig. 52); Dublin-born Barry was in Philadelphia by 1794. The table offers an Anglo-French interpretation of the classical taste: plate 56 of Thomas Sheraton's *Cabinet-Maker and Upholsterer's Drawing Book* (1802) provided the design for the carved-and-pierced back gallery of griffins, while the gilt-brass ornaments and the platform base are clearly French concepts. Representative of the elegant yet restrained interpretation of *le style antique* in New York are the richly veneered mahogany cylinder desk and bookcase and large French press, or armoire, both made under the influence of the Phyfe/Lannuier school. The form of the chairs in the gallery is taken directly from a Greek chair, the klismos (fig. 51). Eagles, symbols of Roman imperial power and American national pride, poise atop the pair of girandole mirrors, possibly made in New York about 1815 to 1820. The argand chandelier, made in England about 1805, illustrates the application of classical motifs (here a Greek key) to technologically advanced lighting devices.

50. View of the Neoclassical Gallery, showing a portrait of Mrs. John Biddle painted in 1821 by Thomas Sully (1783–1872) over a rosewood and marble pier table with gilt-metal caryatids by Charles-Honoré Lannuier (1779–1819).

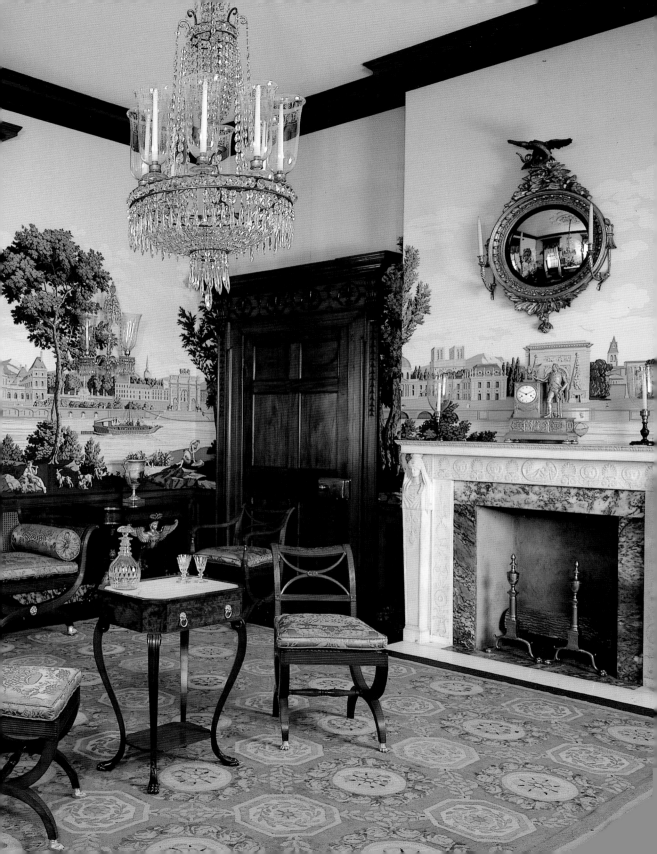

54. Card table, one of a pair made for Stephen Van Rensselaer IV, of Albany, by Charles-Honoré Lannuier (1779–1819), New York, 1817. Mahogany veneer, gilded gesso and verd antique, and gilt brass; yellow poplar, white pine, ash, and basswood. Signed by its maker, this card table is one of a pair from a series of gilded sculptural pieces by New York's resident French *ébéniste*. A nearly identical pair by Lannuier survives with its original invoice, dated June 19, 1817, indicating their price as $250 a pair. Gift of Justine VR Milliken, 1995 (1995.377.1)

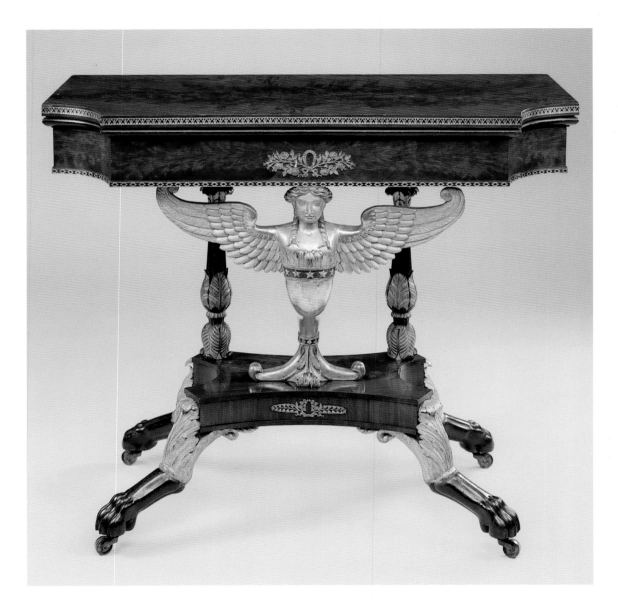

Left
56. Sofa, carving attributed to Samuel McIntire (act. ca. 1782–1811), Salem, Massachusetts, 1800–10. Mahogany. The festoons of drapery, fruit, and flowers—characteristic of McIntire's carving style—stand in relief against the background, which has been decorated with snowflakes by a craftsman using a metal punch. Fletcher Fund, 1926 (26.207)

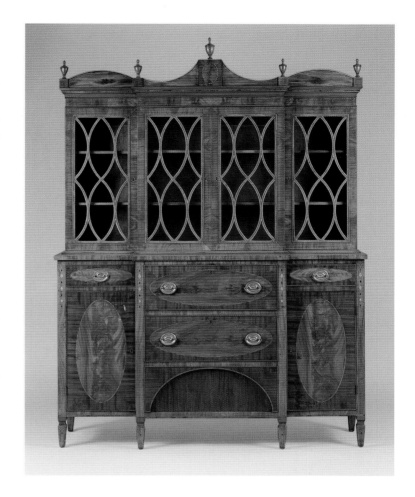

Right
57. Gentleman's secretary-and-bookcase, attributed to Nehemiah Adams (act. ca. 1790–1840), Salem, Massachusetts, 1800–10. Mahogany veneer, mahogany, and satinwood inlay. One of only about a dozen known examples attributed to Adams, this piece shows great unity of design achieved through the rhythmic use of ellipses—a favorite Neoclassical shape—in the panels of the cabinet base that are echoed in the mullions of the glazed upper bookcase doors. Purchase, Gift of Mrs. Russell Sage, Bequest of Ethel Yocum, Bequest of Charlotte F. Hoadley, and Rogers Fund, by exchange, 1971 (1971.9)

the stippled background on a square sofa in the Sheraton taste (fig. 56) are in McIntire's individual style, as are the motifs carved on a vase-back mahogany chair, which is from a set made for the Salem merchant Elias Hasket Derby and derived from a plate in George Hepplewhite's *Guide* (1788). The chimneypiece is from the Derby mansion in Salem. The ornament is of composition (a molded plasterlike substance), except for the grapevines on the wood columns, which McIntire is said to have carved.

Another example of Salem craftsmanship is a gentleman's secretary- or desk-and-bookcase (fig. 57), possibly by the cabinetmaker Nehemiah

Adams. Together with Jacob and Elijah Sanderson, William Appleton, and others, Adams made furniture for export; one of his secretaries was discovered in Cape Town, South Africa. A furniture form made for a man, the top center drawer of the Salem secretary pulls out, the front drops down to reveal a writing surface with drawers and cubbyholes, and behind the rhythmic mullions of the glazed doors there is ample room for a gentleman's library or a merchant's ledgers.

Late Federal Furniture

Toward the end of the long corridor and down the stairs to the left is a gallery with furniture from Boston, New York, Philadelphia, and Baltimore in the robust Classical Revival style of the years 1815 to 1835. During this period furniture became more massive and archaeologically accurate and continued to imitate antique forms. Such is the case with the klismos chair (fig. 59), a superb group of which are displayed here, and the "Grecian" sofa and couch with their scrolled ends modeled after *fulcra*, the raised headrests at the ends of Roman beds and couches. The sofa (fig. 58), made in New York about 1820, has sinuous carved dolphins on the ends, which are painted verd antique in imitation of antique bronze, and a bold Greek key brass inlay in the front rail. It is among the most sculptural American seating forms known in the fully developed, rich antique taste. Hanging above the sofa is a gilded girandole looking glass, decorated with seated winged Grecian figures, that is from New York or England and that displays the grand scale and opulence of the 1820s.

Also in the gallery is a monumental ebonized-and-gilded secretary-and-bookcase (fig. 61).

Comparing it with the inlaid mahogany example from Salem (see fig. 57), made more than a decade earlier, one can appreciate the transformation of American furniture in scale and ornament from the early nineteenth century to the 1830s.

Also exhibited is a colorful Philadelphia pedestal-base center table with an intarsia marble top (fig. 60) and boldly carved lion's-paw feet. It was made in the shop of Antoine-Gabriel Quervelle, a Paris-born cabinetmaker who was in Philadelphia by 1817 and worked there until his death in 1856. The table bears two of Quervelle's printed labels on the underside of its top with his name and his address for the years 1825 to 1849.

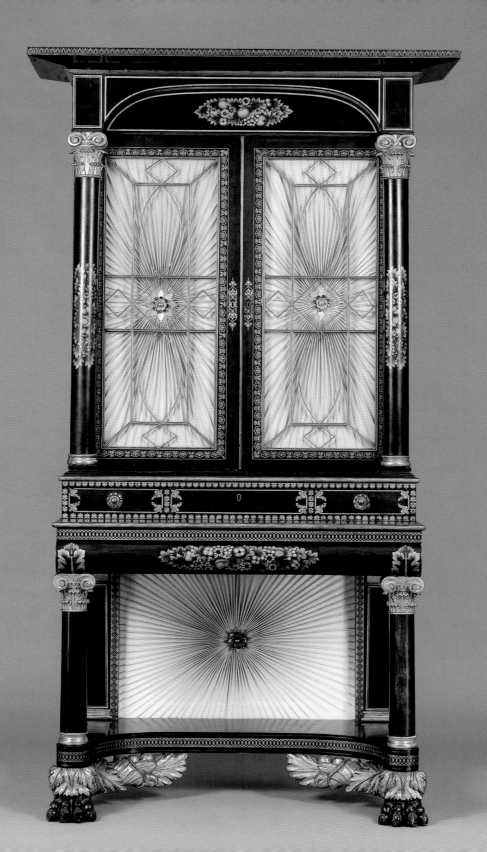

Folk Art

The Folk Art gallery displays a rotating selection of American paintings and textiles. While there are many designations for this kind of art—naive, plain, rural, provincial, outsider, idiosyncratic, or nonacademic—at the Metropolitan we use the term *folk* because it is traditional and recognizable, even if it does not begin to characterize the diversity of artistic approaches, expressions, and media it purports to represent.

The textiles in the Folk Art gallery, which usually include quilts, woven coverlets, and embroideries, tend to be pieces created outside of urban centers. Amish quilts (fig. 65) are almost always on view, as are eccentric and original examples of handmade bed, table, and floor coverings.

The paintings are unified by conventions of method, aesthetic, and circumstance. Most folk painters were itinerant artists who spent their careers on the road, primarily in the Northeast, seeking commissions. While some developed distinctive styles and artistic methods, all of their works evidence a common nomadic lifestyle and production in rural America. Portraiture is by far the most prevalent genre (fig. 62). Those in this gallery are indebted in some measure to academic conventions—the poses, props, and settings for country portraits were no different from those employed by urban artists. In every other respect, however, folk portraits are restrained, character-

ized by sharply defined forms, neatly organized compositions with well-defined spatial arrangements (some with an almost mathematical precision and symmetry), generalized lighting, an absence of expressive brushwork, and an overall flatness and linearity.

Folk artists worked according to criteria set by their rural clientele, often socially reticent sitters who were eager for a likeness but shy of declaring any personality or emotion. Elements of pride and class status are apparent but circumspect. Many folk portraits record lasting traits and conditions —some are even memorials to the dead (fig. 63)— rather than transitory mannerisms and situations.

62. Ammi Phillips (1788–1865). *Mrs. Mayer and Daughter,* 1830–35. Oil on canvas. Phillips developed a formula to facilitate his portraits but then imaginatively individualized each one. Here the artist's masterful design abilities are evident in the cleanly contained forms of the mother and child, enriched by saturated color and careful detail. Gift of Edgar William and Bernice Chrysler Garbisch, 1962 (62.256.2)

63. Ambrose Andrews (ca. 1801–1877). *The Children of Nathan Starr,* 1835. Oil on canvas. Andrews followed the traditional conversation-piece format by showing the family in playful pastimes. The youngest child in the picture, Edward, who holds his gaming stick heavenward, is here memorialized— his death was probably the occasion for the group portrait. Gift of Nina Howell Starr, in memory of Nathan Comfort Starr (1896–1981), 1987 (1987.404)

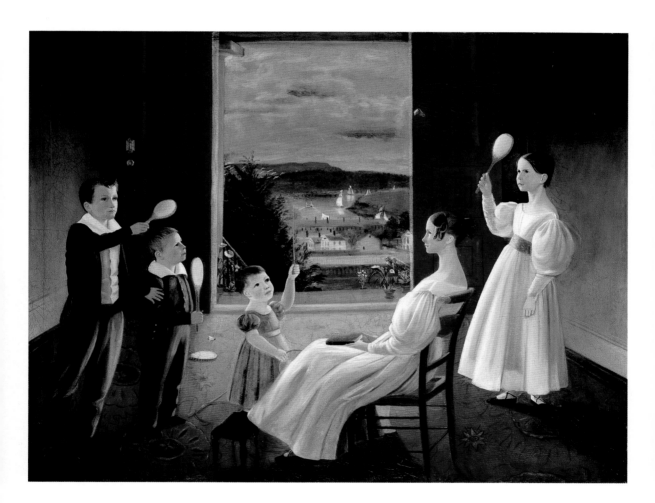

Above, below, where'er the astonished eye
Turns to behold, new opening wonders lie,

The Falls

of Niagara

With uproar hideous first the *Falls* appear,
The stunning tumult thundering on the ear.

This great o'erwhelming work of awful Time
In all its dread magnificence sublime,

18

Rises on our view, amid a crashing roar
That bids us kneel, and Time's great God adore.

25

Although it is common to think of folk painters as untrained, in fact most were highly skilled, and those who apprenticed to craftsmen or artisans developed distinct visual vocabularies and expressive visions (fig. 64). Most folk artists began their careers painting signs or furniture, which required special techniques to ensure legibility and durability. Paintings by artists trained as craftsmen are highly illustrative and moralistic; religious and historical subjects are common, while naturalism is rare. The relative importance of figures is indicated by their size, and animals, which are usually emblematic, are ubiquitous.

64. Edward Hicks (1780–1849). *Niagara Falls*, 1825. Oil on canvas. The text inscribed around the edge is an excerpt from Alexander Wilson's poem "The Foresters" (1809–10), which inspired Hicks's 1819 missionary trip to Native Americans in upstate New York. The falls, seen from the Canadian side, are replete with moose, beaver, rattlesnake, and eagle, all traditional emblems of North America. Gift of Edgar William and Bernice Chrysler Garbisch, 1962 (62.256.3)

65. Center Diamond quilt, maker unknown, Amish, Lancaster County, Pennsylvania, ca. 1910–40. Wool and cotton. The bold yet simply composed Center Diamond pattern is a favorite of the Amish of Lancaster County, considered the most conservative of all the Amish settlements. The large, unbroken areas of plain, deeply colored fabric make the Center Diamond the perfect canvas for the elaborate decorative quilt stitching that is a hallmark of Amish work. Sansbury-Mills Fund, 1973 (1973.157)

Shaker Retiring Room

Eight members of the United Society of Believers in Christ's Second Appearing, led by Mother Ann Lee, their prophet, came to America from England in 1774. This small band was more commonly known as the Shakers because of their unorthodox methods of worship, which often culminated in a frenzied dance. The group first settled in Niskeyuna, New York, northwest of Albany. As the Shakers gained converts, nineteen communities sprang up between Maine and Kentucky. Ann Lee preached that the way to spiritual perfection was through open confession and celibacy. Communal in both spirit and action, the Shakers believed in equality of the sexes. Since they were celibate, Shakers provided for orphans in order to add members to the flock. The brothers and sisters (as they were called) adhered to rules known as the Millennial Laws, which regulated their lives. To support themselves, they offered goods for sale, such as garden seeds, brooms, brushes, and medicinal herbs. Today they are most admired for their simple, elegant furniture that emphasized functionality and quality.

The New Lebanon, New York, community, which functioned between 1781 and 1947, was the central ministry, with approximately six hundred members at its height. The community had eight "families," each with its own dwellings and workshops. The Museum's retiring room (fig. 66) is from the North Family Dwelling. It served as both a bedroom and, as described in the Millennial Laws, a place to retire to "in silence, for the space of half an hour, and labor for a sense of the gospel, before attending meeting." Most retiring rooms were shared by at least two people.

The room reveals some of the most typical characteristics of Shaker design: utility, simplicity, and beauty. It has clean white plaster walls, a scrubbed pine floor, and simple stained woodwork that has aged to a warm ocher. It is furnished with objects that would have been found in a typical retiring room, although none are original to it and some were made at other northeastern Shaker communities.

As in many Shaker interiors, a pegboard runs around the room for objects lifted from the floor for daily storage and to facilitate cleaning. There are built-in drawers and cupboards at one end. Some Shaker furniture, such as the bed, was painted, although in the limited palette strictly dictated by the Laws. The unadorned bedside candlestand, with its gently curving legs, typifies Shaker design at its best.

66. Shaker Retiring Room, New Lebanon, New York, ca. 1830–40. The calm beauty of this retiring room, or bedroom, aptly illustrates the hallmarks of Shaker design philosophy—simplicity and utility. Purchase, Emily Crane Chadbourne Bequest, 1972 (1972.189.1–3)

67–68. John Vanderlyn (1775–1852).
Panoramic View of the Palace and Gardens of Versailles (details), 1818–19. Oil on canvas. The panorama includes portraits of King Louis XVIII (top, in the balcony of the palace) and Czar Alexander I of Russia and King Frederick William III of Prussia (below, in the gardens at right), two of the men who reestablished the French monarchy after the defeat of Napoleon in 1815. Gift of the Senate House Association, Kingston, N.Y., 1952 (52.184)

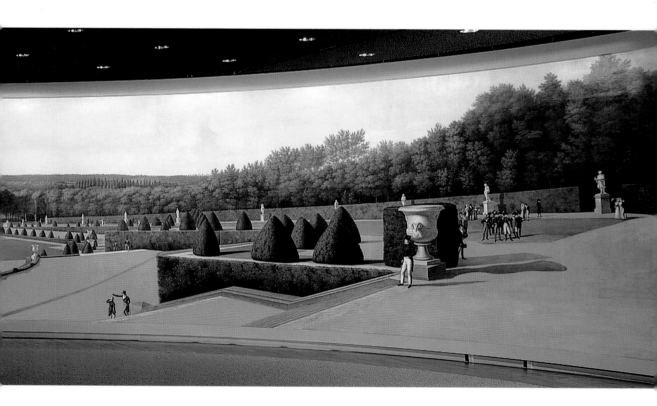

Mid-Nineteenth-Century Furniture

The opening of the Erie Canal in 1825, connecting New York to the Great Lakes and the West, marked the beginning of enormous growth for the city. It became the artistic capital of the United States, surpassing Philadelphia and Boston in cabinetmaking. This change was fueled by an influx of skilled European craftsmen seeking refuge from political turmoil in Europe. Their work reflects the influence of French taste, as illustrated by the objects in this gallery. Dating mostly from the 1850s to the early 1870s, these pieces coincide with the French Second Empire of Napoleon III. Designs were disseminated through French publications and through the great international expositions—in London, New York, and Paris. Despite the strong influence of Europe, American cabinetmakers were not merely copyists, rather they sometimes interpreted imported styles in distinctly original ways.

Rich, naturalistic carving was the hallmark of great cabinetmaking at midcentury, as evidenced by the work of the Frenchman Alexander Roux, the leading cabinetmaker in New York during the 1850s, and by that of John Henry Belter, a German, whose elaborate furniture is featured in the adjacent Rococo Revival Parlor (see fig. 73). Particular woods and styles were deemed appropriate for specific rooms of the house. Roux's rosewood étagère (fig. 69) was conceived for a drawing room, or parlor, with decorative objects displayed on its shelves. Its cabriole legs and stretcher capped by a bouquet recall the eighteenth-century French Rococo style, but the form and the rosewood are of the nineteenth century. Roux's black-walnut étagère-buffet, or sideboard, in the French Renaissance style (fig. 70) was made for a dining room, as suggested by the decoration of carved game, fish, nuts, and berries. This type of sideboard—with shelves above a cabinet—was conceived in Europe during the 1840s and remained popular in America until the mid-1870s.

The French *néo-grec* style, which dominated the 1860s, combined classical and Renaissance motifs with late-eighteenth-century forms and ornamentation and sometimes incorporated Egyptian motifs. Roux, Herter Brothers, Pottier and Stymus, and Léon Marcotte were among the cabinetmakers working in this style before and after the Civil War. Marcotte's ebonized parlor suite of seating furniture and a related library table (fig. 71) epitomizes a more literal interpretation of the eighteenth-century Louis XVI style. Three chairs attributed to Pottier and Stymus, two with gilt-bronze mounts and all with imported Aubusson showcovers, evince heightened interest in Egypt about the time of the opening of the Suez Canal in 1869.

69. Étagère, by Alexander Roux (act. 1836–80), New York, ca. 1855. Rosewood and rosewood veneer; chestnut, poplar, and bird's-eye maple veneer; replacement mirror glass. Although not gilded, this flamboyant table by French émigré Alexander Roux is as finely and richly carved as its predecessors from the age of Louis XV. Sansbury-Mills Fund, 1971 (1971.219)

70. Étagère-buffet, by Alexander Roux (act. 1836–80), New York, ca. 1853–54. Black walnut, pine, and poplar. French Renaissance was the preferred style for midcentury sideboards. Relatively restrained examples such as this one were deemed "not too large for the use and style of moderately wealthy families." Purchase, Friends of the American Wing Fund and David Schwartz Foundation Inc. Gift, 1993 (1993.168)

71. Library table, by Léon Marcotte (1824–1887), New York, ca. 1860. Walnut, amboyna, maple, and other woods. An early example of the Louis XVI Revival style, this elegant table was made for the Fifth Avenue mansion of art patron John Taylor Johnston, the first president of the Metropolitan Museum. Gift of Mrs. Robert W. de Forest, 1934 (34.140.1)

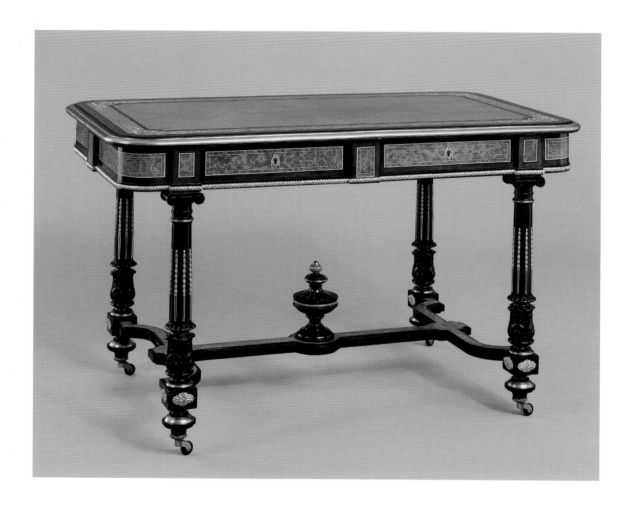

Greek Revival Parlor

Architecture of the nineteenth century was characterized by a series of revival styles, which were widely disseminated through pattern books and journals written for builders and for the emerging middle class. It was thought that the style of one's house should be emblematic of personal values and beliefs. For example, Greek Revival architecture, particularly popular during the 1820s and 1830s, spoke of Americans' optimism at a time when the young nation's democratic system, adapted from the Greek model, was flourishing. By the end of the century pattern-book revival styles—Greek, Rococo, Gothic, Renaissance, Italianate, and Second Empire—were replaced by the work of professionally trained, innovative architects such as McKim, Mead and White and Frank Lloyd Wright.

The Greek Revival Parlor (fig. 72) is a re-creation of a formal front parlor in a New York town house of about 1835. The room was designed by the Museum to showcase a rare suite of seating furniture made by Duncan Phyfe for New York lawyer Samuel A. Foot. The only period elements are the Ionic columnar screen at the entrance with massive mahogany sliding doors, acquired from a New York town house, and the black marble mantelpiece, from a Greek Revival home in Rye, New York. The rest of the room was copied from existing parlors or based on designs found in architectural pattern books, such as Minard Lafever's *The Modern Builder's Guide* (1833).

Buildings in the Greek Revival, or Grecian, style, America's first truly national architectural style, sprang up in the decades between 1820 and about 1840. In rapidly growing New York City, Greek Revival town houses filled block after block from Greenwich Village to Thirty-fourth Street.

Designed to accommodate the expanding middle class, these structures were usually built on lots twenty-five feet wide and one hundred feet deep. The typical house was three full stories above a raised basement and often topped with a garret. The building was usually two rooms deep, with a stair hall on one side. On the main floor were front and back parlors, separated by a columnar screen with sliding doors like that in our room. The front parlor was for formal entertaining, while that in the back was a family sitting room often used for dining.

As was popular in the day, the walls of our room are smoothly plastered and painted a warm beige. A modern reproduction of a wall-to-wall Brussels carpet, copied from an 1827 watercolor pattern found in the archives of an English carpet mill, has been laid on the floor. The curtains, with their unusual bullion-fringe valance, were copied from plate 1979 of J. C. Loudon's *Encyclopedia of Cottage, Farm and Villa Architecture* (1833), one of the nineteenth century's most popular books for building and decorating on both sides of the Atlantic.

The suite of couches, stools, benches, and side chairs—the late work of Duncan Phyfe and his shop—was made to furnish a town house at 678 Broadway, into which Foot moved his family in 1837. The pieces feature luxuriously curving forms that highlight the beauty of their gleaming mahogany surfaces. Also in the room is a pair of armchairs that descended in Phyfe's family and a fall-front desk that may have come from his workshop. All of the seating furniture is upholstered with a reproduction fabric similar to the original coverings.

72. Greek Revival Parlor, New York, ca. 1835. The black and gold Egyptian marble of the mantelpiece matches the top of the center table, a furniture form that first gained popularity in American homes in the 1820s and 1830s.

Rococo Revival Parlor

The architectural elements of the Rococo Revival Parlor (fig. 73) were once part of hat merchant Horace Whittemore's mid-nineteenth-century country house, built about 1852, which overlooked the East River from the then-elegant New York neighborhood of Astoria. The room is a re-creation of one of two matching parlors from the first floor, to which structural modifications were made by the Museum. The plan was slightly widened, a window was removed from one of the long walls, and a chimney breast and mantel were added so that the room would more accurately reflect a typical parlor of the period.

The columnar screen with its elaborate Corinthian capitals originally separated two similar rooms. An 1871 inventory of the house indicates that each room had matching sets of brocatelle draperies with lace undercurtains hung beneath gilded cornices, gilt-framed pier mirrors between the pairs of windows, and the same wall-to-wall carpeting throughout. The current parlor suite by John Henry Belter is probably grander than the Whittemore furniture. It is, in fact, among the most ornate produced by Belter, a German immigrant working in New York who invented a method of lamination whereby wood could be bent into deep curves and then elaborately carved. Belter worked in a style today called "Rococo Revival" but in the 1850s, when it was popular, usually described as "Modern French." The nineteenth-century designers who adopted this mode may have looked to eighteenth-century French furniture for inspiration, but in actuality Rococo Revival furniture is heavier, with deep, naturalistic carving and dramatically grained woods.

The room is decorated in what would have been called the "French taste," the accepted style for parlors during the middle decades of the century. The wallpaper is a reproduction of a period damask pattern that has been separated into panels with trompe l'oeil architectural molding. In trompe l'oeil frames are wallpaper views of Paris made in 1857 by the French manufacturer Jules Desfossé. The upholstery fabric used for the furniture and draperies reproduces a blue-and-gold silk brocatelle found on parlor furniture in Camden, a house in Port Royal, Virginia, built between 1856 and 1859 for planter William Carter Pratt. On the floor is a highly patterned English carpet of a type referred to in the 1850s as a "tapestry velvet." The ornately carved white-marble mantel is from a house in North Attleboro, Massachusetts, built in 1853, and the blue overlay-glass chandelier was made about 1850 by the Boston company of Henry N. Hooper. Vases and statuettes of Parian ware (a type of porcelain), much of it made in Bennington, Vermont, complete the scheme.

73. Rococo Revival Parlor, Astoria, New York, ca. 1852 .Part of the Ionic columnar screen of the nearby Greek Revival Parlor is reflected in the pier glass between the windows.

Gothic Revival Library

In 1852 Frederick Clarke Withers, an English architect, arrived in the booming Hudson River shipping town of Newburgh, New York, to work for Andrew Jackson Downing. Downing was the horticulturist, landscape designer, and architectural theoretician who introduced the concept of the picturesque in architecture and landscaping to pre–Civil War America. The partnership ended with Downing's death in a steamboat accident later that year. Withers remained in Newburgh and was responsible for many houses, including the one from which the library was acquired.

The library was part of a Gothic Revival home designed in 1859 for banker Frederick Deming. The house, which stands in the Balmville section of Newburgh on a large plot of land, has been restored. The library was removed in 1977, by which time the structure had been abandoned for many years.

During the mid-nineteenth century Gothic Revival was considered appropriate for libraries. Even houses that were not of Gothic design sometimes contained libraries decorated in the fashion, which was intended to evoke scholarly preserves such as monasteries and universities. Before this time private libraries were the exclusive domain of wealthy gentlemen, but by the 1850s mechanized production of inexpensive clothbound books brought a good library within reach of middle-class families. Less formal than the best parlor, the library became the sitting room, a place where relaxation and even coziness were encouraged.

Our room is enlivened by the play of contrasting woods. The floor is striped in alternating oak and walnut, and the wainscoting is walnut with chestnut panels. The original paint scheme is replicated, as is the elaborate plaster medallion ceiling. However, the room differs in two ways from its original appearance. Visitors now enter through an enlarged archway, which replaces a full-length window that opened onto the veranda, and the carved walnut mantel is a copy of one from the library of the Newburgh residence that Withers designed for David M. Clarkson in 1856. When the Deming room was acquired, all of the mantels had been stripped from the building.

The room is furnished as an upper-middle-class family library. Plates in contemporary design manuals by Downing and others guided the selection and placement of the pieces, none of which is original to the house. The majority are either oak or walnut and were most likely produced in New York between the early 1850s and the mid-1860s. A few English objects, such as the mantel clock, made about 1845 by H. Smith of York, the bread plate designed by Augustus Welby Northmore Pugin and manufactured by Minton and Company in Stoke-on-Trent, and the drapery fabric, a reproduction of an English wool-and-silk damask, serve as reminders of Withers's roots, as well as of the profound influence of the English Gothic Revival on American design.

74. Gothic Revival Library, Newburgh, New York, 1859. The Gothic Revival style, which came to America from England, was considered perfect for libraries because it evoked images of old-world universities such as Oxford and Cambridge. Gift of Mrs. Hamilton Fish, 1977 (1977.1)

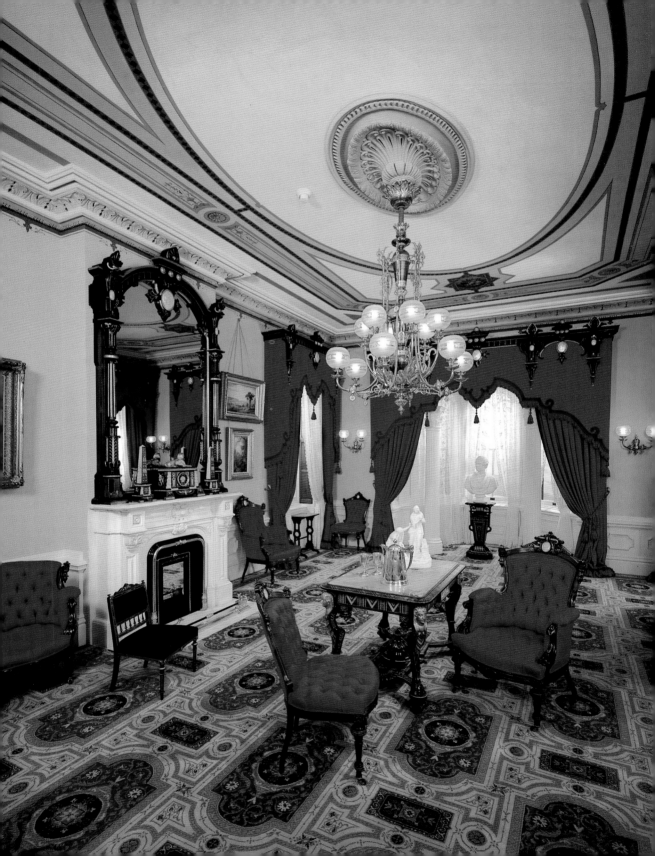

McKim, Mead and White Stair Hall

When the simply massed Metcalfe house was built in 1884, it was probably considered an avant-garde addition to its suburban neighborhood. It was the first house built in Buffalo by the New York architectural firm of McKim, Mead and White. The stair hall (fig. 76) was removed prior to the demolition of the structure in 1980. In 1884 *Real Estate and Builder's Monthly* called the house "an example in domestic architecture unique, so far as we know, in this part of the state." The exterior, which the *Monthly* called "a somewhat conventionalized 'early colonial,'" was inspired by the architects' interest in pre-Revolutionary American architecture. The article also stated that the house was designed with "convenience, utility, and economy" in mind, traits that characterize the interiors of American homes of the early 1700s.

After the death in 1879 of her husband, James Harvey Metcalfe, a bank president, Mrs. Metcalfe built a new house. Two-and-a-half-stories high, it had rough-hewn red sandstone walls for the first story, pressed brick for the second, and red terracotta tiles for the attic gables and the roof. The interior was more ornamented than the exterior; the downstairs was paneled with oak and cherry, described as "very tastefully carved from the designs of the architects."

A stair hall, or living hall, was considered essential to a house built in the 1870s and 1880s. Inspired by the "halls" in early colonial houses, where people ate, slept, and performed myriad tasks, nineteenth-century living halls, in contrast, with their cozy inglenooks furnished with benches on either side of a glowing hearth, were the symbolic centers of the home, meant only for relaxation and leisure.

The stair hall is paneled in quarter-sawed white oak. Most of the carved and turned decoration was inspired by an eclectic range of sources, including Moorish, Japanese, and Italian Renaissance ornament. One of the most striking features is the light (originally daylight) from the leaded-glass windows at the stair landing that spills across the first few steps and hall floor. It gives dimension to the Japanese-style latticework on the right of the staircase and flows through the delicately turned balusters of the screen at the left.

The space is so carefully designed and ornamented that it needs few furnishings. Niches flanking the mantel mirror hold ceramics by the Faience Manufacturing Company of Brooklyn, New York, and the massive deep-blue glazed earthenware vase on the landing was made in 1880 by M. Louise McLaughlin of Cincinnati. The brass andirons and the tall clock at the base of the stairs both date from about the end of the 1700s. These types of late colonial objects were popular for furnishing artistic houses of the late nineteenth century, when they served as icons of a time thought of as simpler, and perhaps better, by Victorians facing the dawn of the twentieth century.

76. McKim, Mead and White Stair Hall, Buffalo, New York, 1884. The cushioned benches, the soft-toned Sienna marble facing of the red terracotta-lined fireplace, and the warmth of polished brass combine to make this inglenook especially inviting. Gift of Delaware North Companies, Incorporated, 1980 (1980.76)

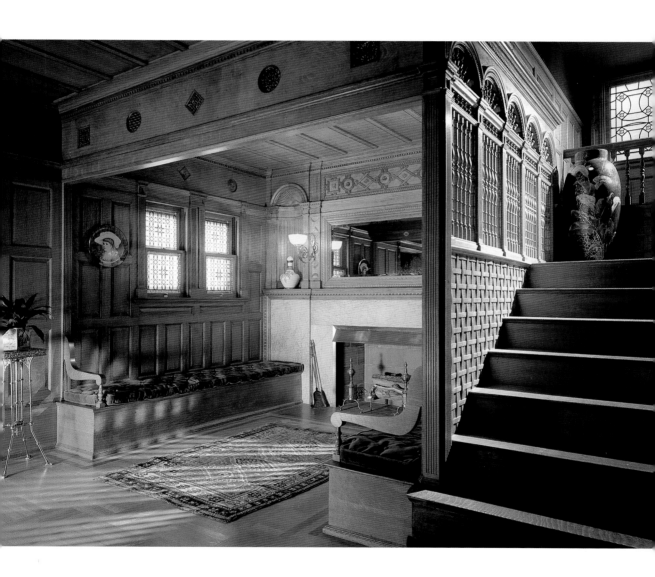

Late-Nineteenth-Century Furniture and Decorative Arts

The Aesthetic movement in America (ca. 1875–85) was inspired by the British design reform movement, a reaction to the perceived vulgarities of mid-nineteenth-century taste. The movement stressed the beautification of "useful" objects, and its goals were conveyed in art periodicals and in advice and pattern books. Underlying both the Aesthetic movement and, subsequently, the Arts and Crafts movement was the belief that well-designed objects and interiors influence the lives of their owners and inhabitants in positive ways.

Designers of the period freely borrowed and adapted motifs and shapes from a wide range of historical periods and exotic cultures, especially those that emphasized geometrical floral patterns and flat surface decoration, banded compositions, and rectilinear shapes. The robust architectonic forms of the British architect Bruce J. Talbert inspired Daniel Pabst's walnut cabinet (fig. 77). With its stylized carvings and geometric plants on glass panels it epitomizes the Modern Gothic style in America. Herter Brothers' distinctive Anglo-Japanese pieces, which reflect the influence of the elegant black art furniture of British designer E. W. Godwin, are represented by the ebonized wardrobe with cascades of light-colored marquetry blossoms (fig. 78) and a delicate reception chair.

About 1880 Herter Brothers, then the greatest cabinetmaking and decorating firm in America, executed luxurious, original interiors for select wealthy patrons. These commissions included pieces such as William H. Vanderbilt's massive rosewood library table (fig. 79) and a painted vitrine—a sophisticated marriage of eighteenth-century Louis XVI and Robert Adam influences with nineteenth-century reform styles—from an ivory, gold, and Pompeian red drawing room designed for Oliver Ames Jr. of Boston.

The American Arts and Crafts movement in America began in the 1890s and continued until World War I. It mirrored a similar movement in Britain, deriving key principles from designer William Morris, who called for "an Art made by the people, for the people, as a happiness to the maker and the user." Gustav Stickley is the best-known American exponent of the style. His mastery is exemplified by his octagonal library table with stacked stretchers (fig. 80), which relies on boldness of form, revealed construction (note the tenon-and-key joints on each leg), and simple materials for its effect.

Ironically, the movement's emphasis on handcraftsmanship often resulted in expensive one-of-kind or limited-production pieces. The Metropolitan's collection includes outstanding examples from the utopian colonies of Rose Valley, Pennsylvania, and Byrdcliffe, in Woodstock, New York; from John Scott Bradstreet's Minneapolis workshop; and from the Pasadena, California, architectural firm of Greene and Greene. Also noteworthy is Louis Comfort Tiffany's large armchair designed for H. O. Havemeyer's library, the prevailing theme of which was Celtic in origin. Part of a suite, it was probably inspired by hand-hewn, rural Irish seating furniture and is an early expression of vernacular style, an important characteristic of the movement.

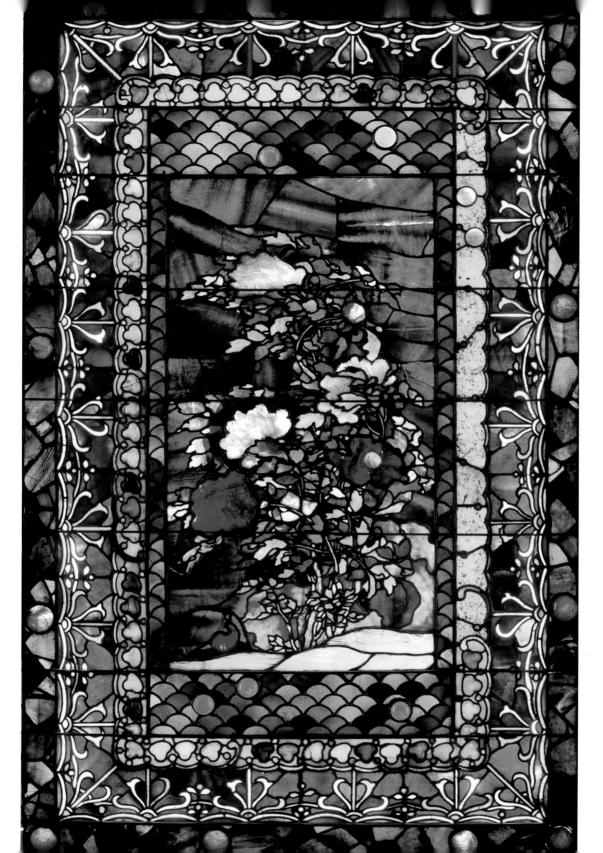

Frank Lloyd Wright Room

Frank Lloyd Wright can be counted among the truly great architects of the twentieth century. This installation provides Museum visitors with a rare opportunity to experience a Wright-designed domestic space. It was originally the living room in the Prairie-style house that Wright created for Mr. and Mrs. Francis W. Little. Little was a banker, and his wife, an avid amateur musician. The Prairie style was Wright's first mature style, and he adhered to it for most of the first two decades of the twentieth century. It was exemplified by low spreading structures—most of which were cruciform in plan—that had first-floor rooms flowing into one another, all organized around a central masonry fireplace. Prairie houses tended to have outdoor terraces that were extensions of the plan, dominant rooflines with wide overhanging eaves, and windows that broke through the walls in continuous bands and visually connected the interior with the exterior landscape.

Wright had built the Littles a home in Peoria, Illinois, in 1903; in 1908 they asked him to design a new one in Wayzata, Minnesota. As with Wright's other great Prairie houses, the Littles' Wayzata house was brilliantly integrated into its site. The pavilions that made up the building seemed to grow from the hilly landscape overlooking a lake. The living room—the largest and the most important in the house—served both as a family gathering place and as an informal concert hall. It is a light-filled pavilion, in which the division between interior and exterior has been minimized. The composition of the side walls—with their lower band of casement windows, long oak shelves, upper band of clerestory windows, and oak-trimmed panels that integrate the wall and ceiling—carries the eye upward to the leaded-glass ceiling light. Textured ocher plaster blends harmoniously with the oak trim and floor and with the brick fireplace.

The furniture comprises pieces that Wright designed for the Peoria house and those he created specifically for the Wayzata room. All are of oak; the earlier furniture is stained dark brown and decorated with small square bands of trim, while the later examples are the same light color as the room trim and simpler and bolder in design. The furniture and other objects were installed following a floor plan made by Wright and a photograph published in 1942.

In 1971 the house faced demolition because the Littles' descendants wanted to build a smaller house on the property and zoning dictated that the original be torn down. In an effort to save as much of the building as possible, the Museum bought the house, documented it, and managed to place many of the other rooms in American museums.

82. Frank Lloyd Wright Room, Wayzata, Minnesota, 1912–14. The room's low horizontal massing, open glass window walls, and soft golden palette create an informal and welcoming space. Purchase, Emily Crane Chadbourne Bequest, 1972 (1972.60.1)

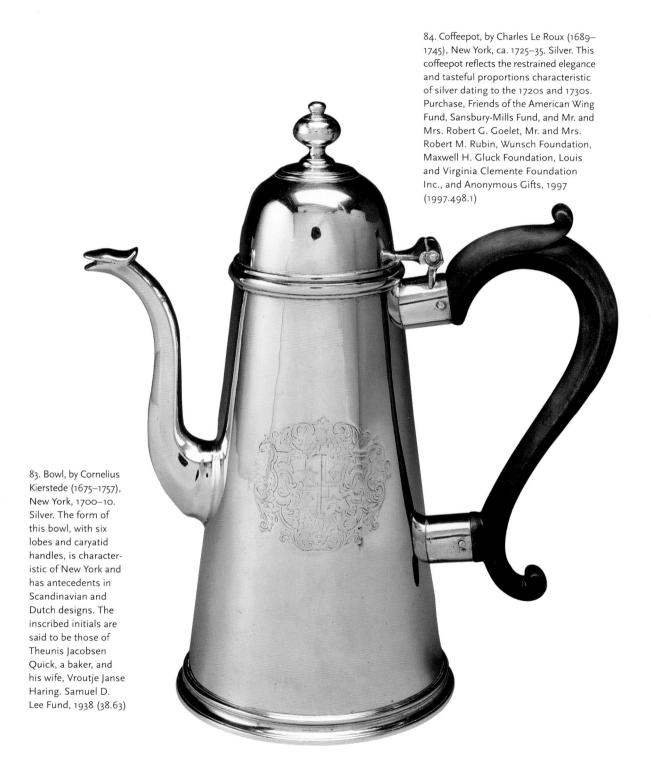

84. Coffeepot, by Charles Le Roux (1689–1745), New York, ca. 1725–35. Silver. This coffeepot reflects the restrained elegance and tasteful proportions characteristic of silver dating to the 1720s and 1730s. Purchase, Friends of the American Wing Fund, Sansbury-Mills Fund, and Mr. and Mrs. Robert G. Goelet, Mr. and Mrs. Robert M. Rubin, Wunsch Foundation, Maxwell H. Gluck Foundation, Louis and Virginia Clemente Foundation Inc., and Anonymous Gifts, 1997 (1997.498.1)

83. Bowl, by Cornelius Kierstede (1675–1757), New York, 1700–10. Silver. The form of this bowl, with six lobes and caryatid handles, is characteristic of New York and has antecedents in Scandinavian and Dutch designs. The inscribed initials are said to be those of Theunis Jacobsen Quick, a baker, and his wife, Vroutje Janse Haring. Samuel D. Lee Fund, 1938 (38.63)

85. Basket, by Myer Myers (1723–1795), New York, 1760–70. Silver. Baskets for bread, cake, or fruit are extremely rare in 18th-century American silver. Myers made this example along with several other exceptional pieces for Samuel Cornell, of New York and North Carolina. Morris K. Jesup Fund, 1954 (54.167)

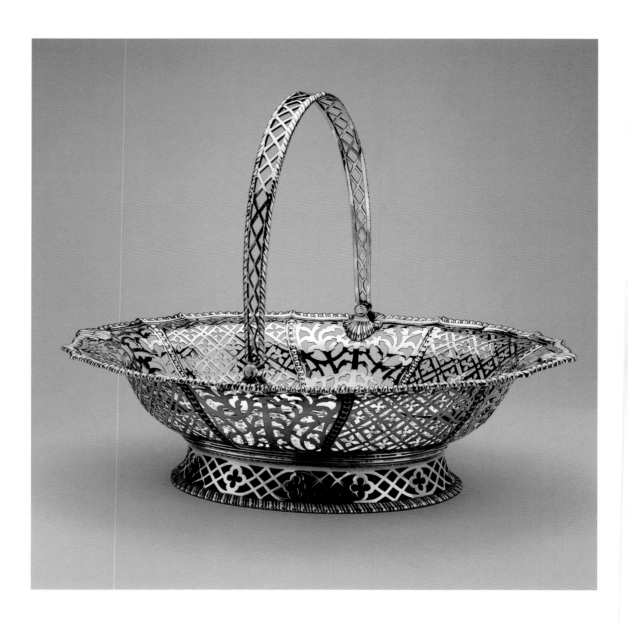

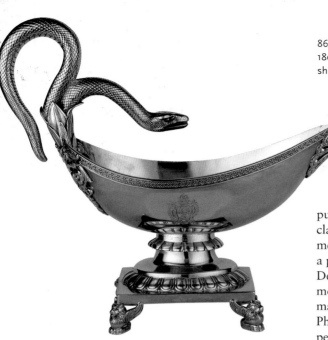

86. One of a pair of sauceboats, by Anthony Rasch (act. ca. 1807–25), Philadelphia, 1808–19. Silver. The strong boat shape of this piece is emphasized by the forward and horizontal thrust of the serpent handle and ram's-head spout. Fletcher Fund, 1959 (59.152.1)

equipage in particular, including sugar bowls, tongs, pitchers, and caddies, became an important segment of production. Other specialized forms, such as salts, casters, and salvers, were also more common at this time.

With the emergence of the Rococo about 1750, the shapes of objects became more fanciful, as seen in a pair of sauceboats with scalloped rims and high scroll handles made by the patriot Paul Revere Jr. of Boston, and ornament regained favor. Scrolls, shells, and foliage were the prime motifs, worked in repoussé or cast, as on a snuffer stand by Philip Syng Jr. of Philadelphia. A large basket by Myer Myers of New York showcases another decorative technique of this style, piercing (fig. 85).

Matching tea sets came into use with the introduction of Classical Revival styles following the Revolution. A service attributed to Christian Wiltberger of Philadelphia, and said to have been a gift from General Lafayette to Eleanor Custis upon her marriage in 1799, exemplifies the Neoclassical taste of the early Federal era in its urn and helmet shapes and delicate engraving. A tall, elegant tea urn from the same period made by Revere is a rarity and is distinguished by the

purity of its lines. In the 1810s a heavier type of classicism employing cast or chased relief ornament was introduced. Outstanding examples are a pair of monumental vases presented to Governor DeWitt Clinton of New York for his role in promoting the building of the Erie Canal (1825) and made by Thomas Fletcher and Sidney Gardiner of Philadelphia and a pair of sauceboats with serpent handles and ram's-head spouts by Anthony Rasch, also of Philadelphia (fig. 86).

In silver as in furniture, the nineteenth century witnessed the revival of a number of other historical styles. Rococo-inspired designs dominated the mid-1800s, featuring foliage in bold repoussé, as seen on a kettle-on-stand retailed by Ball, Tompkins and Black of New York that is laden with grape leaves and clusters. In the 1860s Renaissance-derived ornament such as medallions gained popularity. A colorful tea set by Tiffany and Company of New York, with enameled decoration based on Islamic motifs, is a vivid example of the influence that exotic cultures, particularly East Asia and the Near East, exerted on silver design beginning in the 1870s.

The second half of the nineteenth century saw the rise of large international expositions, in which major American manufacturers participated. Tiffany and Company created the opulent Magnolia Vase (fig. 87) especially for the World's Columbian Exposition held in Chicago in 1893. The Gorham Company of Providence, Rhode Island, introduced its line of Art Nouveau silver called Martelé, of which our ewer and plateau are prime examples, at the 1900 Paris International Exposition.

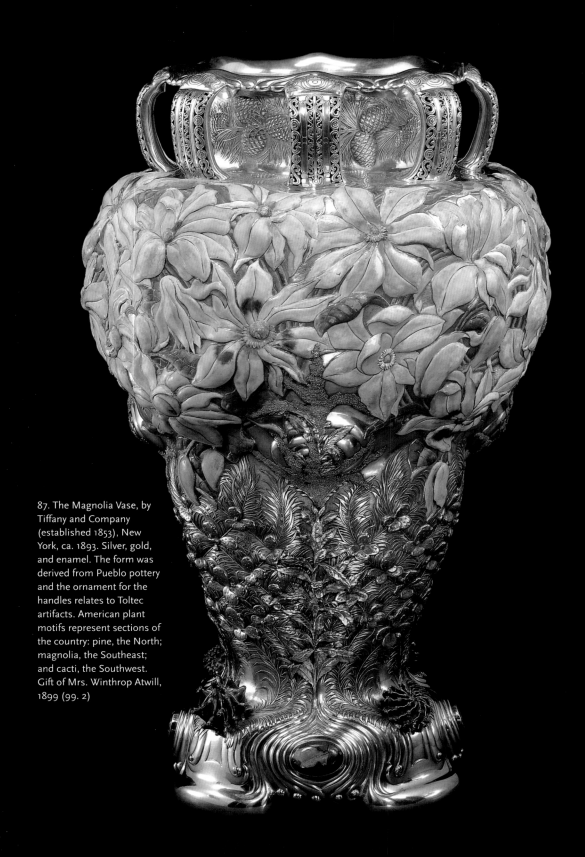

87. The Magnolia Vase, by
Tiffany and Company
(established 1853), New
York, ca. 1893. Silver, gold,
and enamel. The form was
derived from Pueblo pottery
and the ornament for the
handles relates to Toltec
artifacts. American plant
motifs represent sections of
the country: pine, the North;
magnolia, the Southeast;
and cacti, the Southwest.
Gift of Mrs. Winthrop Atwill,
1899 (99. 2)

Glass

Glassmaking was America's first industry, as witnessed by two attempts at the earliest settlements at Jamestown, Virginia, to supply finished products for export. Despite these failed ventures, the eighteenth century saw the rise of about a dozen glasshouses that provided mainly windowpanes and bottles. Although the fledgling firms experienced technical and labor difficulties and competition from abroad, Caspar Wistar's factory, founded in Alloway, New Jersey, in 1739, was an exception, enjoying lasting success until the Revolution. Wistar's mainstays were window glass and bottles, produced by a largely immigrant staff of European blowers, but they also fashioned tablewares in unrefined green glass, as well as parts for Benjamin Franklin's electrical experiments. Many products had German characteristics, such as our small, green dog-shaped bottle, or *Schnappeshunde*. Wistar's tradition of mouth-blown glass with applied or tooled ornament was continued at rural factories throughout the nineteenth century.

The factory established in 1764 by ironmaster Henry William Stiegel in Manheim, Pennsylvania, initially produced German-style wares. By the end of the decade, with the help of skilled English workers, Stiegel created table forms resembling English glass, including engraved goblets or

mugs and other forms—in jewel-like blue and amethyst and fashioned by blowing the gather into an iron mold, occasionally with diamond or rib patterns—that were indistinguishable from British counterparts. The amethyst pocket bottle in the unusual daisy-within-a-diamond pattern, however, is thought to be by Stiegel (fig. 88). Many later factories, especially in the Midwest, revived the dip-molding technique in amber or aqua bottles, sugar bowls, and pitchers with diamond- or rib-molded designs.

Blown-molded pattern pocket bottles and salts were also made in the third successful eighteenth-century factory, founded by German-born John Frederick Amelung, in Frederick County,

88. Pocket bottle, attributed to American Flint Glass Manufactory (1765–74) of Henry William Stiegel, Manheim, Lancaster County, Pennsylvania, 1769–74. Blown-molded glass. The jewel-like amethyst glass accentuates the blown-molded patterning on this pocket bottle. Small bottles such as this, suitable for carrying, might have been used for alcoholic beverages or medicinal waters, such as camphor. Gift of Frederick W. Hunter, 1914 (14.74.17)

Maryland. The most illustrious testaments to this enterprise, however, were the colorless goblets and tumblers with ambitious engraved decoration. The Museum's covered goblet, or *pokal,* features an elaborate Rococo coat of arms of Bremen, Germany, and an inscription, "Old German success and the New Progress" (fig. 89). Signed and dated 1788, it is presumably the piece Amelung sent to his backers in Germany to assure them of his financial stability.

Stiegel's was the first American firm to use the brilliant lead glass favored by British and Irish makers. Significant factories of the early nineteenth century, notably in Pittsburgh, and Sandwich and East Cambridge, Massachusetts, made luxury table forms in colorless lead glass. Like fashionable European wares, some had applied and tooled ornament, while others were cut and engraved in Anglo-Irish styles.

Mold-blown forms in geometric patterns recalling those on cut glass were more affordable than cut and engraved pieces. Even more economical was pressed glass, developed in America about 1825. Table wares were made by pouring molten material into an iron mold, which formed and ornamented the vessel in one step. The first designs were geometric, resembling those on cut glass, but pressed pieces soon assumed a distinctive decorative vocabulary, which included Rococo Revival and Gothic Revival motifs. These at first incorporated allover stippling, giving rise to the term "lacy" glass. New forms were created, notably a cup plate to put under the teacup while drinking the cooling liquid from the saucer. By the mid-nineteenth century glassmakers eliminated stippling, enlarged forms, and produced various shapes in a single pattern. A striking late example is our "thumbprint" compote, with its repeated convex oval motif (fig. 90).

Glass cased with different colors, with detailed cutting and engraving based on Bohemian styles, was made primarily in New England and New York. Even more dramatic changes in cut glass began about 1880, when technology allowed deep, elaborate allover cutting on heavy glass blanks, resulting in facets that refracted light. Called "rich cut" at the time, it is today often referred to as "brilliant cut."

The last decades of the nineteenth century witnessed an explosion in "art" glass. Designers experimented with different colors and surfaces,

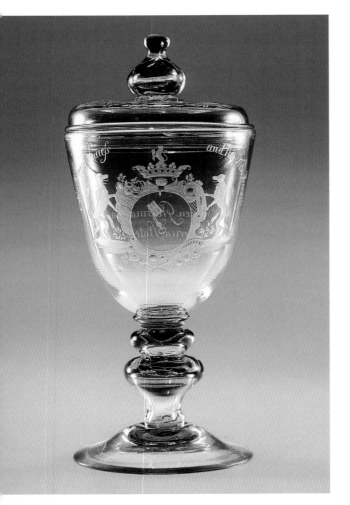

89. Covered goblet (*pokal*), New Bremen Glass Manufactory (1787–95) of John Frederick Amelung, New Bremen, Frederick County, Maryland, dated 1788. Blown and engraved glass. This covered goblet, the earliest-known dated example from the Amelung factory, may have been a gift from Amelung to his financial backers in Germany as a triumphant toast to his successful American glass factory. Rogers Fund, 1928 (28.52)

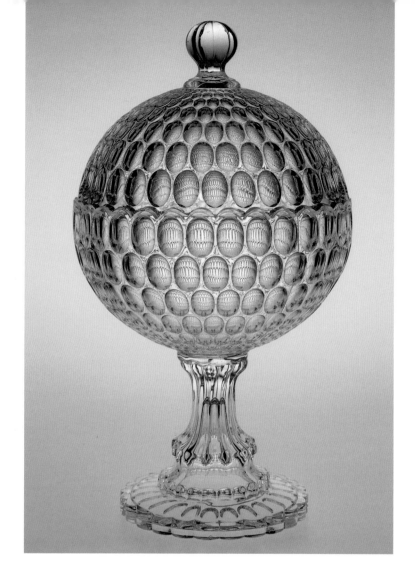

90. Covered compote, Bakewell, Pears and Company (1836–82), Pittsburgh, 1860–70. Pressed glass. The allover geometric pattern of convex ovals, or thumbprints, of this covered compote creates a highly reflective surface and an almost prismatic effect within the individual prints. This would have been the most impressive and most decorative element of a table service in the same pressed pattern. Gift of Mrs. Emily Winthrop Miles, 1946 (46.140.83a,b)

combinations of materials, and new shapes, many of which were derived from the fascination with the exotic styles of the Near and Far East that began in the 1870s. Some examples replicated semi-precious stones or Chinese porcelains. Others were decorated in enamel and gold. Appealing to purchasers, glassmakers gave their works foreign names such as "Burmese," "Crown Milano," and "Vasa Murrhina."

Louis Comfort Tiffany was the preeminent creator of art glass in America. Beginning in the late 1870s his work on windows led to new types of varicolored and textured glass, and in 1893, with the establishment of his own furnace at Corona, Queens, New York, he added blown glass to his repertoire. Many of his Favrile pieces, as he called them, were inspired by nature, including willowy flower forms, gourdlike shapes, and those shining with the iridescence of peacock feathers (fig. 91). Others derived their shimmering surfaces from long-buried ancient glass. The ingenious techniques, textures, and colors of these vases were among Tiffany's most creative achievements and led to international acclaim.

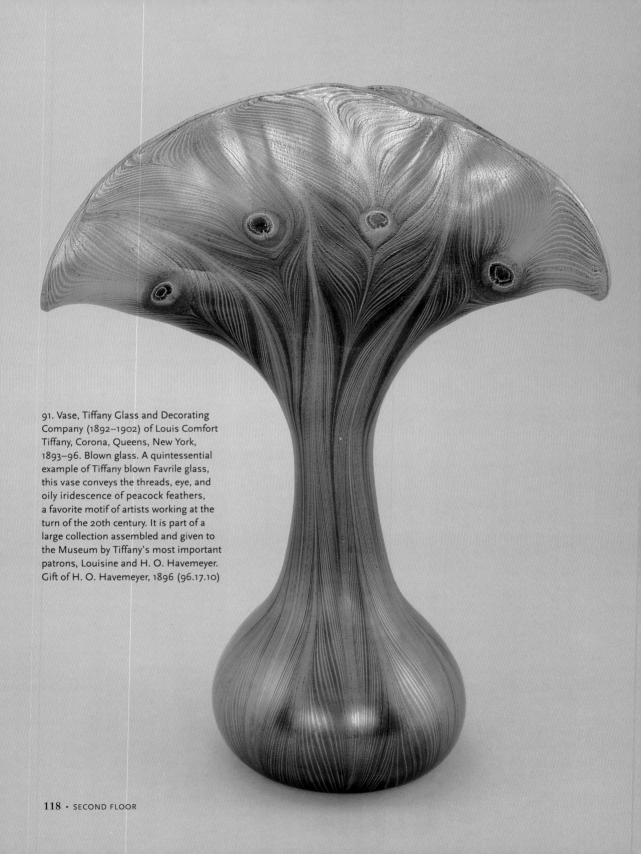

91. Vase, Tiffany Glass and Decorating Company (1892–1902) of Louis Comfort Tiffany, Corona, Queens, New York, 1893–96. Blown glass. A quintessential example of Tiffany blown Favrile glass, this vase conveys the threads, eye, and oily iridescence of peacock feathers, a favorite motif of artists working at the turn of the 20th century. It is part of a large collection assembled and given to the Museum by Tiffany's most important patrons, Louisine and H. O. Havemeyer. Gift of H. O. Havemeyer, 1896 (96.17.10)

Ceramics

During the eighteenth century fine English earthenwares and Chinese porcelains were found in most elite American households. Some pieces were decorated with the American market in mind, such as those with coats of arms or initials intended for a specific family. A Chinese plate bearing a painted badge of the Society of the Cincinnati is possibly from a service ordered by George Washington in 1786. Later, other motifs or scenes of American interest appeared on white earthenwares with underglaze-blue transfer-printed decoration imported from Staffordshire,

England, in the second quarter of the nineteenth century.

Unrefined red earthenware clays were plentiful in colonial America as was wood for the kilns, and ceramics were made from the earliest days of settlement. Utilitarian forms for food preparation, storage, and service predominated, and everyday items were often simply decorated. Ornamented low-fired red earthenwares made along the eastern seaboard varied widely in form and motif, from North Carolina's boldly patterned designs in colored slips to the soft, subtle

92. Pickle stand, by American China Manufactory (1770–72; Bonnin and Morris), Philadelphia, 1770–72. Porcelain. This pickle stand is the most ambitious, and the most expensive, of all the known forms surviving from the American China Manufactory. Known also as a sweetmeat stand, it was intended to hold various comfits, such as sugared fruits or nuts. Friends of the American Wing Fund, 1990 (1990.19)

glazes of northern New England. Among the most colorful are the plates and hollowware shapes by Pennsylvania German potters, with sprightly patterns related to frakturs and motifs on painted chests. These talented redware potters used either slip decoration—drawn in liquid clay with a quill—or sgraffito—scratched through the pale slip to reveal the red clay body. Bold Germanic motifs of birds, tulips, and vases, along with German inscriptions, harked back to the craftsmen's origins (fig. 93).

Stoneware, of finer, denser clays fired at much higher temperatures than earthenware, was made as early as the eighteenth century. This gray-bodied ware was enlivened by designs incised or painted in cobalt blue, such as seen on an example from the eighteenth-century pottery established at Corlear's Hook, in lower Manhattan, with boldly incised flowers and leaves in deep cobalt (fig. 94). Later pieces, particularly from New York State and Bennington, Vermont, show

93. Plate, by Henry Roudebouth (act. ca. 1790–1816), Montgomery County, Pennsylvania, 1793. Red earthenware. Decorative plates such as these were made either as special gifts or for important occasions and were not intended for everyday use. The bold peacock and stylized tulip are motifs popular in Pennsylvania German art. Gift of Mrs. Robert W. de Forest, 1933 (34.100.124)

capricious combinations of trees, birds, and animals painted freehand on the surface.

Refined thin-bodied earthenwares with molded decoration attempting to replicate English products displayed a lustrous brown glaze, sometimes mottled and streaked or mixed with metallic oxides for different colors. They took on a wide variety of forms, from picture frames to spittoons, and many of them, such as the popular hound-handled pitcher, were based on English prototypes.

Porcelain required more specialized clays, equipment, and training than earthenware. The examples produced in Philadelphia by Goussé Bonnin and George Anthony Morris between late 1770 and 1772 stand out as extraordinary successes amid the continuous failures of colonial manufacturers. Their few surviving pieces—shell pickle stands (fig. 92) and openwork baskets—virtually duplicated English shapes; and their underglaze blue-and-white painted or transfer-printed designs were in the prevailing Rococo and chinoiserie modes. By the early nineteenth century French styles were in vogue, and masterful vases and pitchers in classical shapes with polychrome

94. Jar, probably by Thomas Commeraw (act. 1797–1819) or David Morgan (act. 1797–1802), New York, 1797–1819. Stoneware. Open-mouthed jars of this kind were produced in quantity for use in the kitchen or pantry as storage receptacles for preserves, cream, butter, and other foods. Rogers Fund, 1918 (18.95.13)

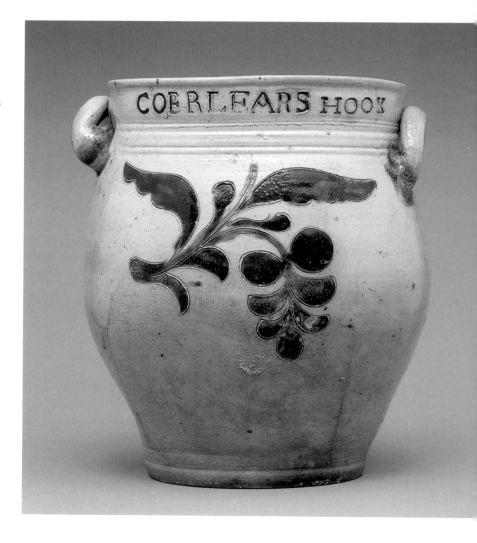

painted and gilded ornament were produced by William Ellis Tucker's factory, established in 1826 in Philadelphia.

By the mid-nineteenth century technological advances and increased mechanization enabled Americans to produce porcelain more economically and in different grades and bodies. Many pieces featured relief ornament akin to the Rococo Revival style then in vogue and in contrast to the grace of earlier forms. Both English-inspired designs and distinctly American images were used.

The 1876 Centennial Exhibition in Philadelphia was a watershed event for American ceramics. Porcelain manufacturers, eager to make an impressive showing, hired sculptors to design exhibition pieces. Karl L. H. Müller was responsible for major examples from the Union Porcelain Works in Greenpoint, Brooklyn. His large Centennial

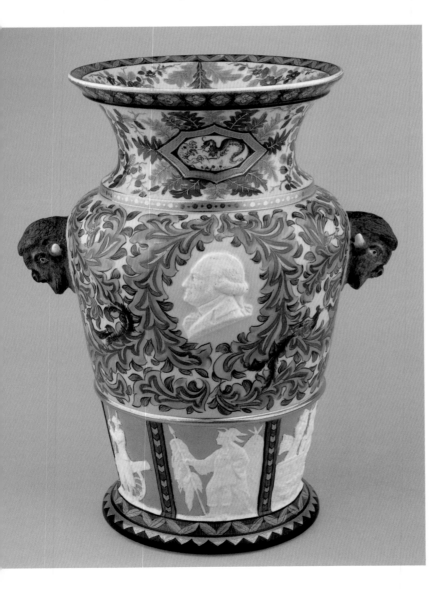

95. Century vase, designed by Karl L. H. Müller (1820–1887), made by Union Porcelain Works (1863–ca. 1922), Greenpoint, New York, 1877. Porcelain. This vase incorporates motifs emblematic of America in celebration of the nation's centennial: a bisque profile portrait of George Washington in relief on either side; North American bison heads as handles; and six biscuit relief panels around the base depicting different events in American history. Friends of the American Wing Fund, 1987 (1987.12)

column and Century vase were impressive celebrations of the nation's one-hundredth birthday. The vase, also manufactured in a smaller version (fig. 95), featured vignettes of American history and other patriotic motifs, sometimes embellished with lavish painting. The years after the Centennial saw the production of eggshell-thin wares that emulated the famed Irish Belleek, much of it turned out by firms in Trenton, New Jersey, which became America's leading porcelain center. Other examples of the period displayed rich ground colors and gold decoration that vied with the best of their transatlantic rivals such as Royal Worcester and Crown Derby.

The Centennial also introduced contemporary French and English art wares, as well as those from Japanese potteries. This prompted women to begin decorating ceramic "blanks," and their work became the catalyst for the Art pottery movement. Inspired largely by English reform movements in the second half of the nineteenth century, American Art pottery was guided entirely by the aesthetic intent of its designer and makers. Ceramics varied widely in fabrication and ornamentation and included both pieces made in studios, such as those by George E. Ohr and Adelaide Alsop Robineau (fig. 96), as well as products of factories like Rookwood Pottery. Some examples featured painted decoration executed in a naturalistic manner, as on the Rookwood vase with its meticulously rendered peacock feather; others relied on form and colored glazes for aesthetic effect, as does the twisted double-gourd shape by Ohr or the Chinese *sang de boeuf* red vase by Chelsea Keramic Art Works. Their diversity makes these ceramics very appealing today.

96. Coupe, by Adelaide Alsop Robineau (1865–1929), Syracuse, New York, 1924. Porcelain. A virtuosic work, this delicate coupe is one of only two surviving eggshell porcelains by Robineau (she destroyed all imperfect works). Its shape and soft palette of subtle shades of yellow and blue were inspired by Japanese forms. Purchase, Edward C. Moore Jr., Gift, 1926 (26.37)

Paintings and Sculpture

Colonial Portraiture

A number of artists were active in several of the colonies during the 1600s. Their works were hardly distinguishable from paintings brought from overseas—provincial adaptations of fashionable European portraits. There was little or no specialization in the profession in early colonial America. The artist, with or without formal training, might well turn his hand to producing shop signs or figureheads, or decorations for homes. It was not until the mid-eighteenth century that any painter in America managed to live solely on his earnings as an artist.

By the beginning of the eighteenth century, portraiture was firmly established in colonial cities as an art form embodying the ambitious ideals and tastes of a wealthy society, even if it fell far short of European standards of professional accomplishment. The arrival of Scottish émigré John Smibert in Newport, Rhode Island, in 1728 changed everything. An artist of considerable skill and the first academically trained painter to work in the colonies, Smibert executed more than 250 likenesses over the next seventeen years. He completed most of them during his first decade in New England as he satisfied the colonists' pent-up desire for fine British-style portraits. His depictions of Mr. and Mrs. Francis Brinley and their son Francis, begun in May 1729, shortly after Smibert settled in Boston, epitomize the canvases that ensured his success (fig. 97). Crisply painted and filled with attributes of affluence and character, such works exhibited the materialism that the colonists embraced and set a new standard for excellence in American painting.

Smibert's success inspired other British-born portraitists to bring their talents to the colonial American marketplace. These artists, including Joseph Blackburn and John Wollaston, easily attracted commissions from the merchant elite of Boston and New York, who were eager for likenesses executed in the flamboyant Rococo style then fashionable in England. As is apparent in his portrait of Mrs. Samuel Cutts (fig. 98), Blackburn

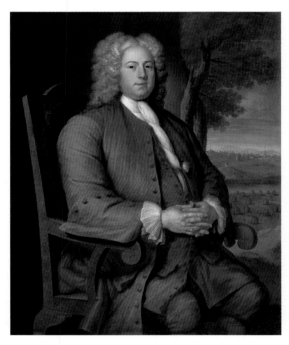

97. John Smibert (1688–1751). *Francis Brinley*, 1729. Oil on canvas. Smibert hoped that his success with this portrait would bring him commissions from other members of Boston's elite. The artist took extraordinary care in executing it, especially in rendering Brinley's clasped hands, a complicated pose that he employed in this instance and never again. Rogers Fund, 1962 (62.79.1)

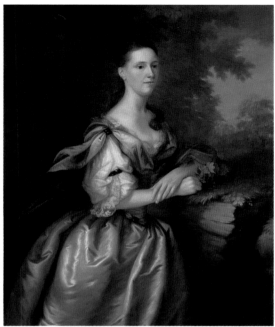

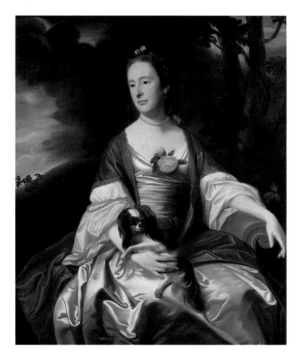

98. Joseph Blackburn (active 1752–ca. 1778). *Mrs. Samuel Cutts (Anna Holyoke)*, ca. 1762–63. Oil on canvas. Blackburn willingly enhanced his sitters' appearances with stylish trappings and clever gestures. Here the artist endowed Anna Holyoke Cutts with fashionably rouged cheeks and an elaborate dress in the Van Dyck style and cast her as a modern version of Flora in a woodsy outdoor setting. Bequest of Clarence Dillon, 1979 (1979.196.2)

99. John Singleton Copley (1738–1815). *Mrs. Jerathmael Bowers (Mary Sherburne)*, ca. 1763. Oil on canvas. Copley offered his clients portraits as realistic as they were artificial. Mary Bowers opted for a depiction that combined perfect fidelity to her facial likeness with absolute fantasy for the rest: the costume, setting, and dog are copied bit for bit from the British artist Sir Joshua Reynolds's esteemed 1759 portrait of Lady Caroline Russell. Rogers Fund, 1915 (15.128)

excelled at meticulously rendering silks, satins, and lace, skills he had learned as a drapery painter in London.

Blackburn's way with fabrics left a strong impression on the young John Singleton Copley, America's first native-born artist of significant promise. All the more astounding for his lack of professional training, Copley surpassed Smibert and Blackburn in skill and ingenuity. He took his cue from the works of these artists and studied mezzotints after contemporary British canvases to better serve his discriminating Anglophile clients. Before long, as a result of his innate ability to handle paint, Copley was producing portraits more accomplished than any he had ever seen and was eclipsing any previously executed in America. His career was an absolute triumph. His clients came from throughout New England: women wishing to be fashioned as noblewomen, as in the case of Mary Sherburne Bowers (fig. 99), and men appreciative of his gift for conveying aristocratic elegance and gentility.

Early National Portraiture and History Painting

By the time the American Revolution began in 1775, America's two greatest native-born artists had moved to England in pursuit of professional education and patronage, never to return. John Singleton Copley's artistic facility took him in 1774 to Rome and from there to London, where he quickly and apparently effortlessly adopted a painterly style in keeping with the prevailing English taste, as is abundantly evident in his portrait of Midshipman Augustus Brine (fig. 100). While Copley had found a successful career as a portraitist and history painter, his exact contemporary, Benjamin West, had been named history painter to King George III. West left his native

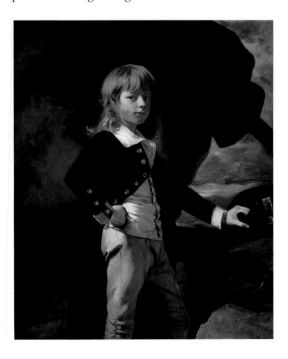

Pennsylvania for Europe in 1760. The first American artist to study in Italy, he toured the Continent until 1763, when he settled in London. Aside from his own outstanding productions, West played a crucial role in welcoming any and all American artists who came to London seeking instruction. Matthew Pratt, the first to arrive, paid homage to his mentor in *The American School* (fig. 101). This conversation piece, a group portrait with narrative elements, portrays West teaching his students, including Pratt himself at his easel, in one of the paneled and brocaded rooms of West's house.

Among the next group of artists to visit West was Charles Willson Peale, who studied in London between 1767 and 1769 before returning to the colonies. An artist, inventor, scientist, and writer, Peale fought in the Revolutionary War and in 1779 accepted a commission from the Supreme Executive Council of Pennsylvania for a full-length depiction of his commander in chief, General George Washington (fig. 102). He subsequently produced many versions of this work, some with the assistance of his brother James, a noted miniaturist and still-life painter.

In the early years of the American republic two artists were ascendant: Gilbert Stuart in portraiture and John Trumbull in history painting.

100. John Singleton Copley (1738–1815). *Midshipman Augustus Brine,* 1782. Oil on canvas. Upon arriving in London, Copley traded his crisp American manner for a painterly English style in which general effect supersedes specific details. Here, for example, the anchor, barely distinguishable from the rocky promontory, and the storm-tossed ship, which is merely suggested, firmly link the boy to the sea. Bequest of Richard De Wolfe Brixey, 1943 (43.86.4)

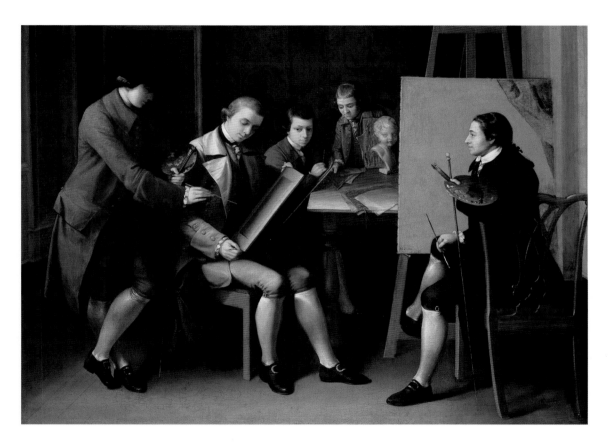

Stuart, neither well-born nor formally educated, was the personal and artistic antithesis of Trumbull, who was the son of a Connecticut governor and a Harvard graduate. They were in West's London studio together for a period of about a month in 1780, after which Stuart moved on to refine his skills as a fashionable portraitist and Trumbull remained to nourish his ambition to become a history painter. Stuart was witty, secular,

gregarious, and a bon vivant; it was not surprising that he would shun the ideological preachiness of history subjects and devote himself instead to revelations of human character. A brilliant artist who possessed enormous natural talent, Stuart could adapt his style to suit his subjects. He was acclaimed in London for his grand full-length likenesses, such as that of Captain John Gell (fig. 103). Upon his return to America he won

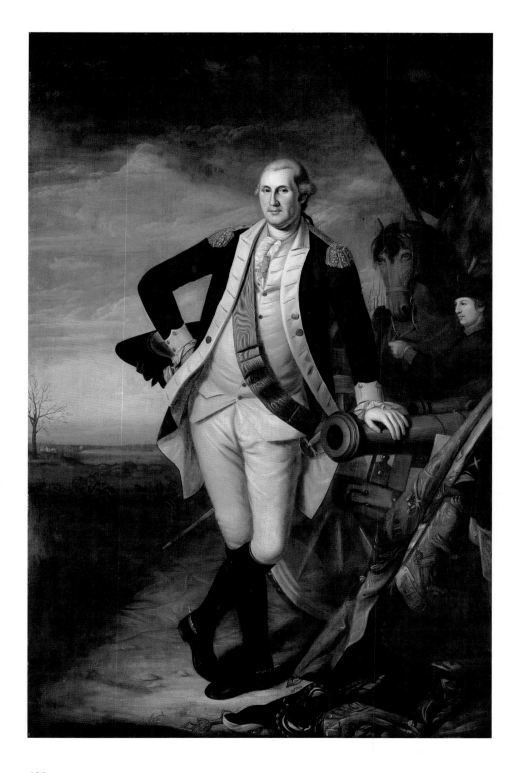

favor with remarkably forthright portraits of New Yorkers, including Matthew Clarkson (ca. 1794). Stuart also worked in Washington, Boston, and Philadelphia, where he fulfilled his ultimate goal: portraying George Washington. He painted several bust-length and full-length likenesses of the first president, all of which capture the humanity, loftiness, and modesty of the nation's founding father and greatest hero.

Trumbull's most important contributions to American art were the Revolutionary War scenes he began to paint in England between 1786 and 1788. About the same time he also depicted a recent British military victory,

Left

102. Charles Willson Peale (1741–1827). *George Washington*, ca. 1780. Oil on canvas. Of the many versions of this monumental portrait by Peale, this is the only one in which Washington wears his state sword and his blue silk general's sash. The desolate landscape represents the Delaware River at Trenton, New Jersey, where Washington won a major victory. Gift of Collis P. Huntington, 1897 (97.33)

Right

103. Gilbert Stuart (1755–1828). *Captain John Gell*, 1794. Oil on canvas. Stuart conveyed Gell's heroism with theatrical expression, turning a real character into an ideal one through the judicious use of fine strokes and bravura sweeps. The painting suggests spontaneity in execution but is in fact a work of considerable strategy. Purchase, Dorothy Schwartz Gift, Joseph Pulitzer Bequest, and 2000 Benefit Fund, 2000 (2000.450)

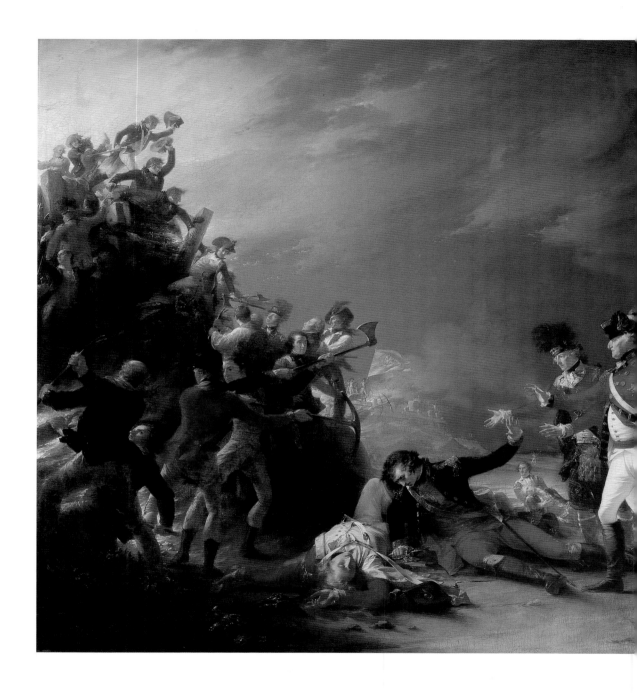

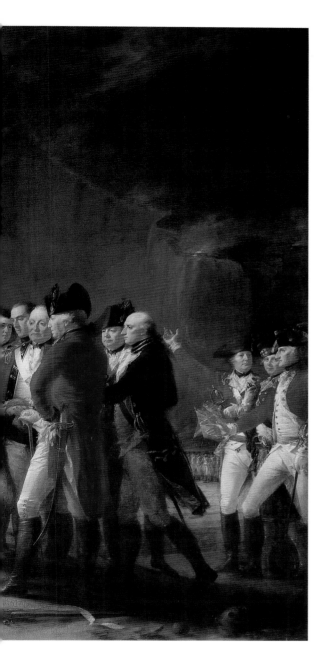

104. John Trumbull (1756–1843). *The Sortie Made by the Garrison of Gibraltar,* 1789. Oil on canvas. By arranging his composition in three parts, Trumbull requires viewers to witness simultaneously the fray of the attack at the left, the noble death of the Spanish leader in the center, and the magnanimity of the commanding British officers at the right. Purchase, Pauline V. Fullerton Bequest; Mr. and Mrs. James Walter Carter and Mr. and Mrs. Raymond J. Horowitz Gifts; Erving Wolf Foundation and Vain and Harry Fish Foundation Inc. Gifts; Gift of Hanson K. Corning, by exchange; and Maria DeWitt Jesup and Morris K. Jesup Funds, 1976 (1976.332)

The Sortie Made by the Garrison of Gibraltar (fig. 104). Trumbull may have seen the picture as a way of redressing the offense his paintings of the American Revolution had given in England, yet the choice of subject also deliberately put him in direct competition with Copley, who was then at work on an image of the same event. Trumbull imbued the *Sortie* with moral purpose and didactic intent, as he did each of his history subjects. In this case, the specific British victory over the Spanish is idealized in the figural rhetoric: the victor gallantly offers his assistance, which is stoically refused by the defeated and dying officer. Trumbull has created a visual sermon on heroism as a virtue and the disciplinary code of gentlemen, regardless of nationality or position.

Provincial Portraiture in the Early National Era

In the post-Revolutionary period, Charles Willson Peale was the ablest and most influential of America's painters. A man of wide interests and knowledge, Peale adapted Copley's compositional formulas for portraits of his Maryland and Pennsylvania sitters by divesting them of their aristocratic English character. He took great interest in the scientific study of physiognomy and firmly believed that a person's inner character and quality of mind are revealed in his or her facial features and expressions. Peale's portraits, such as that of Mrs. Samuel Mifflin (fig. 105), offer realistic human visages meant to evoke philosophical contemplation. Peale's rather sedate style appealed greatly to his rural clients.

In Connecticut, the most successful painter during the Early National era was Ralph Earl, who studied with Benjamin West in London and traveled extensively through England. Although Earl acquired a graceful and fashionable style, he quickly disposed of it upon his return to America in favor of a restrained manner that better suited the modest taste of the Connecticut country gentry. Earl preferred full-length portraits, and at his best, as in his well-known image of the New Milford dry-goods merchant Elijah Boardman (fig. 106), he used his considerable powers of coloring and arrangement to create persuasive likenesses in highly complex and ambitious settings. Earl's influence on contemporary painters of Connecticut and Massachusetts was considerable. For example, Reuben Moulthrop's familiarity with the conventions of English portraiture, as seen in his portraits of Mr. and Mrs. Job Perit (1790), probably came from Earl.

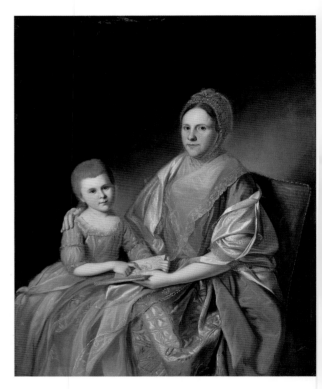

105. Charles Willson Peale (1741–1827). *Mrs. Samuel Mifflin and Her Granddaughter Rebecca Mifflin Francis*, 1777. Oil on canvas. Mrs. Mifflin is shown instructing her granddaughter with the book *Emblems, for the Entertainment and Improvement of Youth* (1735). They study the page illustrating conjugal concord, filial love, and love of virtue. Egleston Fund, 1922 (22.153.2)

106. Ralph Earl (1751–1801). *Elijah Boardman*, 1789. Oil on canvas. Bolts of plain and patterned textiles—including one with a prominently displayed British tax stamp—reveal Boardman's profession as a dry-goods merchant, just as the richly bound volumes in his counting desk attest to his learnedness. Bequest of Susan W. Tyler, 1979 (1979.395)

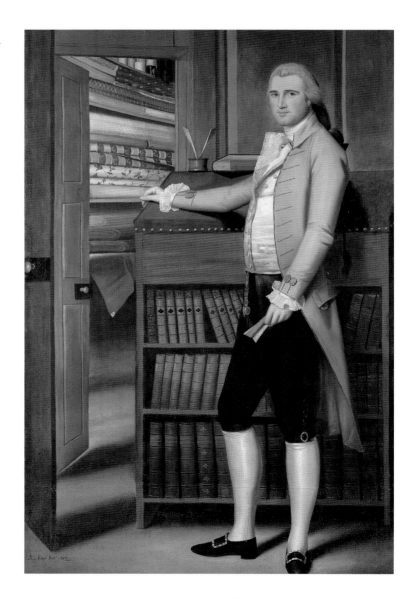

Grand Manner and Fancy Portraiture

GALLERY 218

During the first decades of the nineteenth century, Gilbert Stuart remained a paragon because most American artists were still portraitists. His professional independence and success added a much-needed measure of prestige to the otherwise taxing business of taking likenesses. His painterly style prevailed in the hands of younger highly sought-after artists, such as Samuel F. B. Morse and Thomas Sully. A Massachusetts-born portraitist and history painter, Morse arrived in New York City in 1824 as if on a crusade to improve American taste. He hosted social gatherings for artists, helped colleagues forge relationships with potential patrons, founded the National Academy of Design, and lectured on the higher branches of art. Morse stopped painting in about 1836 to 1837 and concentrated on scientific pursuits. By this time the younger generation of artists had benefited from his earlier efforts. His extraordinary portrait of his seventeen-year-old daughter, Susan Walker Morse, as a modern muse (fig. 107)—perhaps her father's inspiration—was painted just before he gave up the brush.

Over the course of his long and fruitful career, Sully painted more than 2,500 flattering likenesses; most of them were bust-length works but many were full-length, grand manner images of the sort popular among the British elite. The highlight of Sully's career was perhaps his portrait of Queen Victoria, painted in 1838 (private collection), just before her coronation. The Museum owns the artist's captivating oil study (fig. 108), the canvas he carried back and forth to Buckingham Palace for sittings. In this image the much-portrayed queen appears elegant and regal, yet informal and girlish. The likeness seems a rather rakish American response to the decorously conventional portraits painted by Sully's obliging British contemporaries.

The best American portraitists of the Victorian era aimed, from time to time, for something more elevated than straightforward realistic likenesses. Inspired by the example of the British painter Sir Thomas Gainsborough, they produced fancy pictures, that is, depictions not of individuals but of social types. The term *fancy* was also applied to portraits that contained poetic or provocative elements rather than identifying attributes. For example, G. P. A. Healy posed the confident, graceful, and stylish Euphemia White Van Rensselaer (1842) against a view of the Roman campagna. In Charles Cromwell Ingham's *Little Girl with Flowers (Amelia Palmer)* (1830), the child appears as a benevolent wood nymph in an idyllic forest glen. *The Flower Girl* (fig. 109), also by Ingham, is a work of great refinement within the genre of fancy portraiture. Its exquisite execution, for which the artist was famous, here produces a chromatic lushness that elevates the literal subject—a street vendor—to the level of allegory.

107. Samuel F. B. Morse (1791–1872). *Susan Walker Morse (The Muse)*, ca. 1836–37. Oil on canvas. Morse depicts his daughter as the personification of drawing or design by giving her attributes of the artist's craft: a large folio in which she sketches, a magnifying glass on a long ribbon, and a classical vase that suggests inspiration from antique sources. Bequest of Herbert L. Pratt, 1945 (45.62.1)

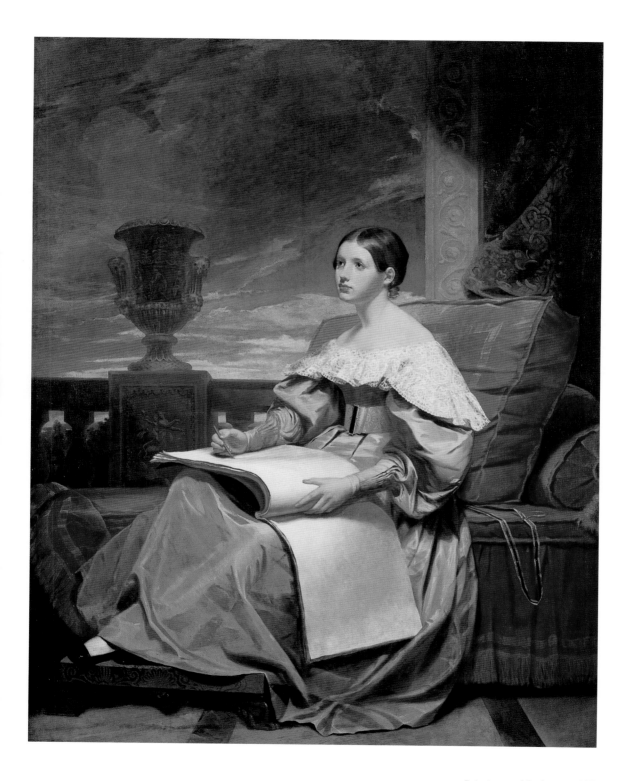

109. Charles Cromwell Ingham (1796–1863). *The Flower Girl,* 1846. Oil on canvas. The gesture of proffering blossoms links the portrait to personifications of Flora, the goddess of flowers. In American books on the language of flowers, fuchsias symbolize love or, more specifically, frustrated love. Gift of William Church Osborn, 1902 (02.7.1)

108. Thomas Sully (1783–1872). *Queen Victoria,* 1838. Oil on canvas. Sully's study of Queen Victoria, painted just before her coronation, is unique in its evocation of her beauty and sensuality; no English artist would have depicted her bare shouldered. Bequest of Francis T. S. Darley, 1914 (14.126.1)

Narrative Subjects

Although portraiture remained the dominant strain in American painting through the 1830s, the artistic horizon broadened dramatically during the early decades of the nineteenth century. Annual shows at newly established academies and other cultural institutions and art galleries induced artists not only to submit their best works for public display but also to create paintings specifically for exhibition, without commissions. By the late 1820s New York overflowed with still lifes, landscapes, portraits, and narrative scenes, shown not only at new art institutions but also at myriad other venues, from dry-goods shops to churches. A new class of patron eager to own humorous pictures of domestic life and idyllic landscapes entered the market. Moreover, critical coverage of exhibitions increased and writers extolled genre and landscape painting as the result of an effort to create a truly national art.

William Sidney Mount began his career as a portraitist but swiftly changed his course and became America's most successful painter of narrative scenes. Though interested in Dutch genre pictures, which he would have seen in New York private collections, he resisted study abroad and derived his subjects from rural life on his native Long Island. Mount nonetheless managed to transcend the manifest content of his pictures to address the social and political realities of the time. *The Raffle (Raffling for the Goose)* (1837), showing an impromptu lottery, is Mount's good-humored allusion to the food shortages brought on by the financial panic of 1837. *Cider Making* (fig. 110) is a picturesque but accurate depiction of country life in which virtually every element is rich in political subtext. Mount's close contemporary

Francis William Edmonds, who pursued simultaneous careers in art and banking, painted similarly complex narrative scenes, such as *The New Bonnet* (1858), but with a more anecdotal and moralizing approach. Edmonds took his subjects from literature as well as from contemporary life, and his compositions variously reveal the influence of seventeenth-century Dutch genre painting and the works of the Scottish artist Sir David Wilkie, who was active mainly in London during the early nineteenth century.

George Caleb Bingham made a brilliant career of recording scenes in his native Missouri and sending them regularly to New York, where audiences and patrons were eager for views of life in the western states. *Fur Traders Descending the Missouri* (fig. 111) depicts a then-vanished world of innocence and tranquility on the American frontier. To heighten the impact of the canvas at exhibition, Bingham titled it *French-Trader— Half-breed Son* to identify the racial character of his pioneers. It is a reassuring vision; the delicate coloristic effects and stillness suggest a moment frozen in time, and the traders show no sign of fear as they float downstream in the warm morning light with their furs safely stowed.

Like mid-nineteenth-century figure painters, American sculptors favoring the Neoclassical style preferred narrative subjects, most often drawing on ideal themes from mythology, literature, and history. Edward Sheffield Bartholomew and Thomas Crawford both studied first in New York and then relocated to Rome to establish their careers in a milieu that provided an abundant supply of marble, trained craftsmen and carvers, and the inspiration of antique and

110. William Sidney Mount (1807–1868). *Cider Making*,
1840–41. Oil on canvas. With great specificity, Mount mod-
eled each figure as an allusion to the "hard-cider" presidential
campaign of 1840, in which the Whigs defeated the Jackson-
ian Democrats by promoting their candidate William Henry
Harrison as a common man who would rather drink cider in
a cabin than move to the White House. The cider mill, which
Mount sketched, existed at Setauket, Long Island, until the
early 20th century. Purchase, Charles Allen Munn Bequest, by
exchange, 1966 (66.126)

111. George Caleb Bingham (1811–1879). *Fur Traders Descending the Missouri*, ca. 1845. Oil on canvas. This painting, rendered in marvelous opalescent tonalities, has a deceptively simple subject: a man and his son traveling in a dugout canoe along a tranquil river, with a wild cub they will probably sell for meat. Bingham draws viewers into this idyllic scene of the West by having the figures look directly at them. Morris K. Jesup Fund, 1933 (33.61)

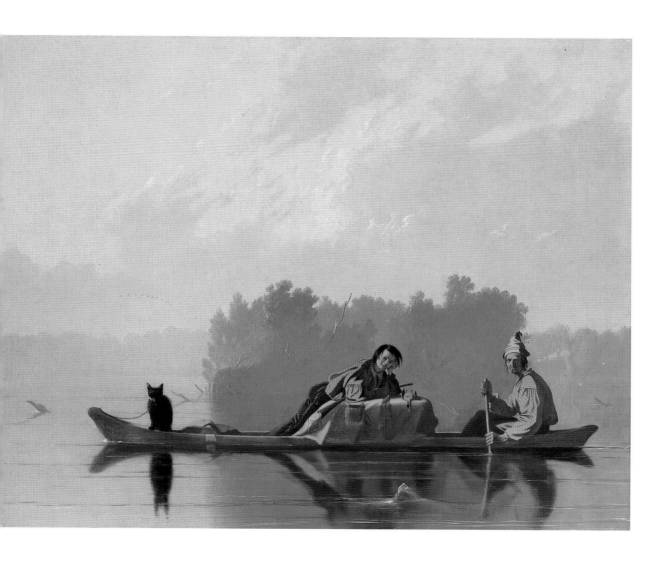

Renaissance art. Bartholomew excelled in relief sculpture of biblical and classical subjects. His *Blind Homer Led by the Genius of Poetry* (fig. 112) has plausible autobiographical references because Bartholomew, who was color-blind and lame, may have identified with Homer, who was said to have been blind. Crawford's *Genius of Mirth* (1842; MMA carving, 1843) is a fanciful representation of a boy making merry, clapping his cymbals and dancing. Such joyous childhood themes were popular with American artists and patrons alike.

112. Edward Sheffield Bartholomew (1822–1858). *Blind Homer Led by the Genius of Poetry*, 1851. Marble. This relief is a stylistic pastiche: its arched upper edge imitates Greek grave stelae while its crisply modeled forms recall the work of early-19th-century European sculptors Antonio Canova and Bertel Thorvaldsen. Purchase, Morris K. Jesup Fund, and Gift of William Nelson, by exchange, 1996 (1996.74)

Early Hudson River School Paintings and Neoclassical Sculpture

Beginning in the 1820s, American artists celebrated a wilderness that had been ignored by Stuart, Trumbull, and other early portraitists and history painters. These years saw the rise of a significant tradition in landscape painting, notably in the canvases of an unorganized fraternity of painters known as the Hudson River School. In their meticulously detailed yet lyrical pictures of the hills and lakes, the valleys and rivers of their still semiwild continent, these men faithfully portrayed the beauty and grandeur of the American land, as Washington Irving, James Fenimore Cooper, and William Cullen Bryant were celebrating it in their writings.

Thomas Cole early developed into a superb landscapist whose work had a strong influence on this group of painters. Cole, who wandered the Ohio and Pennsylvania frontiers after emigrating to America from England in 1818, was the first painter to portray the American landscape in dramatic terms that expressed its original wild state. In his *View from Mount Holyoke, Northampton, Massachusetts, after a Thunderstorm—The Oxbow* (fig. 113), Cole represents the wilderness on the left as the green forest, with a lightning-struck tree bending beneath a departing storm. Against that mountainous, howling woodland he juxtaposes the broad, cultivated valley of the Connecticut River in the breaking sunshine at the right. Cole contrasts not only the savage and the pastoral landscape but also, poetically, America's untamed past and its agrarian present. *The Oxbow* surely had special significance for the artist, who—in this rare instance—painted himself in the lower center near the closed umbrella, pausing from his field-sketching to turn and regard us.

Cole's deep affection for nature impelled him to leave New York City and settle in the village of Catskill, New York, at the foot of his beloved mountains. In *View on the Catskill, Early Autumn* (fig. 114), he recasts the surrounding countryside as an arcadian bower, with the Catskill Creek winding toward the mountains beyond and umbrageous trees arching over a mother and her child in the foreground.

Asher B. Durand was directly inspired by Cole to become a landscape painter. When Cole died in 1848, Durand succeeded him as a guiding light for younger artists. Some of his pictures, such as *Landscape—Scene from Thanatopsis* (1850), closely resemble Cole's arcadian visions and incorporate scenic motifs Durand had sketched on a trip to Europe in the 1840s. In his mature pictures, however, Durand became renowned for intimate, sometimes haunting, American forest interiors such as *In the Woods* (fig. 115). Inspired by the outdoor studies done by the British master John Constable during the 1820s and the revisionist texts on landscape art written by the English critic John Ruskin in the 1840s, Durand pioneered the practice of making detailed, on-the-spot oil sketches of rocks and trees. This practice reveals itself strikingly in the textured surfaces of forms in *In the Woods* as contrasted with the more formulaic elements in pictures such as *The Beeches* (1845), which Durand completed a decade earlier.

Included with the landscapes of the early Hudson River School artists are those of several of their predecessors and contemporaries, such as Thomas Doughty and Joshua Shaw, both of whom exploited more generalized styles that were indebted to British landscape painters such as Richard Wilson.

113. Thomas Cole (1801–1848). *View from Mount Holyoke, Northampton, Massachusetts, after a Thunderstorm—The Oxbow,* 1836. Oil on canvas. The view shows the picturesque loop in the Connecticut River that was a popular sight-seeing attraction when Cole and other artists portrayed it. Gift of Mrs. Russell Sage, 1908 (08.228)

114. Thomas Cole (1801–1848). *View on the Catskill, Early Autumn*, 1837. Oil on canvas. From the vantage point of his home village of Catskill, New York, Cole represents the eastern Catskill Mountains, where he sketched for the paintings that first established his name. Gift in memory of Jonathan Sturges by his children, 1895 (95.13.3)

Like the Hudson River School paintings, the Neoclassical marbles in this gallery combine both interpretive and transcriptive approaches to subject matter. Thomas Crawford and Hiram Powers worked in Italy and gained international reputations. Crawford's *The Babes in the Wood* (fig. 116), a veiled reference to the fragility of life, draws on an old English ballad that equates sleep with death. Such a tranquil scene typifies Neoclassical funerary monuments of the period. Powers's *Fisher Boy* (1841–44; MMA carving, 1857) is one of the few representations of a male nude in nineteenth-century American sculpture. Harriet Hosmer led a talented group of Rome-based women sculptors. Hosmer's *Daphne* (1853; MMA carving, 1854)

sinks away into laurel leaves, a reference to her flight from Apollo. Henry Kirke Brown's *Thomas Cole* (by 1850) and Edward Augustus Brackett's *Washington Allston* (1843; MMA carving, 1843–44) portray venerated artists and reveal the tendency of American sculptors of the period to conjoin natural likenesses with classical devices, for *Cole* a drape and for *Allston* a herm form.

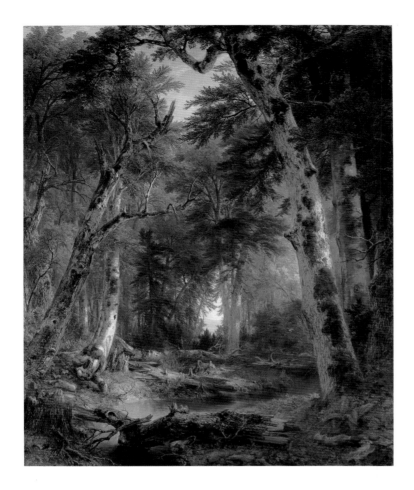

115. Asher B. Durand (1796–1886). *In the Woods,* 1855. Oil on canvas. For all the naturalism the artist brought to this picture, he reminds his viewers that America's antique ruins, unlike Europe's classical remains, are her virgin forests. Gift in memory of Jonathan Sturges by his children, 1895 (95.13.1)

116. Thomas Crawford (1813?–1857). *The Babes in the Wood,* ca. 1850; this carving, 1851. Marble. The boy and his younger sister slumber eternally as death has come to them without melo-drama or anguish. The painstakingly rendered details, from the leaves and acorns to the boy's patterned jacket, are characteristic of mid-19th-century American marbles. Bequest of Hamilton Fish, 1894 (94.9.4)

Late Hudson River School Paintings and Early Bronze Sculpture

Thomas Cole and Asher B. Durand inspired a younger generation of landscape painters, among them Frederic Edwin Church. Church's striking *The Heart of the Andes* (fig. 117), considered his masterpiece, is installed in a grand curtained frame like the one in which he originally exhibited it. One of Cole's few pupils, Church was stimulated by natural science and expeditionary narratives to seek subjects beyond the nation's borders—particularly in South America. In *The Heart of the Andes* he included all of Earth's climatic zones—torrid, temperate, and frigid—as they might be observed from the lowland jungles to the snowy summits of the Andes near the equator. Church's expression of vast space in the painting's background is balanced by his minute rendering of tropical flora and fauna in the foreground, where tree ferns, orchids, air plants, morning glories, birds, and butterflies can all be identified.

Opposite Church's picture is *The Rocky Mountains, Lander's Peak* (fig. 120), by America's most renowned artist of the West, Albert Bierstadt. Having studied in Düsseldorf and traveled in Europe, Bierstadt was provoked by Church's ambitious landscapes of South America to visit the Rocky Mountains. His first trip was in 1859 with a government surveying expedition led by Colonel Frederick W. Lander. Already fluent in portraying the Swiss Alps, Bierstadt emphasized the dizzying height of the mountains but did not neglect his own brand of foreground detail: a tribe of Shoshone Indians gathered around the spoils of a recent hunt. Bierstadt, like Church, showed his large paintings in theatrical settings, charged admission to see them, and profited as well from sales of engraved reproductions.

American sculptors of the period were also fascinated by Native American culture and western wildlife. John Quincy Adams Ward's *Indian Hunter* (fig. 121) is a compelling portrayal of a lithe young brave restraining an eager dog with his right hand while grasping a bow and arrow in his left. The highly naturalistic human and canine features distinguish the composition from contemporary Neoclassical marbles. This finely wrought statuette with its impressive textural variety is one of the earliest examples of American bronze casting, an industry that developed beginning in the early 1850s.

John Frederick Kensett, a close associate of Durand's, typified the majority of younger Hudson River School artists who painted subjects that gratified an emerging American vacationing class after midcentury. His masterpiece, *Lake George* (fig. 118), the serenity of which contrasts markedly with the dramatic terrain and atmosphere in landscapes by Cole, Church, and Bierstadt, conveys not merely the artist's even temperament but the expectations of his patrons for soothing reminders of summer resorts. Similarly, Sanford Robinson Gifford's *Kauterskill Clove* (fig. 119), painted while the artist was on leave from National Guard duty during the Civil War, idealizes a Catskill Mountain tourist site first painted by Cole nearly four decades earlier. In place of the limpid air and placid waters fashioned by Kensett at Lake George, however, Gifford suffused the forested depths of Kauterskill Clove with a solar glow and a violet atmosphere, which may suggest his and his country's nostalgia for the waning of the wilderness. As it did for Kensett and Gifford, light became the virtual subject for

many later Hudson River School artists and their contemporaries, as can be seen also in the luminous works of Fitz Hugh Lane and Martin Johnson Heade. In their preoccupation with light, mid-nineteenth-century landscape painters articulated simultaneously their interest in naturalistic effects and their perception of the spiritual essence of nature.

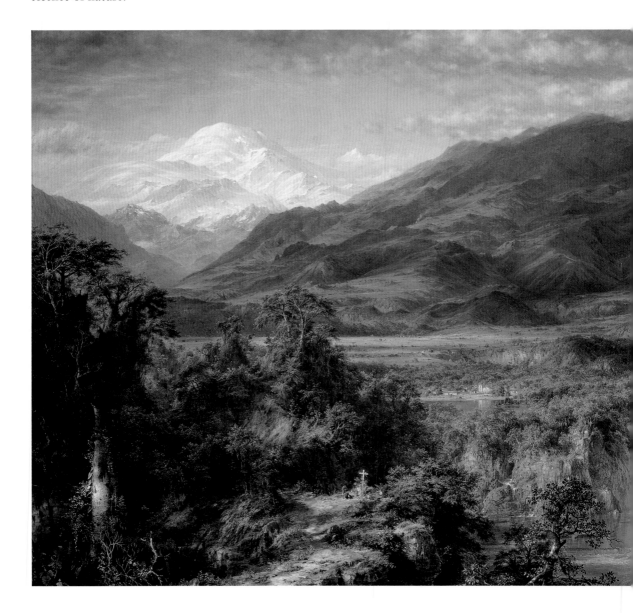

117. Frederic Edwin Church (1826–1900). *The Heart of the Andes,* 1859. Oil on canvas. Church combined in this painting sketches he made of localities in Ecuador more than one hundred miles apart. Bequest of Margaret E. Dows, 1909 (09.95)

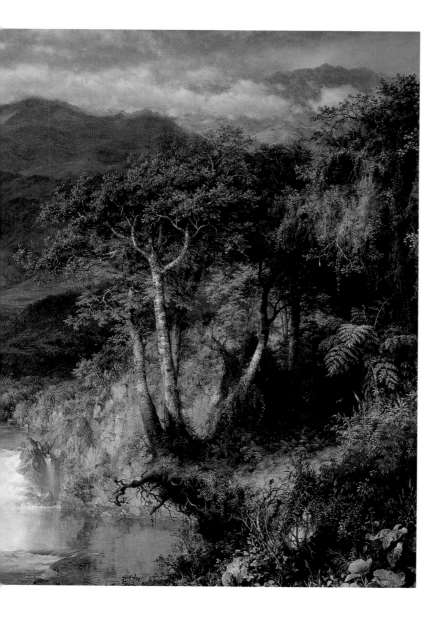

118. John Frederick Kensett (1816–1872). *Lake George*, 1869. Oil on canvas. Looking northeast from an island near Bolton's Landing, New York, Kensett simplified the view of Lake George and its neighboring peaks to achieve this grand and serene impression of the popular Adirondack resort. Bequest of Maria DeWitt Jesup, from the collection of her husband, Morris K. Jesup, 1914 (15.30.61)

119. Sanford Robinson Gifford (1823–1880). *Kauterskill Clove,*
1862. Oil on canvas. The distant Haines Falls, with the Indian-
summer sun aligned directly above it, forms the focal point of
Gifford's dreamy view of the bowl-like gorge in which Rip Van
Winkle took his legendary nap. Bequest of Maria DeWitt
Jesup, from the collection of her husband, Morris K. Jesup,
1914 (15.30.62)

120. Albert Bierstadt (1830–1902). *The Rocky Mountains, Lander's Peak,* 1863. Oil on canvas. Bierstadt composed his heroic alpine portrait from sketches made in the part of the Nebraska Territory that is now Wyoming. Rogers Fund, 1907 (07.123)

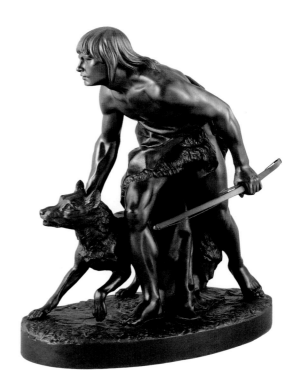

121. John Quincy Adams Ward (1830–1910). *The Indian Hunter,* 1860; this cast, before 1910. Bronze. Ward refined and enlarged *The Indian Hunter,* based on studies from a trip to the Dakota Territory, for placement in New York's Central Park in 1868. It was the first American sculpture to be erected there. Morris K. Jesup Fund, 1973 (1973.257)

Civil War and the 1870s

The Civil War (1861–65) coincided with a resurgence of figural art, represented most vigorously by Winslow Homer. Homer's engagement in the war had been reportorial; his first canvases grew out of his work as an illustrator for weekly magazines. His *Prisoners from the Front* (fig. 122) earned the artist his first widespread critical acclaim when it was exhibited in New York in 1866 and in Paris the following year. In constructing a simple frieze of a victorious Union officer and three defeated Confederates confronting each other before a landscape wasted by battle, Homer created an iconic summation of the war fought between Americans and commented eloquently on its costs.

After the war Homer portrayed Americans on their farms and at some of the same resorts as those frequented by the Hudson River School painters, as reflected in *Eagle Head, Manchester, Massachusetts* (fig. 123), better known by the title of its illustrated version, *High Tide*, published in a magazine the same year. Homer often depicted fashionable women with parasols promenading by the Atlantic, but in *Eagle Head* he peers, almost voyeuristically, at three Yankee girls who have just emerged from the surf in the low light

122. Winslow Homer (1836–1910). *Prisoners from the Front*, 1866. Oil on canvas. The location of Homer's narrative is Petersburg, Virginia, near both Richmond, the capital of the Confederacy, and Appomattox, the site of the South's formal surrender. Gift of Mrs. Frank B. Porter, 1922 (22.207)

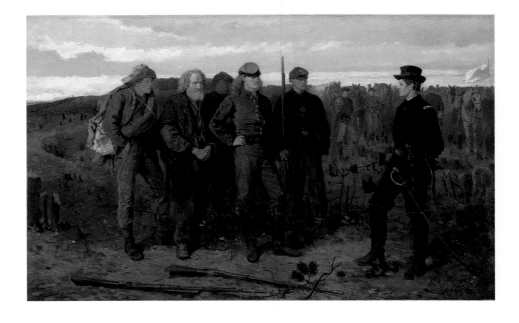

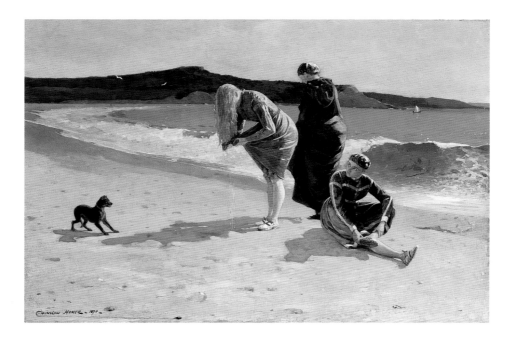

of early morning. The artist has seized a stolen moment, made enigmatic by the long shadows, the hidden faces, the backward glance of the seated woman, and the little dog's wariness of the dripping hair and swimsuit—as if the pet has mistaken its mistress for a mermaid.

In the decades following the war American sculptors produced portrait busts and statues to commemorate its heroes and martyrs. Among the most innovative and inspiring was Augustus Saint-Gaudens's *Farragut Monument* (1877–80; Madison Square Park, New York). This portrait, based on a head study for the monument (1879–80; MMA cast, 1910), captures every wrinkle on the admiral's alert face with uncompromising fidelity. The monument inspired greater naturalism in American sculpture and catapulted Saint-Gaudens to fame. Another Civil War subject, *Wounded to the Rear/One More Shot* (1864; MMA cast, 1865) by John Rogers, depicts two intrepid soldiers who, injured, have retreated. Even so, one is loading his rifle, determined to have another shot at the enemy. The statuette, widely reproduced in tinted plaster, was a popular gift for Union veterans.

The era of Reconstruction following the Civil War encompassed the nascent liberty and inherited poverty of America's former slaves, conveyed in Homer's *Dressing for the Carnival* (1878), as well as the princely wealth of the Gilded Age, catalogued in Eastman Johnson's *The Hatch Family* (fig. 124). Johnson, America's most astute genre painter at the time of the Centennial, was among the first of this country's artists after midcentury to seek formal training in Paris. Johnson's time in France followed a stint in Düsseldorf, where the academy had attracted a number of Americans in the 1850s. In *The Hatch Family*, a grand conversation piece, Johnson portrays a Wall Street broker and his extended family amid the trappings of

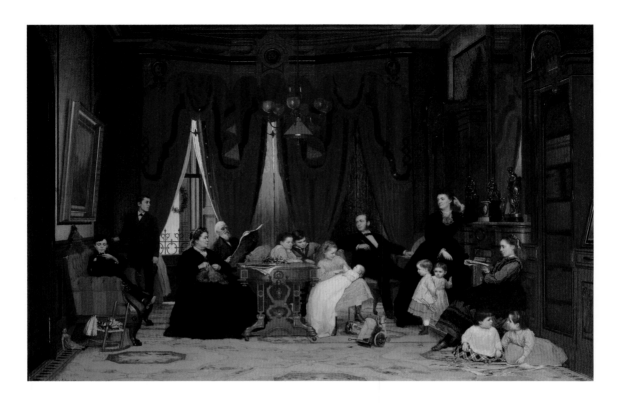

their palatial parlor on Park Avenue. The artist interests himself as much in the roles ordained by society for this new class of bourgeois nobility as in individual portraits. The seated Alfrederick Hatch, the head of household, has turned to regard both past and future of the dynasty: his father, Dr. Horace Hatch, reading the newspaper, and his eldest son, John, respectfully returning Alfrederick's gaze. The younger brother diligently does figures on a slate, while virtually all the women, girls (even the oldest sister, at right, peering past her magazine), and younger children are focused on the newest addition to the family, Emily Nichols, cradled in the lap of her sister, Emily Theodosia.

124. Eastman Johnson (1824–1906). *The Hatch Family*, 1871. Oil on canvas. The artist himself considered this to be his finest work. The eighteen months he labored on the painting necessitated changes to accommodate the arrival of the baby, born while work was in progress. Gift of Frederic H. Hatch, 1926 (26.97)

An American Salon

This gallery replicates the Museum's earliest installations, which were derived from those of contemporary European museums, galleries, and salons. Before 1905 paintings were hung frame-to-frame and floor-to-ceiling on richly colored walls, as shown in Frank Waller's *Interior View of The Metropolitan Museum of Art When in Fourteenth Street* (1881), which is hung in this gallery. Much of the sculpture collection was abundantly displayed in the Museum's Great Hall with select pieces shown along with the paintings. Such dense arrangements were standard in both America and Europe. Curators and collectors alike favored long skylit spaces with high ceilings, in which as many works as possible could be arranged to suggest their relative importance, eye level being the favored position. Nothing was to be kept in storage.

Here, paintings hang in approximate chronological order. The earliest are at the gallery's

125. Jasper Francis Cropsey (1823–1900). *The Valley of Wyoming,* 1865. Oil on canvas. Cropsey was a prolific member of the second generation of Hudson River School painters. In this landscape of pastoral tranquility and providential light, the juxtaposition of the cultivated farmland and the distant smoking chimneys of Wilkes-Barre, Pennsylvania, celebrates agricultural bounty and industrial progress. Gift of Mrs. John C. Newington, 1966 (66.113)

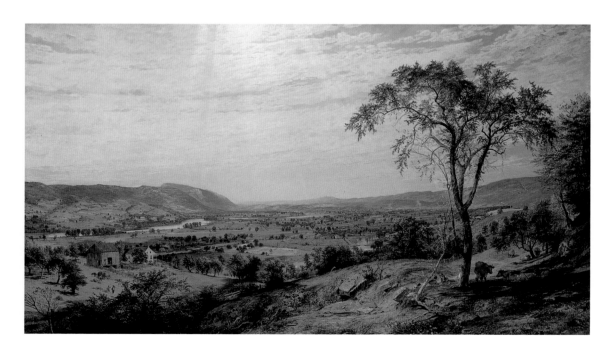

126. Emanuel Leutze (1816–1868). *Washington Crossing the Delaware,* 1851. Oil on canvas. The success of this painting lay not only in Leutze's choice of subject but in his adopting a pyramidal arrangement within which is contained a series of opposing diagonals—bodies, oars, poles, and ice floes—that create a dynamic scene in which Washington is the figure in absolute control. Gift of John Stewart Kennedy, 1897 (97.34)

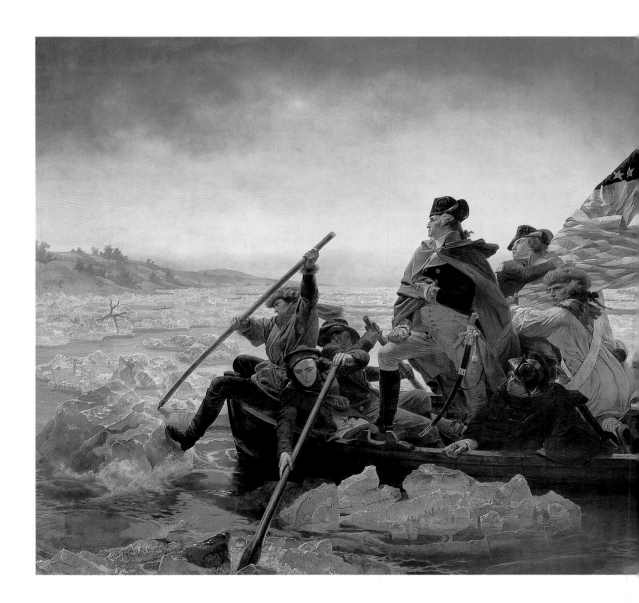

north end, beginning with Henry Peters Gray's *The Wages of War* (1848), the first American canvas acquired by the Metropolitan (the 1873 gift of Museum benefactors), and Jasper Francis Cropsey's pastoral idyll, *The Valley of Wyoming* (fig. 125). The latest, at the south end, include such works as Frederic Edwin Church's visionary composition *The Aegean Sea* (1877) and Thomas Hovenden's masterful portrayal of *The Last Moments of John Brown* (1884). Emanuel Leutze's monumental *Washington Crossing the Delaware* (fig. 126) is the room's centerpiece. The gallery features several outstanding examples of Neoclassical marble sculpture by such artists as Hiram Powers and William Wetmore Story, both of whom achieved international reputations in the middle quarters of the nineteenth century. Powers's bust of Andrew Jackson (fig. 127) combines a truthful likeness modeled from life with classicizing drapery. *The White Captive* (fig. 128) by Erastus Dow Palmer, who maintained a studio in Albany, New York, is an idealized depiction of a pioneer girl, her nightdress stripped away and her hands bound to a post. Story's dramatic over-lifesize *Medea* (1865; MMA carving, 1868) depicts the Greek sorceress in a moment of deep contemplation, scheming her revenge against the Argonaut Jason.

Changes in display at the Metropolitan and other museums came largely as the result of artists' objections to having their pictures "skied," or hung above eye level. James McNeill Whistler, a vociferous critic of Salon displays, started a new trend in his one-artist shows by hanging all of his works "on the line" with

127. Hiram Powers (1805–1873). *Andrew Jackson*, 1834–35; this carving, 1839. Marble. When Jackson sat for Powers in 1837, he told the sculptor, "Make me as I am...and be true to nature always....I have no desire to look young as long as I feel old." His features are recorded in outstanding detail: thick mane of hair, face wrinkles, and sunken, toothless mouth. Gift of Mrs. Frances V. Nash, 1894 (94.14)

generous space between them. In 1898, for the first exhibition of the group of American painters known as the Ten, the works of each artist were installed separately and spaciously, and the show was a great success. At the Metropolitan such displays began about 1905 and were deemed attractive by critics and curators, who commented that they increased the intelligibility of works of art. It was noted in the Museum's *Bulletin* in 1941 that "the viewer is not taxed by attempting to seize upon too much at once." The rehanging of all the Museum's American galleries in this modern taste took almost forty years.

128. Erastus Dow Palmer (1817–1904). *The White Captive*, 1857–58; this carving, 1858–59. Marble. The subject alludes to the endless frontier skirmishes between colonial settlers and Native Americans. The girl's chastity, despite her nudity, is conveyed by her helplessness as well as by the symbolic purity and classical associations of the white marble. Bequest of Hamilton Fish, 1894 (94.9.3)

Cosmopolitan Impulses

In the late nineteenth century, especially after the Civil War, the United States enjoyed unprecedented participation in international political and economic affairs. Newly wealthy American art patrons, especially Northerners who had profited from the war, traveled abroad and avidly absorbed European culture. To announce their new sophistication, they acquired scores of traditional and contemporary paintings and sculptures (many of which would provide the foundation for museum collections such as the Metropolitan's). The cosmopolitan taste of these patrons encouraged American artists to try to compete with European rivals. Rather than merely undertaking the grand tour, which had satisfied their antebellum predecessors, most sought the essential professional imprimatur afforded by formal training abroad. Some studied in Munich, but the great majority went to Paris, where government-sponsored exhibitions, lively critical debate, and improved art schools made the city the world's artistic center.

Many American painters who studied in Paris about 1850 were attracted to Thomas Couture, who taught a method based on Venetian High Renaissance art and who urged his students to preserve the freshness of the sketch in their completed works. William Morris Hunt arrived in Couture's studio in 1846 and remained until 1852, when he went to Barbizon, a village situated on the edge of the Fontainebleau forest about forty miles southeast of Paris, to work with Jean-François Millet, who painted peasant subjects. Hunt's devotion to both mentors is apparent in his portraits, figure paintings, and landscapes such as *Sand Bank with Willows, Magnolia* (1877).

John La Farge, one of the most sophisticated and cosmopolitan late-nineteenth-century American artists, absorbed many influences and interests. Having worked with Couture about 1855, La Farge emulated his teacher's style by exploiting broad planes of paint for his self-portrait (fig. 129). The picture also records La Farge's appreciation of the unmodulated shapes and flattened space of Japanese prints and, in its freely rendered background, his experiments in plein air landscape painting. La Farge's *Autumn Study, View over Hanging Rock, Newport, R.I.* (1868) is an informal record of an unprepossessing site, unlike those in the grandiose views of the Hudson River School. Responding to Japanese prints in its vertical format and flattened forms, the landscape also anticipates in its sketchy casualness the Impressionists' rapidly painted vignettes of nature.

Numerous American artists came under the influence of French painters working in Barbizon. These painters' informal subjects, sketchy treatment, and interest in nature's changing moods distinguished their works from contemporary academic landscapes. George Inness, who had initially espoused the style of the Hudson River School, saw Barbizon paintings in the United States and during visits to France in the 1850s and gradually adopted the poetic Barbizon manner. His *Delaware Water Gap* (fig. 130), a transitional work, combines panoramic breadth with richly applied pigment and only summary details. Moody, large-scale canvases such as *Peace and Plenty* (1865) and *Pine Grove of the Barberini Villa* (1876) exemplify Inness's later style, which eschewed narrative detail and focused on color, atmosphere, and the interplay of forms. The works

129. John La Farge (1835–1910). *Portrait of the Painter,* 1859. Oil on wood. This self-portrait, which La Farge painted in October 1859 at his family's estate in Glen Cove, Long Island, shows the artist ready to embark on a landscape-painting expedition. Samuel D. Lee Fund, 1934 (34.134)

130. George Inness (1825–1894). *Delaware Water Gap,* 1861. Oil on canvas. For this view of a site that he painted several times between 1857 and 1891, Inness established his vantage point on the Pennsylvania side of the Delaware River. The Kittatinny Mountains, shrouded by mist, appear in the distance. Morris K. Jesup Fund, 1932 (32.151)

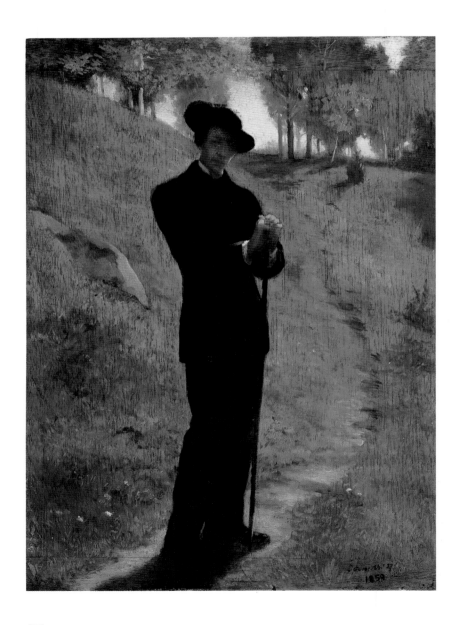

of Inness and the enthusiasm of American collectors for Barbizon art did much to foster the Barbizon-inspired Tonalist style, which flourished among American artists and collectors until after 1900.

Albert Pinkham Ryder, who was introduced to Couture's method by an artist friend in New York and who appreciated Barbizon landscapes, developed a distinctive style for portraying literary themes and storm-tossed boats under moonlit skies, his favorite subject. Ryder looked closely at nature, taking long nocturnal walks in New York's parks, for example, but he sought to describe his subjects' inner meanings, not just their appearance. *The Toilers of the Sea* (fig. 131) typifies Ryder's peculiar and powerful Symbolist vision, which matured during the 1880s. The work depends on a few essential forms created with thick layers of pigments, glazes, and varnishes that have cracked

and darkened over time, adding even more eloquence to that with which Ryder had imbued it.

Henry Ossawa Tanner's *Flight into Egypt* (fig. 132) is a mature work by an esteemed American artist who resided in France. After painting landscape, animal subjects, and, in only two major canvases, African-American genre scenes, Tanner concentrated on biblical themes familiar from his childhood, which was spent in a household headed by a leader of the African Methodist Episcopal Church. In his biblical paintings Tanner developed a painterly, highly personal style based on empirical observation and inner vision.

131. Albert Pinkham Ryder (1847–1917). *The Toilers of the Sea*, ca. 1880–85. Oil on wood. Ryder's painting seems to relate to Victor Hugo's novel of the same title, in which the protagonist, a fisherman on the island of Guernsey, undergoes desperate struggles with the forces of nature and is described in several scenes in his boat illuminated by moonlight. George A. Hearn Fund, 1915 (15.32)

132. Henry Ossawa Tanner(1859–1937). *Flight into Egypt,* 1923. Oil on canvas. *Flight into Egypt* is based on one of Tanner's favorite bible stories (Matthew 2: 12–14). It expressed his sensitivity to issues of personal freedom, flight from persecution, and the migration of African-Americans from the South to the North. Marguerite and Frank A. Cosgrove Jr. Fund, 2001 (2001.402)

Bronze Sculpture

The core of the Metropolitan Museum's collection of American small bronzes was formed in the first decades of the twentieth century, during the time when these objects were most popular as domestic adornments. Sculptor Daniel Chester French, a trustee of the Museum from 1903 to 1931, served as the de facto curator of these sculptures for many years, systematically acquiring a comprehensive collection by living artists. With bold vision, he purchased works from both established and up-and-coming sculptors. Among the most exceptional acquisitions of this period were casts by Frederic Remington, William Rimmer, and Augustus Saint-Gaudens, examples of which are represented in this display of cabinet-size bronzes.

At the same time as most American Neoclassical sculptors were at the pinnacle of their careers in Italy, there was a nascent movement in the United States to create sculpture on home shores. In the 1850s and 1860s Henry Kirke Brown and John Quincy Adams Ward pioneered a naturalism in bronze that anticipated the realistic and lively aesthetic sculptors would later learn in the art schools of Paris. Brown in particular fostered the development of the medium in this country. One of his earliest pieces is the *Filatrice* (fig. 133), a classically dressed subject that was inspired by his four years in Italy. Commissioned in 1850 by the American Art-Union, an organization that distributed works by lottery—mainly to middle-class subscribers—this sand-cast statuette introduced the concept of the small bronze to an American audience.

Augustus Saint-Gaudens, who studied at the École des Beaux-Arts in Paris, represents the

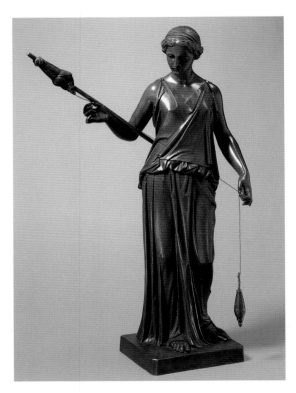

133. Henry Kirke Brown (1814–1886). *Filatrice*, 1850; this cast, 1850. Bronze. Brown's attention to craftsmanship is evident in the textural variation of the figure's skin and garment as well as in the meticulous wire thread wound around the bobbin. Purchase, Gifts in memory of James R. Graham, and Morris K. Jesup Fund, 1993 (1993.13)

dominance of France over Italy as a training ground for aspiring American artists after about 1870. Paris-trained American sculptors such as Saint-Gaudens, Frederick William MacMonnies, and Paul Wayland Bartlett mastered shimmering

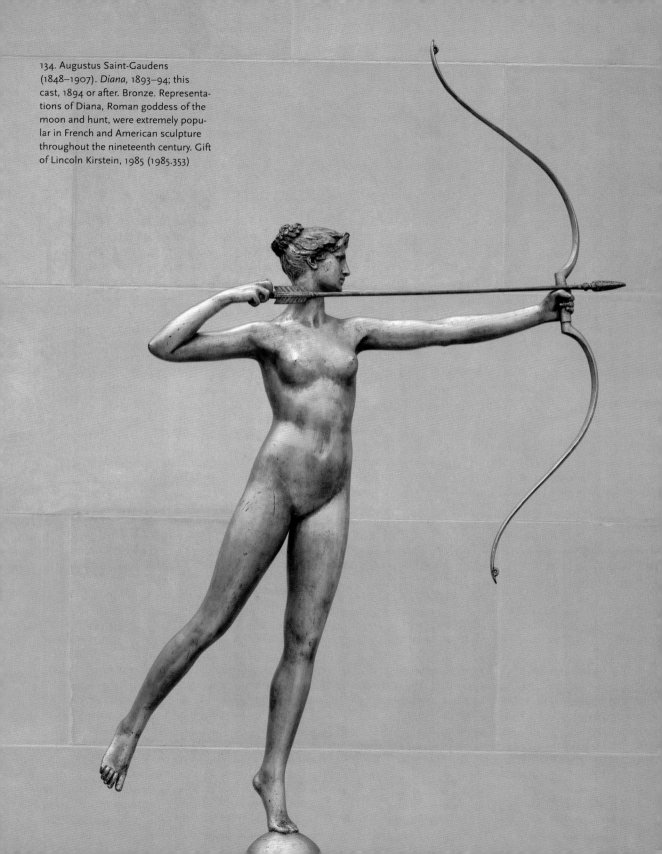

134. Augustus Saint-Gaudens (1848–1907). *Diana,* 1893–94; this cast, 1894 or after. Bronze. Representations of Diana, Roman goddess of the moon and hunt, were extremely popular in French and American sculpture throughout the nineteenth century. Gift of Lincoln Kirstein, 1985 (1985.353)

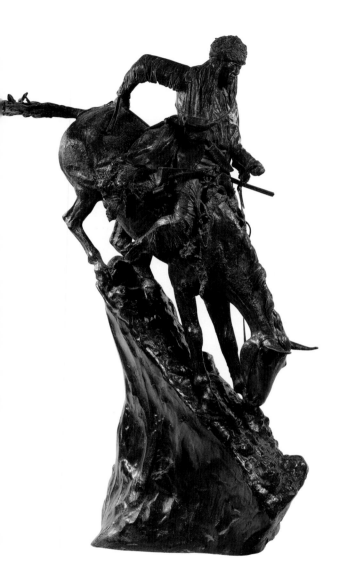

Square Garden as a weathervane. He produced three variant statuettes, of which the Metropolitan's seen here (fig. 134) is the rarest. (The half-size reduction after the thirteen-foot *Diana* for Madison Square Garden is the centerpiece of the Engelhard Court.) The figure, poised atop a full orb on a two-tier base, gracefully draws her arrow. The resplendent gold-colored surface bespeaks the sculptor's successful experiments with patination. Saint-Gaudens's most gifted assistant was MacMonnies, whose historical portrait of Nathan Hale was erected in New York's City Hall Park in 1893. The Hale statuette (1890), like the full-scale piece, represents the schoolteacher-turned-spy bound at his arms and feet, defiant and proud.

Subjects of the American West offered a fertile field for sculptors, many of whom by the 1880s or 1890s saw it as their mission to record the rapidly vanishing native culture and fauna. Edward Kemeys and Alexander Phimister Proctor were this country's first specialists in animal sculpture, enlisting French styles to portray Western wildlife. Proctor's *Stalking Panther* (1891–92; MMA cast, ca. 1914–17 [?]), an engaging study of a predator moving toward its prey, is one of the artist's earliest depictions of an animal in uncivilized nature. Frederic Remington, the chronicler par excellence of the American West, often focused on man's relationship with beast, whether tension-fraught, as in *The Bronco Buster* (1895; MMA enlarged cast, by 1910), or symbiotic. In one of Remington's most compositionally daring works, *The Mountain Man* (fig. 135), an Iroquois trapper tentatively guides his heavily encumbered horse down a precarious incline.

surfaces, fluid modeling, and a highly naturalistic approach to the human figure. By the early 1890s the demand for reductions related to their public statues allowed these sculptors to enhance their reputations and incomes. Saint-Gaudens's over-lifesize *Diana* (1892–93), his only female nude, adorned the tower of New York's Madison

Trompe l'Oeil Still Life and Other Late-Nineteenth-Century Subjects

The American still-life tradition flourished during the late nineteenth century as artists looked to examples of past and current European masters for technical and thematic inspiration. The most skillful and emulated of the Americans practicing trompe l'oeil (trick-the-eye) painting was William Michael Harnett, who studied in Munich during the 1880s. His tabletop compositions, such as *The Banker's Table* (1877), present everyday objects—coins, books, letters, inkwells—with startling textural veracity. In *Still Life—Violin and Music* (fig. 136), Harnett pushed the art of trompe l'oeil to its limits, depicting three-dimensional objects on a two-dimensional plane: the sheet music and calling card are shown with edges bent, not flat; the partly open door suggests depth behind it; heavy items are suspended on strings or balanced precariously on nails.

Harnett's friendly rival, John F. Peto, made a specialty of portraying the homemade letter rack and worked in a less illusionistic, soft-edged style. In *Old Souvenirs* (ca. 1881–1901), tape is tacked to a wood board and holds an assortment of Peto's memorabilia added to and reworked over a period of twenty years; these include a Philadelphia newspaper, a photo of his daughter, and a dated postcard. John Haberle practiced trompe l'oeil during the 1880s and 1890s. The eyestrain brought on by his work on *A Bachelor's Drawer* (fig. 137), with its minutely rendered newspaper clippings, currency, and pictures tacked to a drawer front, led the artist to abandon this type of depiction.

Paintings of craftsmen, artists, or even scientists at work were also popular during the late nineteenth century, as artists became more self-consciously professional and as nostalgia developed for fading handicraft traditions. In Henry Alexander's *In the Laboratory* (ca. 1885–87), a San Francisco chemist and assayer, Thomas Price, is surrounded by his equipment. This *portrait d'apparat* has strong roots in European painting and reflects Alexander's training at the fine-arts academy in Munich. Stacy Tolman studied in Paris and completed *The Etcher* (ca. 1887–89) upon his return. His friend William Bicknell is shown working with serious concentration, using a mirror that reflects a page from the book propped up at his left. Artists often created paintings of fellow artists as tokens of friendship, as in the case of Kenyon Cox's commanding image of America's leading Beaux-Arts sculptor, Augustus Saint-Gaudens (fig. 138). Saint-Gaudens is shown modeling a bas-relief of American artist William Merritt Chase. The sculptor's profile pose with extended arm echoes that of Chase, shown reaching out to paint on an unseen canvas. Surrounding Saint-Gaudens in his studio are a cast of the *Femme Inconnu* (Musée du Louvre), an Italian Renaissance portrait that he greatly admired, and the fruits of his own labor, including bas-reliefs of Sarah Redwood Lee and the sculptor's young son, Homer. Saint-Gaudens was a master of delicate bronze portrait reliefs, as is seen in his image of Mariana Griswold Van Rensselaer (fig. 139). Charming touches characterize his work, such as the wisps of hair at her nape, loosely delineated with single tool marks, and the high collar of her blouse with a ruffled edge.

136. William Michael Harnett (1848–1892). *Still Life—Violin and Music,* 1888. Oil on canvas. Harnett, an avid amateur musician, skillfully depicted a standard 19th-century violin and a granadilla-wood piccolo hanging against a partially open door. The upside-down horseshoe, the sheet music of a melancholic Irish ballad, and the all-seeing eye on the padlock imply that the painting encodes more symbolism than is at first apparent. Catharine Lorillard Wolfe Collection, Wolfe Fund, 1963 (63.85)

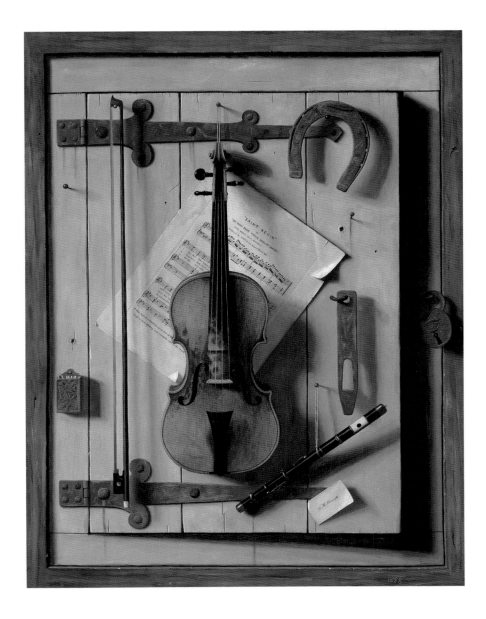

137. John Haberle (1856–1933). *A Bachelor's Drawer,* 1890–94. Oil on canvas. Souvenirs from bachelor days—theater ticket stubs, playing cards, a cigar-box lid, and "girlie" photographs—are arranged against a simulated wood drawer. A pamphlet entitled "How to Name the Baby" and a cartoon of a crying infant suggest that their owner's days of freedom from family responsibilities may be numbered. Purchase, Henry R. Luce Gift, 1970 (1970.193)

138. Kenyon Cox (1856–1919). *Augustus Saint-Gaudens*, 1887; this replica, 1908. Oil on canvas. Cox's original portrait of 1887 burned in a disastrous 1904 fire in Saint-Gaudens's studio. This enlarged replica was created for the sculptor's memorial exhibition, which was held in the Great Hall of the Metropolitan Museum in 1908. Gift of a group of friends and admirers of Augustus Saint-Gaudens, 1908 (08.130)

139. Augustus Saint-Gaudens (1848–1907). *Mrs. Schuyler Van Rensselaer (Mariana Griswold)*, 1888; this cast, 1890. Bronze. This profile portrait of Mariana Griswold Van Rensselaer, a leading Gilded Age critic and writer, is surrounded by a carved oak frame of architect Stanford White's design. The shell pattern flanked by floral medallions echoes the rosettes at the lower edge of the bronze, a harmonious example of the frequent collaborations between Saint-Gaudens and White. Gift of Mrs. Schuyler Van Rensselaer, 1917 (17.104)

Thomas Eakins

Thomas Eakins is deemed one of the greatest American painters for his masterful technique and his powers of characterization and is also appreciated as a sculptor and an innovative photographer. After study in Philadelphia in the early 1860s, he was a pioneer in pursuing additional academic training at the French government school, the École des Beaux-Arts, Paris. There he worked from 1866 to 1869 with Jean-Léon Gérôme, a successful orientalist painter who would become a popular teacher of Americans. Eakins then studied for a few months with portraitist Léon Bonnat, whose style was indebted to that of seventeenth-century Spanish painters, especially Diego Velázquez, and he visited Madrid and Seville before returning to Philadelphia.

The first major canvas that Eakins completed at home was *The Champion Single Sculls (Max Schmitt in a Single Scull)* (fig. 140). This is the best-known work in Eakins's series on the subject of rowing, a popular activity closely associated then and now with Philadelphia's Schuylkill River. Despite its mundane subject, which orthodox academics would have disdained, *The Champion Single Sculls* demonstrates Eakins's reliance on Beaux-Arts principles and practices: careful preparatory studies, stagelike composition, focus on nearly nude figures, almost surreal stasis, meticulous treatment of details and surface, and luminous light that freezes rather than invigorates forms.

Eakins's durable appreciation of the Old Masters is evident in *The Chess Players* (1876), inspired by seventeenth-century Dutch painters such as Pieter de Hooch. Eakins gave the picture to the Metropolitan in 1881, hoping to gain attention in New York. His portrait of his calligrapher father as *The Writing Master* (1882) is a tribute to Rembrandt's sympathetic works. *The Thinker: Portrait of Louis N. Kenton* (fig. 141) invokes the limited palette, silhouetted figure, flattened space, and psychological subtlety of portraits by Velázquez, all invested in a modern American man dressed in an ordinary business suit.

Eakins typically approached portrait painting with a relentless interest in character as well as in appearance. Accordingly, he received few commissions—even acquaintances whom he invited to sit for him sometimes refused to accept their portraits as gifts—and he became notorious for his uncompromising realism. Eakins's innovative teaching methods—he emphasized study of nude models and challenged the constraints of Philadelphia decorum—provoked controversy and cost him his professorship at the Pennsylvania Academy of the Fine Arts. Yet he had several devoted students. Among them was Samuel Murray, whose realistic statuette of Eakins (1907; MMA cast, by 1923) shows the painter sitting cross-legged with palette and brushes in hand as he did while working on part of his great group portrait, *The Agnew Clinic* (1889; University of Pennsylvania Collection of Art).

Eakins's reputation was established only posthumously, in large measure by Bryson Burroughs, the Metropolitan's curator of paintings from 1909 to 1935. Burroughs organized a memorial exhibition at the Museum in cooperation with Susan Macdowell Eakins, the artist's widow—whom Eakins had portrayed in the 1880s in *The Artist's Wife and His Setter Dog* (fig. 142)—and acquired several important oils and watercolors for the collection.

140. Thomas Eakins (1844–1916). *The Champion Single Sculls (Max Schmitt in a Single Scull)*, 1871. Oil on canvas. The painting, whose title refers to the champion in single-sculls competition, was probably inspired by Schmitt's dramatic victory in an important race on October 5, 1870. Yet Eakins chose to portray his friend and rowing companion at ease, after a late-afternoon practice session. Eakins himself rows in the middle distance. Purchase, The Alfred N. Punnett Endowment Fund and George D. Pratt Gift, 1934 (34.92)

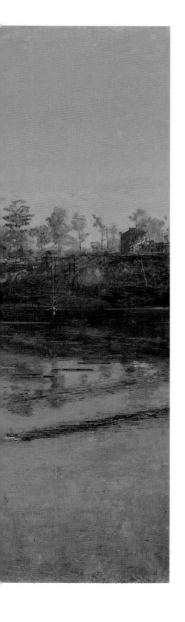

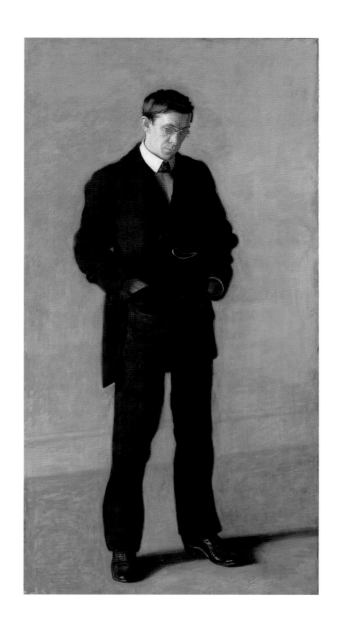

141. Thomas Eakins (1844–1916). *The Thinker: Portrait of Louis N. Kenton*, 1900. Oil on canvas. Using as his model his brother-in-law, about whom little is known, Eakins created a memorable image of both an individual and an archetypal modern man of the new century, proclaimed with the artist's signature in the elegant inscription at the lower right. John Stewart Kennedy Fund, 1917 (17.172)

142. Thomas Eakins (1844–1916). *The Artist's Wife and His Setter Dog,* ca. 1884–89. Oil on canvas. Susan Macdowell (1851– 1938), one of Eakins's most promising pupils, married the artist in January 1884 and probably sat for this portrait in his studio shortly thereafter. Having completed the portrait by 1886, Eakins repainted it, increasing the pathos of his wife's features and expression and perhaps projecting onto the image his own concurrent troubles at the Pennsylvania Academy. Fletcher Fund, 1923 (23.139)

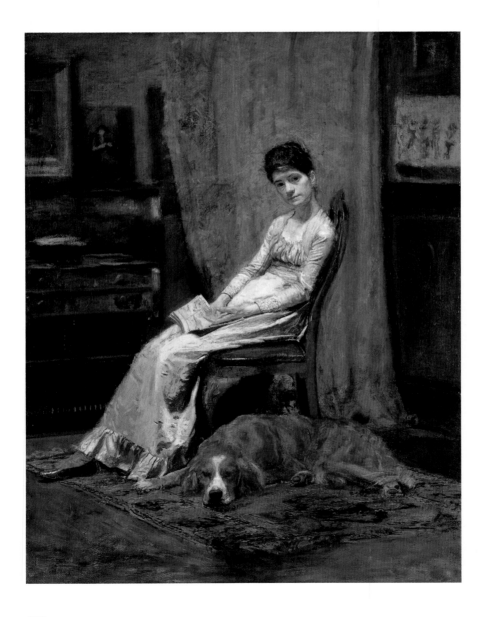

James McNeill Whistler and Mary Cassatt

Among America's most notable expatriate artists are James McNeill Whistler and Mary Cassatt. Born in Massachusetts, Whistler entered the Parisian atelier of the Swiss academic painter Charles Gleyre in 1855 but was more susceptible to the influence of Gustave Courbet's realism. He moved to England in 1859 and leased a house not far from Cremorne Gardens, noted for its festive milling crowds, glowing kiosks, and colored lights. *Cremorne Gardens, No. 2* (fig. 143), with its calligraphic rendering of chairs, trees, and figures, reflects Whistler's rejection of his earlier flirtation with realism, his assimilation of Japanese art, and his revolutionary commitment to an aesthetic, decorative effect. The ephemeral mood is achieved with paint that is diluted to the consistency of a wash and applied to a prepared dark ground. By the 1880s Whistler had attained international recognition for his devotion to "art for art's sake," and American painters such as William Merritt Chase flocked to his studio. The two artists' brief but tumultuous friendship is documented in Chase's portrait of Whistler (1885). In this work Chase captures not only the

143. James McNeill Whistler (1834–1903). *Cremorne Gardens, No. 2*, ca. 1870–80. Oil on canvas. Originally a private twelve-acre estate, Cremorne Gardens was a popular amusement park from 1845 until it closed to the public in 1877. This is the second in a series of six known Nocturnes by Whistler derived from activities within the gardens but eschewing naturalistic detail in favor of decorative pattern. John Stewart Kennedy Fund, 1912 (12.32)

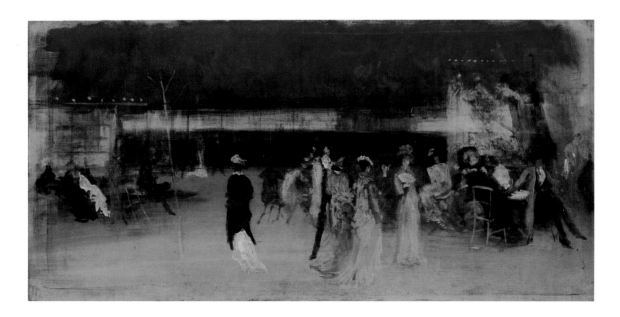

144. James McNeill Whistler (1834–
1903). *Arrangement in Flesh Colour and
Black: Portrait of Théodore Duret*, 1883.
Oil on canvas. Whistler painted the col-
lector and art critic in full evening
dress according to Duret's request, but
suggested that he hold a lady's pink
cloak, a purely decorative addition to
the composition. The reduction of con-
tent to the most essential and expres-
sive forms, the strong silhouette, and
the monogram reflect the influence of
Japanese art. Catharine Lorillard Wolfe
Collection, Wolfe Fund, 1913 (13.20)

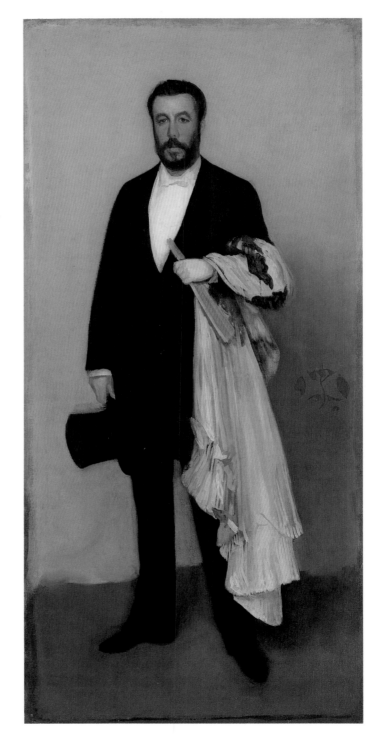

145. Mary Cassatt (1844–1926). *Lady at the Tea Table*, 1883–85. Oil on canvas. Mrs. Robert Moore Riddle is shown seated at a table set with a blue-and-white gilded porcelain tea service, given to the Cassatt family by Mrs. Riddle's daughter. The emphasis on the silhouette and the simplicity of the composition reflect Cassatt's interest in Japanese prints. Gift of the artist, 1923 (23.101)

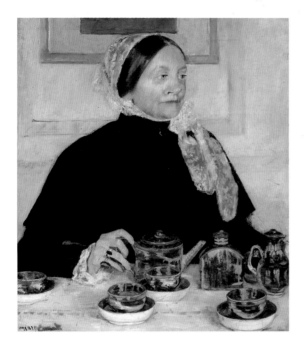

appearance and personality of his subject but also the distinctive limited and flattened space of his paintings, derived from an appreciation of Velázquez and evident in Whistler's *Arrangement in Flesh Colour and Black: Portrait of Théodore Duret* (fig. 144).

Mary Stevenson Cassatt was born in Pittsburgh to an upper-middle-class family and studied at the Pennsylvania Academy of the Fine Arts at the same time that Thomas Eakins did. Like Eakins she was a pioneer in seeking further training in Paris; she received private lessons from French artists Jean-Léon Gérôme and Thomas Couture and visited Italy and Spain before settling in Paris in

1874. Edgar Degas saw one of her paintings in the Salon that year and invited her to show with the Impressionists. Cassatt was the only American who wholeheartedly embraced their style in the mid-1870s, when it was still radical, and the only American whose works hung in their exhibitions. Like Degas, her mentor, she was chiefly interested in figural compositions. Her typical subjects of the late 1870s and early 1880s were Parisian women engaged in quotidian activities such as drinking tea, visiting parks, and attending theater and opera performances. She often used members of her own family as models: her sister Lydia Simpson Cassatt posed for *The Cup of Tea* (ca. 1879) and *Lydia Crocheting in the Garden at Marly* (1880), and her mother's cousin Mrs. Robert Moore Riddle posed for *Lady at the Tea Table* (fig. 145). In 1880 Cassatt began exploring what would later become her signature theme—mothers or nurses tending to children—which she treated with warmth and naturalness in paintings, pastels, and prints. *Young Mother Sewing* (fig. 146) exemplifies Cassatt's ability to convey the intimacy between mother and child with eloquent simplicity.

A number of female artists were especially successful in describing women's activities. Bessie Potter Vonnoh, one of the leading sculptors of the period, produced statuettes of women in various familiar roles. Relying more on psychological mood than physical detail, Vonnoh suggested the boundless love of a mother for her infant in *A Young Mother* (fig. 147). Vonnoh's *Girl Dancing* (1897; MMA cast, ca. 1906) responded to a vogue for statuettes of dancers. The lithe figure, garbed in a timeless high-waisted gown, practices a skirt dance, then a popular diversion for young women.

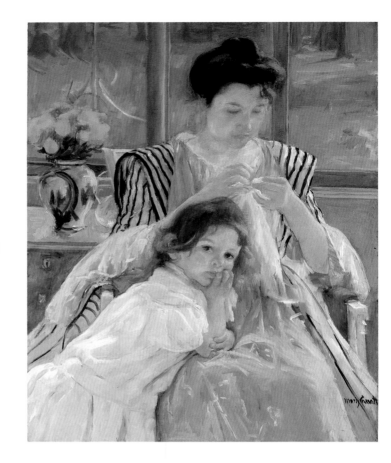

146. Mary Cassatt (1844–1926). *Young Mother Sewing*, 1900. Oil on canvas. This is one of Cassatt's most successful representations of the unaffected relationship between mother and child and, as usual, included unrelated models whom she paid to pose. Margot Lux, a child from a village near the artist's country home at Mésnil de Théribus in France, appears in approximately forty-seven other works by Cassatt. H. O. Havemeyer Collection, Bequest of Mrs. H. O. Havemeyer, 1929 (29.100.48)

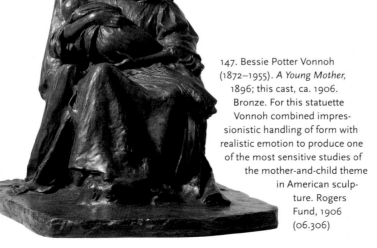

147. Bessie Potter Vonnoh (1872–1955). *A Young Mother,* 1896; this cast, ca. 1906. Bronze. For this statuette Vonnoh combined impressionistic handling of form with realistic emotion to produce one of the most sensitive studies of the mother-and-child theme in American sculpture. Rogers Fund, 1906 (06.306)

American Impressionism

Expatriate Mary Cassatt embraced Impressionism in the mid-1870s, and John Singer Sargent experimented with the style in Paris beginning in 1878–79. However, the first convincing Impressionist paintings executed in the United States were William Merritt Chase's scenes of New York's public parks, such as *Mrs. Chase in Prospect Park* (1886). By 1886 Chase, who had worked in a Realist style in Munich in the 1870s, had been inspired by the art of Sargent, Whistler, and Édouard Manet. But he had not yet been much affected by orthodox French Impressionism of the sort that Claude Monet practiced between 1873 and 1886. In the 1890s, having seen French Impressionist paintings at home and abroad,

Chase created many freely brushed, light-filled canvases at Shinnecock, in the fashionable town of Southampton on the eastern end of Long Island. *At the Seaside* (fig. 149), like his other Shinnecock scenes, celebrates the leisure activities that modern city dwellers pursued in new suburban resorts and country retreats.

In the late 1880s some American painters in France who had learned their academic lessons well began to appreciate the freedom afforded by French Impressionism. For example, Childe Hassam adopted the Impressionists' familiar subjects and rapid brushwork during his student years in Paris between 1886 and 1889. Upon his return home, he found a fertile field for Impressionist experiments,

148. Childe Hassam (1859–1935). *Celia Thaxter's Garden, Isles of Shoals, Maine,* 1890. Oil on canvas. Beginning in the early 1890s Hassam painted on Appledore Island, one of the Isles of Shoals off the New Hampshire coast, where poet Celia Thaxter's hospitable garden and home welcomed painters, writers, and musicians. Offering a sumptuous contrast to the island's rugged terrain, Thaxter's cultivated wildflower garden was a carpet of vibrant poppies accented by graceful hollyhocks. Partial and Promised Gift of an Anonymous Donor, 1994 (1994.567)

especially during his many summer visits to the
Isles of Shoals, off the New Hampshire coast.
Celia Thaxter's Garden, Isles of Shoals, Maine
(fig. 148) is the earliest of three Shoals scenes in
the collection. These illustrate the development of
Hassam's style from purely perceptual Impres-
sionism in the rapidly rendered, informal garden
scene (1890), to greater coloristic and composi-
tional control in *Coast Scene, Isles of Shoals*
(1901), and, finally, to the flattened space and
arbitrary palette of Post-Impressionism in *Surf,
Isles of Shoals* (1913).

By 1887 several American painters had been
attracted to the French village of Giverny, first by
its charm and then by the presence of Monet,
who had settled there in May 1883. Theodore
Robinson, who had studied with various Ameri-
can and French teachers and had absorbed the
Barbizon style, was converted to Impressionism
in 1888, when he began four years of work in
Monet's company at Giverny. Reflecting Monet's
interest in vernacular images, Robinson recorded
Giverny's characteristic yellow stucco walls and
red rooftops in many paintings, including *A
Bird's-Eye View* (fig. 150) and *The Old Mill (Vieux
moulin)* (ca. 1892).

Back in the United States, Hassam and Robin-
son shared their enthusiasm for French Impres-
sionism with American colleagues, including John
H. Twachtman and J. Alden Weir. Twachtman,
who had painted *Arques-la-Bataille* (fig. 151) in
Normandy under Whistler's influence in 1885,
adopted Robinson's broken strokes and varied
palette in the 1890s, when he painted works such
as *Waterfall* (ca. 1890–1900) in Cos Cob, Con-
necticut. Weir also made his home in Connecticut,

149. William Merritt Chase (1849–1916). *At the Seaside,* ca. 1892. Oil on canvas. Long Island's Southampton began to flourish as an artistic venue in 1891, when Chase started to teach in a school for outdoor painting in the Shinnecock area, adjacent to a Native American reservation. Chase's Shinnecock images, mostly of his family, suggest a halcyon life of leisure in an elegant country retreat. Bequest of Miss Adelaide Milton de Groot (1876–1967), 1967 (67.187.123)

where he found inspiration for gentle commentaries on the intrusion of industry into the rural land-scape, as is apparent in *The Red Bridge* (fig. 152) and *The Factory Village* (1897). Olin Levi Warner's spirited bronze portrait bust of Weir (1880; MMA cast, 1897–98) reveals the sculptor's command of the Beaux-Arts aesthetic, which he had learned in Paris, and the particular influence of nineteenth-century French master Jean-Baptiste Carpeaux.

150. Theodore Robinson (1852–1896). *A Bird's-Eye View*, 1889. Oil on canvas. From a hill above Giverny, Robinson portrayed the village's quaint stone houses and walls, cultivated fields, and moisture rising from the rivers that bathed the valley in iridescent vapors. Gift of George A. Hearn, 1910 (10.64.9)

151. John H. Twachtman (1853–1902). *Arques-la-Bataille,* 1885.
Oil on canvas. In summer 1884 Twachtman painted at
Arques-la-Bataille, a town four miles southeast of Dieppe in
Normandy. By comparison with his more naturalistic sketch
of the scene, Twachtman's monumental canvas demon-
strates his absorption of principles from Whistler's works:
concentration on harmonious design, use of flat veils of
subtle color, and a poetic interpretation of nature. Morris K.
Jesup Fund, 1968 (68.52)

152. J. Alden Weir (1852–1919). *The Red Bridge*, 1895. Oil on canvas. The original title of this painting (until about 1900)— *Iron Bridge at Windham*—suggests Weir's concern with changes in the Connecticut landscape wrought by technology. At first he was dismayed to discover that this truss bridge had replaced an old covered wood bridge over the Shetucket River, but he found his compositional components in its geometric structure and its fresh coat of vibrant red paint. Gift of Mrs. John A. Rutherfurd, 1914 (14.141)

Images of Women

About 1900, refined women were favorite sub-
jects of many American artists. The works in this
gallery reflect the contemporary notion that a
woman's proper sphere was within an aesthetic,
harmonious interior, absorbed in cultivated pas-
times, or outdoors, engaged in leisure activities.
These works also suggest the wide range of styles
that artists enlisted to depict these genteel subjects.

John White Alexander's *Repose* (fig. 153) is
emblematic of feminine lassitude and documents
the artist's appreciation of Whistler's elegant
arrangements of shapes and colors in the interest
of aesthetic effects. Edmund Tarbell's *Across the
Room* (ca. 1899), in which a luxuriously dressed
woman lounges on an antique Sheraton-style
settee, reflects the influence of the Impressionists,
particularly Degas, in its oblique vantage point
and asymmetrical composition. William
McGregor Paxton's *Tea Leaves* (1909), which
records a common ritual among upper-middle-
class women, is highly detailed, bespeaking the
artist's adherence to academic principles.

Robert Reid's *Fleur de Lis* (ca. 1895–1900)
and Frederick Carl Frieseke's *Summer* (1914)
depict women as decorative objects outdoors and
demonstrate both artists' attraction to filtered
sunlight and Impressionist brushwork. Maurice
Prendergast's *Central Park* (fig. 154), populated
mostly by elegant women in carriages, on horses,
and promenading on the paths, captures the
festive spirit of New York's leisure class in this
great urban "living room." Working in a Post-
Impressionist manner, Prendergast flattened space
and used a decorative treatment of forms that
recalls works by Pierre Bonnard. In *A Rose* (1907)

Thomas Anshutz portrays his model as contem-
plative yet intellectually and emotionally alert,
using a style that displays both his training with
realist Thomas Eakins and his susceptibility to
John Singer Sargent's painterly freedom.

Cecilia Beaux's *Ernesta (Child with Nurse)*
(fig. 155) shows an endearing little girl taking her
first steps within a privileged world. Beaux's
exposure to the French Impressionists, especially
Degas, is evident in the painting's disconcerting
cropping, suggestion of imminent movement of
the figures, light palette, and spontaneous brush-
work. Like Mary Cassatt, Beaux devoted herself
to an artistic career, rejecting the confines of the
domesticity that was often her subject.

153. John White Alexander (1856–1915). *Repose*, 1895. Oil on canvas. The spirit of the American dancer Loïe Fuller, who modeled for the painting, is captured in the undulating curves of her body and the sweeping flow of her voluminous dress. Fuller's butterfly dances with iridescent chiffon veils were adored by Parisians during the 1890s. Anonymous Gift, 1980 (1980.224)

154. Maurice Prendergast (1858–1924). *Central Park*, ca. 1914–15. Oil on canvas. Prendergast captured the festive activity in Central Park on a sun-drenched summer day, when the spot was an irresistible magnet for a varied crowd. The impression of energy is disciplined by broad horizontal bands that reflect the park's tripartite traffic system, which accommodated carriages, horses, and pedestrians. George A. Hearn Fund, 1950 (50.25)

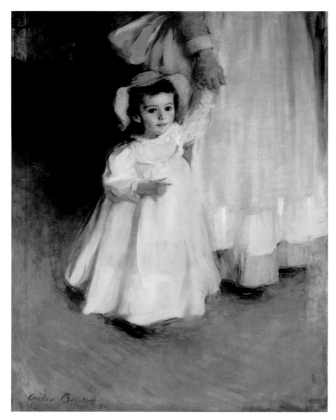

155. Cecilia Beaux (1855–1942). *Ernesta (Child with Nurse)*, 1894. Oil on canvas. Ernesta Drinker (born 1892) was Beaux's niece and favorite model. She is viewed from the eye level of another child, taking her first steps while holding the hand of her nurse. Maria DeWitt Jesup Fund, 1965 (65.49)

Winslow Homer and the 1890s

In the 1880s Winslow Homer gradually moved away from journalistic and anecdotal subjects (see figs. 122–23) in favor of more emblematic meditations on universal themes. After settling in Prout's Neck on the Maine coast in 1883, he continuously observed and recorded the ocean under different conditions of light and weather. Not until after 1890, however, did he generally abandon narrative to concentrate on the beauty and force of the sea itself. When Homer first showed *Northeaster* (fig. 157) in 1895, the picture included two men in foul-weather gear crouched on the rocks at the left of the composition. Sometime before 1900 Homer eliminated the narrative element in the picture by painting out the two figures and emphasized the magnificent power of the storm by enlarging the column of spray. A critic observed that the modified *Northeaster* presented "three fundamental facts, the rugged strength of the rocks, the weighty, majestic movement of the sea and the large atmosphere of great natural spaces unmarked by the presence of puny man." *Northeaster* and other dramatic seascapes such as *Moonlight, Wood Island Light* (1894), *Cannon Rock* (1895), and *Maine Coast* (1896) are among Homer's most distinctive and celebrated paintings. Greatly admired by his contemporaries, they are today appreciated for their virtuoso brushwork, depth of feeling, and hint of Modernist abstraction. Their legacy was felt by George Bellows, John Marin, Edward Hopper, and other American painters.

Like Homer's paintings, American sculptures also celebrated New England as a morally pure and reassuring cultural bedrock. Augustus Saint-Gaudens created for the town of Springfield, Massachusetts, a statue of one of its founders, Deacon Samuel Chapin, entitled *The Puritan* (fig. 156). Unveiled on Thanksgiving Day 1887, the large-scale sculpture and ensuing reductions venerated a stern-visaged forefather who, in steeple hat and billowing cape, assertively

156. Augustus Saint-Gaudens (1848–1907). *The Puritan*, 1883–86; this cast, 1899 or after. Bronze. The figure's heavy bound Bible and the pine branches underfoot suggest New England's beginnings and the pious integrity and hardheaded determination of its settlers. Bequest of Jacob Ruppert, 1939 (39.65.53)

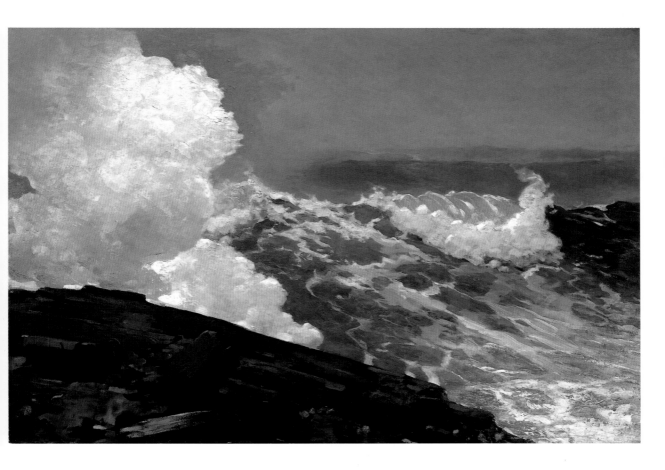

strides through the New England wilderness.

While Homer's heroic seascapes are universally comprehensible as depictions of the eternal conflict between land and sea, they may also be understood to embody the pervasive Darwinian preoccupation with struggle and survival, which the artist suggests in his terrifying painting *The Gulf Stream* (fig. 158). Homer created this composition from studies made during several trips to the Caribbean after 1884. Dazzling tropical light provides an ironic setting in which the solitary protagonist faces a veritable catalogue of disasters: a mastless and rudderless boat, sharks churning up a blood-tinged sea, a waterspout on the horizon, and his obliviousness to possible rescue by the distant schooner.

157. Winslow Homer (1836–1910). *Northeaster*, 1895. Oil on canvas. *Northeaster* demonstrates Homer's superb sense of pictorial design and his gift for grasping the essence of the stormy sea. The broadly painted asymmetrical composition, the proximity of the rocky shore in the foreground, and the use of a high horizon convey the immediate force of the breaking surf. Gift of George A. Hearn, 1910 (10.64.5)

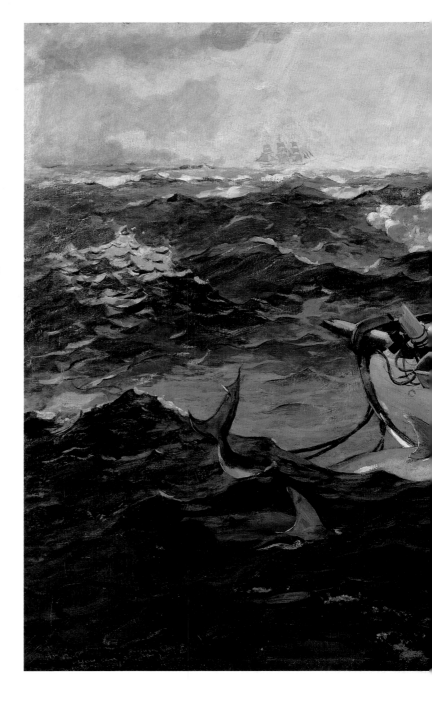

158. Winslow Homer (1836–1910). *The Gulf Stream,* 1899. Oil on canvas. In 1902 Homer suggested to his dealer that he try to sell *The Gulf Stream* to a public gallery. Because of its graphic subject, the artist explained, "No one would expect to have it in a private house." In 1906 it became the first work by Homer to enter the Metropolitan's collection. Catharine Lorillard Wolfe Collection, Wolfe Fund, 1906 (06.1234)

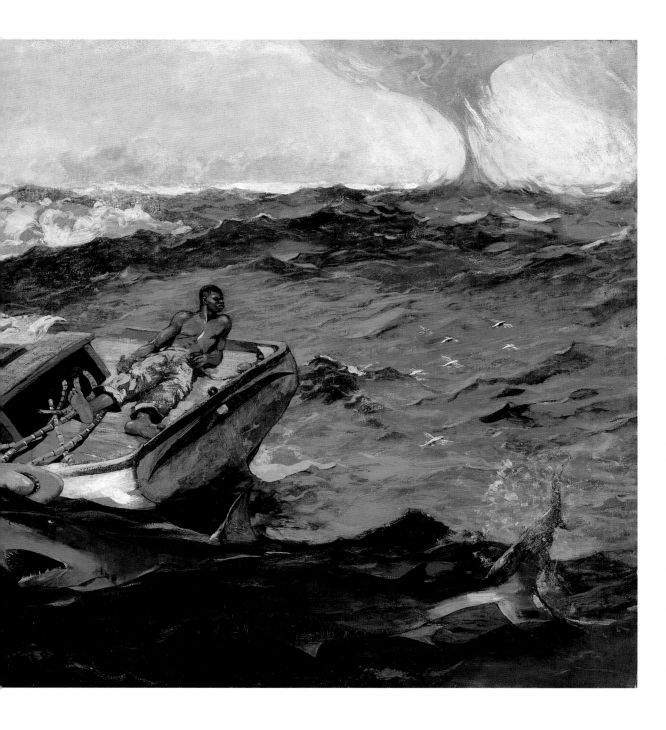

John Singer Sargent

John Singer Sargent was the quintessential cosmopolitan painter. Born in Italy to American parents, he lived most of his life in Europe but cultivated his career on both sides of the Atlantic. He is best known for his elegant international-style portraits of the distinctive personages of his era, but he was also a brilliant landscapist in oil and watercolor, a proficient draftsman, a sought-after muralist, and an occasional sculptor. He experimented with Impressionism in the 1880s, as is seen in *Two Girls with Parasols at Fladbury* (1889), and after 1907 shunned portrait commissions in favor of subjects such as *The Hermit* (1908) and *Alpine Pool* (ca. 1909).

Throughout his peripatetic childhood, Sargent manifested precocious talent, constantly drawing and painting in watercolor the world around him. In 1874 he began his first serious formal training in the Paris atelier of portraitist Carolus-Duran and at the École des Beaux-Arts. *Lady with a Rose* (1882), an early Salon success, demonstrates Sargent's debts to the French academic tradition and to Carolus-Duran, who encouraged his pupils to study Velázquez.

Sargent was deeply attracted to the eccentric beauty of Virginie Avegno Gautreau, the Louisiana-born wife of a prominent Parisian banker, and asked her to pose for him in 1882. When *Madame X (Madame Pierre Gautreau)* (fig. 159) was exhibited at the Salon of 1884, the result was a succès de scandale. The haughty and striking profile, the deathly pale skin, the immodest décolletage, and the fact that Sargent had shown the jeweled strap of her gown falling off her right shoulder shocked visitors to the exhibition and placed *Madame X* outside the bounds of decorum. Sargent later repainted the shoulder strap and kept the painting. To the modern eye, *Madame X* is more than a portrait: it is a symbol, a highly stylized distillation of a professional beauty intensely and timelessly captured in her self-conscious devotion to her appearance.

In the 1890s, Sargent's so-called great decade of portraiture, the control and restraint of *Madame X* gave way to a brilliant painterliness and elongation of figures, stylistic hallmarks that Sargent put into the service of an international clientele. The dazzling *Mrs. Hugh Hammersley* (1892) marked the beginning of Sargent's unqualified success in London, where he had settled in 1885. The fluid brushwork and ingenious composition of *Mr. and Mrs. I. N. Phelps Stokes* (fig. 160) convey a mannered elegance and grandeur that are typical of Sargent's late portraits. *The Wyndham Sisters: Lady Elcho, Mrs. Adeane, and Mrs. Tennant* (fig. 161) is a technical tour de force; within the bold composition, dynamic brushstrokes mingle with quick dabs of paint to delineate forms and suggest the textures of the sisters' opulent gowns against the brocade of the settee.

159. John Singer Sargent (1856–1925). *Madame X (Madame Pierre Gautreau)*, 1883–84. Oil on canvas. After the scandal that erupted when the portrait was first exhibited in 1884, Sargent did not show the painting publicly again until 1905. In 1916, the year after Madame Gautreau died, Sargent sold it to the Metropolitan, calling it "the best thing I have done." Arthur Hoppock Hearn Fund, 1916 (16.53)

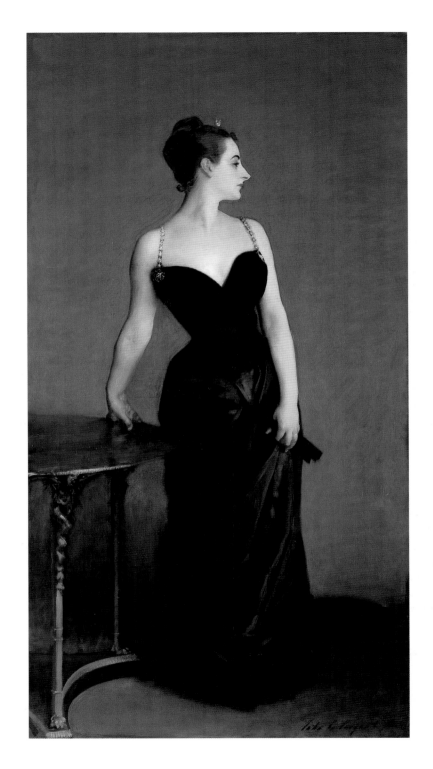

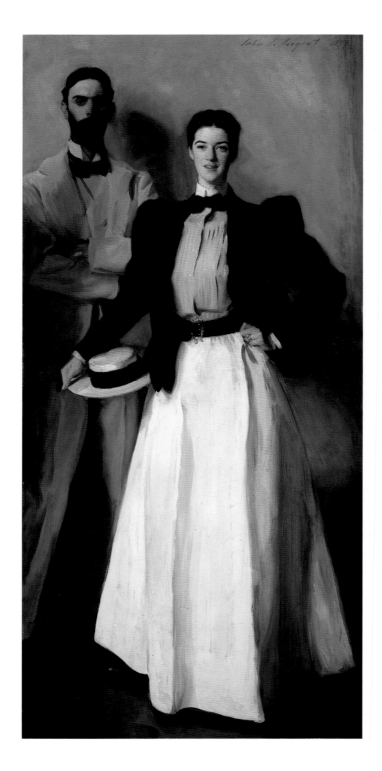

160. John Singer Sargent (1856–1925). *Mr. and Mrs. I. N. Phelps Stokes,* 1897. Oil on canvas. The portrait, a wedding gift to the newly married couple, was to depict only Mrs. Stokes posed beside a Great Dane. As the portrait neared completion, the dog was unavailable. Mr. Stokes wrote in his autobiography, "I had a sudden inspiration, and offered to assume the role of the Great Dane in the picture. Sargent was delighted.... He painted me in three standings— purely as an accessory." Bequest of Edith Minturn Phelps Stokes (Mrs. I. N.), 1938 (38.104)

161. John Singer Sargent (1856–1925). *The Wyndham Sisters: Lady Elcho, Mrs. Adeane, and Mrs. Tennant,* 1899. Oil on canvas. Unlike most of Sargent's other patrons, who posed in his studio, the Wyndham sisters sat for the artist in the splendid drawing room of their London home. Their mother appears in the guise of a portrait of her by George F. Watts, which Sargent cleverly depicted hanging in the background. When *The Wyndham Sisters* was shown at the Royal Academy in 1900, the Prince of Wales dubbed it "The Three Graces." Catharine Lorillard Wolfe Collection, Wolfe Fund, 1927 (27.67)

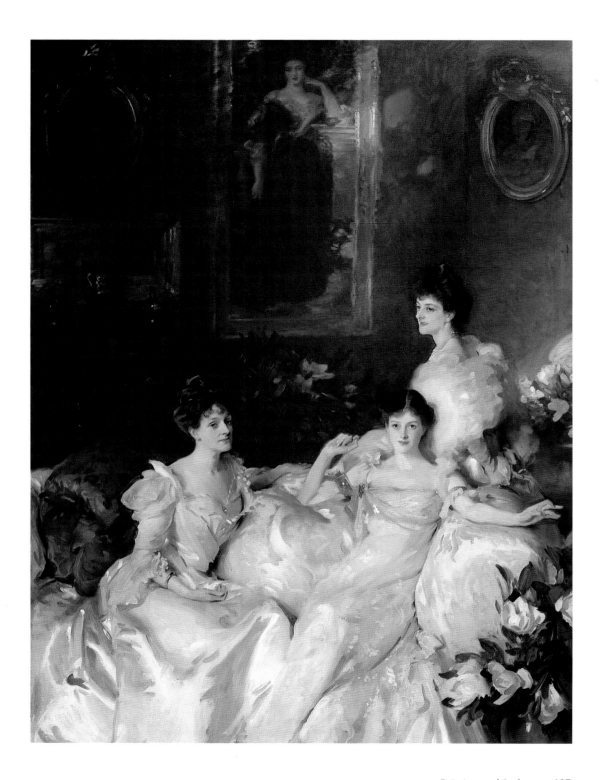

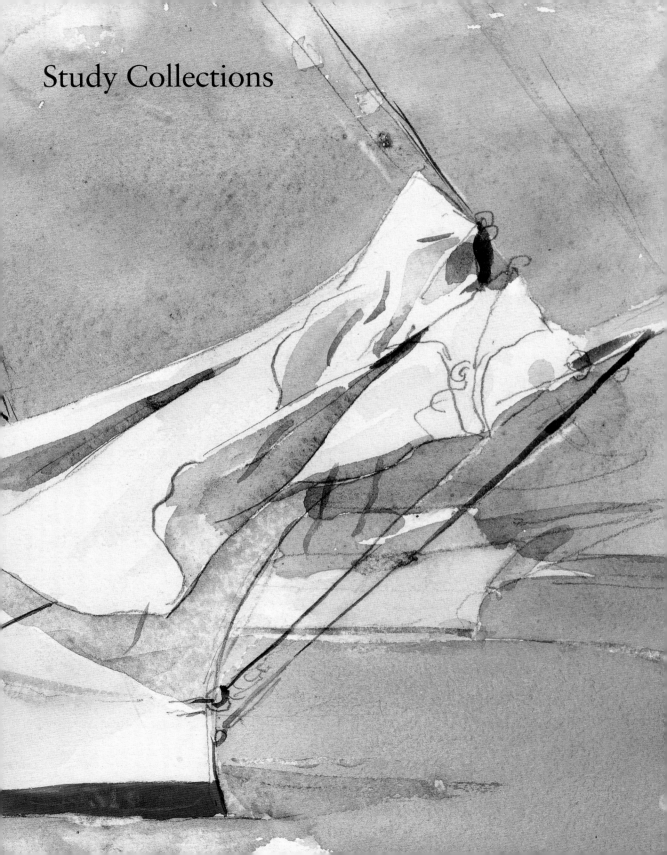

Study Collections

The Henry R. Luce Center for the Study of American Art

The Henry R. Luce Center for the Study of American Art, which opened in December 1988 on the mezzanine level of the American Wing, houses the collections that previously had been held in closed storage. Approximately ten thousand works of fine and decorative art that are not on view in the galleries or on loan to other institutions are shown in floor-to-ceiling glass cases. Pieces are arranged generally by medium or material and specifically by date, style, form, type, or method of manufacture. The Luce Center (named in recognition of support from The Henry Luce Foundation Inc.) allows the Museum to display its complete holdings of American art except for drawings, textiles, and other light-sensitive objects. Visitors are encouraged to use the Luce Center's computerized database, which includes documentation on all the works in the collection. New research is added frequently to the database.

The concept of visible storage carries on the Metropolitan's tradition of study rooms, which began in 1909 with the opening of an area for textiles and soon thereafter was extended to similar facilities for other departments. The study rooms aligned the Metropolitan with the Smithsonian Institution and other major museums founded in the late nineteenth and early twentieth centuries that considered their collections as two entities, one meant for the public and the other available by appointment to students and specialists. The Luce Center built upon this tradition to make the entire collection of American art accessible.

The objects in the Luce Center constitute nearly two-thirds of the Museum's holdings of American art. The works represent a wide range of quality in terms of craftsmanship, technique, and state of preservation. Some are of questionable attribution, place of origin, or date, and await further research. Others duplicate but nonetheless amplify the works shown in the main galleries. Because the Luce Center is the American Wing's storage facility, it is not unusual to find masterpieces of the collections on view from time to time in the course of a reinstallation or on their way to or from a borrowing institution, the Museum's conservation laboratories, or photography studio.

An integral part of the Luce Center is its special exhibition gallery, just to the right as you enter the mezzanine from the American Wing's central staircase. This space annually houses three installations, each drawn from the permanent collection according to an idea or theme that presents new research and discoveries. Often these shows augment special exhibitions mounted concurrently in other galleries at the Metropolitan.

Drawings and Watercolors

The American Wing owns more than two thousand drawings, which can be exhibited only for limited periods because of their vulnerability to damage from light. They range in date from about 1710 to 1925, measure from two inches to four-and-a-half feet wide, and run the gamut of media: graphite, ink, charcoal, chalk, crayon, watercolor, and pastel, or combinations thereof. Most, if not all, of them were executed by artists represented in the paintings and sculpture collection: pastel portraits and figural studies by John Singleton Copley and John Trumbull; landscape sketches and compositions by Thomas Cole, Asher B. Durand, and other American landscape artists; American Pre-Raphaelite and Hudson River School watercolors; the largest collection of drawings by Thomas Eakins; life drawings in charcoal and pencil; and American Impressionist works in both pastel and watercolor.

Highlights of the collection include late watercolors by Winslow Homer, such as *Fishing Boats, Key West* (fig. 162). After 1883, when Homer regularly spent part of his winters in Bermuda,

162. Winslow Homer (1836–1910). *Fishing Boats, Key West,* 1903. Watercolor and graphite on white wove paper. Homer appears to have realized such outdoor scenes with great immediacy, but the pentimento of the sloop in the left background indicates a highly deliberate creative process. ßAmelia B. Lazarus Fund, 1910 (10.228.1)

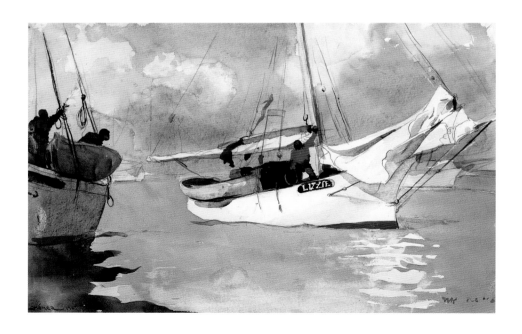

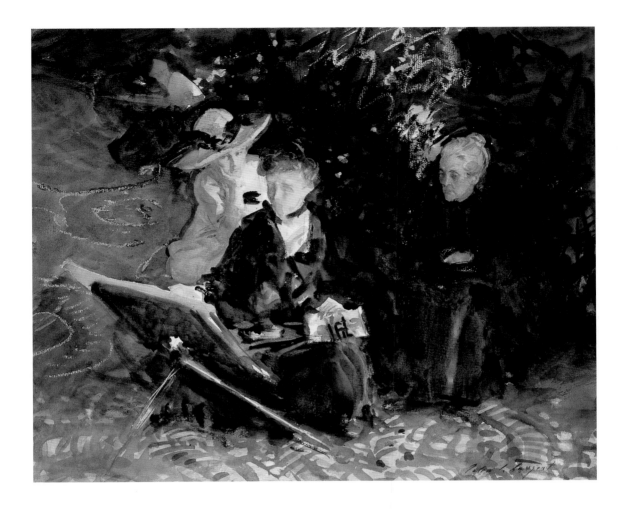

163. John Singer Sargent (1856–1925). *In the Generalife, Granada, Spain*, c. 1912. Watercolor, wax, and graphite on white wove paper. In his plein air watercolors and oils Sargent frequently adopted the high, voyeuristic point of view typical of the French Impressionists, immersing the human figure in environment and making it a part of the ambience of sunlight and shadow. Purchase, Joseph Pulitzer Bequest, 1915 (15.142.8)

Florida, or the West Indies as a respite from the harsh Maine coast, this was the medium of choice during his travels. With it he achieved both transparency and striking depth, evident in *Fishing Boats* in the powerful silhouettes of the boat, the figures, and the reflection on the left that sets off the principal vessel, whose sun-blanched hull, sail, and reflections are merely untinted white paper. Homer constantly challenged himself with the watercolor medium, working it more nimbly than almost any other artist without sacrificing compelling design.

In 1915 the Museum acquired from John Singer Sargent several splendid watercolors, including *In the Generalife, Granada, Spain* (fig. 163). Eventually, through a generous gift from Sargent's sister Violet Sargent Ormond, more than four hundred of the artist's drawings entered the collection. In watercolor Sargent was as spontaneous as Homer but conceived his pictures differently. Rather than

laying down broad washes of color, as Homer did, Sargent richly daubed the pigment, producing an almost rococo extravagance of effect in pursuit of optical neutrality and instantaneity. The subject of *In the Generalife* is his sister Emily, painting outdoors in the company of a friend and an elderly attendant.

The collection includes fifteen pastels by Mary Cassatt, who was surely a phenomenon of artistic authority, creating brilliant, indelible images out of the familiar domestic world. Her pastels, such as *Mother Playing with her Child* (fig. 164), possess the scale, concentration, and rich, assertive pigmentation of her paintings.

164. Mary Cassatt (1844–1926). *Mother Playing with Her Child.* Pastel on wove paper. The mother offers the toddler flower petals, with which the artist decorates the grassy, sun-spotted background of the picture. From the Collection of James Stillman, Gift of Dr. Ernest G. Stillman, 1922 (22.16.23)

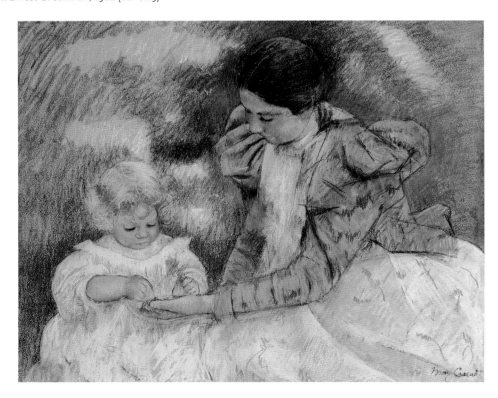

Textiles

The Department of American Decorative Arts owns more than one thousand textiles. Because of their fragile and light-sensitive nature, only a few pieces are on view in the American Wing galleries at any given time. Highlights of the collection include some 140 quilts and coverlets from all regions of the United States, a choice group of eighteenth- and nineteenth-century samplers and needlework pictures (fig. 165), and a variety of furnishing textiles, such as bed hangings (fig. 166), window curtains, tablecovers, rugs, and fabric lengths. The American collection is stored with those of most of the other departments in the Museum's Antonio Ratti Textile Center, where they can be seen by appointment.

165. "The Indian Princess" needlework picture, Boston, ca. 1740–60. Wool and silk on linen. This is one of five known versions of this design completed by anonymous young women at school in Boston. The shepherdess at center traditionally has been called the Indian Princess—in the 18th century an accepted symbol for the American colonies—because of what appears to be a feathered headdress peeking out from behind her hair. Gift of Mrs. Screven Lorillard, 1953 (53.179.13)

166. Phebe Warner coverlet, probably by Sarah Furman Warner Williams (b. ca. 1765), New York, ca. 1803. Linen and cotton. This bed cover is perhaps the finest existing example of an American appliquéd coverlet. The maker was influenced by the central flowering-tree motif common to the imported Indian bed hangings called palampores and by 18th-century pastoral landscape needlework pictures. Gift of Catharine E. Cotheal, 1938 (38.59)

Donors

Many individuals and corporations offered generous support to the American Wing. They are recognized in the American Wing galleries as follows:

FIRST FLOOR

The Charles Engelhard Court

Gallery 105 James and Margaret Carter Federal Gallery

Gallery 108 The installation of this Neoclassical gallery is made possible through the generosity of Donaldson, Lufkin & Jenrette, Inc. and Richard Hampton Jenrette

Gallery 110 The Richmond Room endowed in memory of Annie Laurie Aitken

Galleries 113, 115, and 117 The Israel Sack Galleries

Gallery 116 This Gallery endowed by Kennedy Galleries, Inc.

Gallery 119 The Lawrence A. and Barbara Fleischman Gallery

Gallery 120 The Martha and Rebecca Fleischman Gallery

Galleries 122 and 124 The Richard and Gloria Manney Rooms

Gallery 125 This installation was made possible by a gift from the Overbrook Foundation

Gallery 127 The installation of the Frank Lloyd Wright Room is made possible through the generosity of Saul P. Steinberg and Reliance Group Holdings, Inc.

Gallery 130 Deedee Wigmore Gallery

Galleries 126 and 128 The Erving and Joyce Wolf Galleries

MEZZANINE

Galleries M1–M6 The Frank A. Cosgrove, Jr. Galleries

The Henry R. Luce Center for the Study of American Art

SECOND FLOOR

Galleries 204 and 205 The George M. and Linda H. Kaufman Galleries

Gallery 206 The Virginia and Leonard Marx Gallery

Gallery 207 This installation was made possible by the gift of Mrs. Knight Wooley in memory of her daughter, Clara Lloyd-Smith Weber

Galleries 209–215 The Doris and Stanley Tananbaum Galleries

Galleries 217–223 The Joan Whitney Payson Galleries

Gallery 224 The Frank A. Cosgrove, Jr. Galleries

Richard J. Schwartz Display of American Sculpture

Generous support was also supplied by the Pew Charitable Trusts.

An additional grant was received from the National Endowments for the Humanities and the Arts.

207

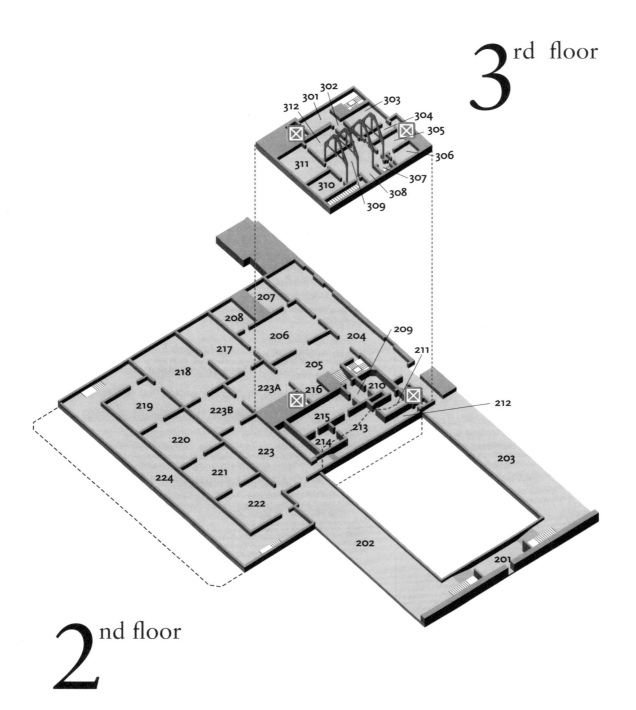

3rd floor

2nd floor